JAMES McNEILL WHISTLER

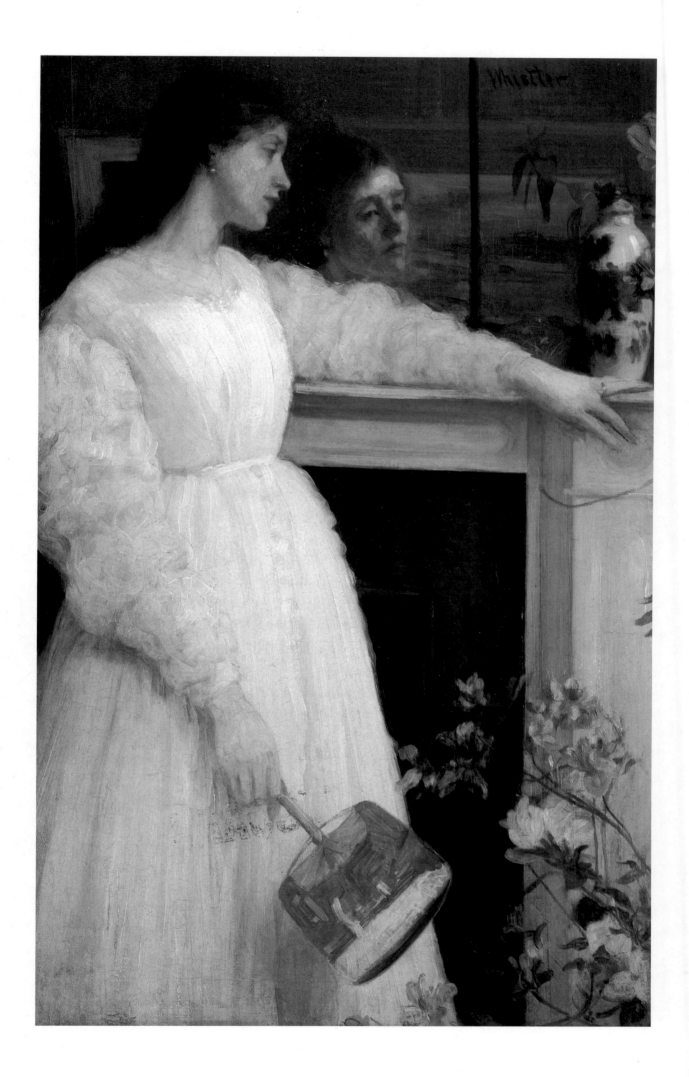

James McNeill Whistler

JOHN WALKER

Harry N. Abrams, Inc., Publishers, New York

IN ASSOCIATION WITH

The National Museum of American Art, Smithsonian Institution

Series Director: Margaret L. Kaplan
Editors: Margaret Donovan, Janet Wilson
Designer: Michael Hentges

Library of Congress Cataloging-in-Publication Data

Walker, John, 1906 Dec. 24–
 James Abbott McNeill Whistler.
 (The Library of American Art)
 Bibliography: p. 154
 Includes index.
 1. Whistler, James Abbott McNeill, 1834–1903.
2. Artists—United States—Biography. I. Whistler,
James Abbott McNeill, 1834–1903. II. Title.
III. Series: Library of American Art (Harry N. Abrams,
Inc.)
N6537.W4W34 1987 760'.092'4 [B] 86–32279
ISBN 0–8109–1786–6

Frontispiece:
Symphony in White, No. 2: The Little White Girl, page 43

Times Mirror Books

Printed and bound in Japan

Contents

Acknowledgments

THERE ARE TWO PLACES above all others to study Whistler: the Freer Gallery of Art in Washington, D.C., established by his close friend and patron, Charles L. Freer, and the Hunterian Art Gallery in Glasgow, the beneficiary of the gift by Whistler's sister-in-law, ward, and executrix, Rosalind Birnie Philip, who inherited Whistler's unsold pictures, scrapbooks, and correspondence. I am deeply indebted to the Freer, especially to its librarians, who provided me with the most complete bibliography of books on Whistler in any library, as well as calling to my attention many obscure articles I might otherwise have missed. At the Hunterian I found a cooperation from the entire staff beyond the hope of any author. This enabled me in a relatively short time to peruse scores of letters, articles, scrapbooks, and other materials accumulated by Whistler. Without the help of these devoted Whistlerian scholars, American and Scottish, this text would never have been written.

My particular gratitude goes to a former member of the staff of the Hunterian, Mrs. Margaret MacDonald, who is now devoting herself to Whistlerian scholarship. She helped me choose the etchings and lithographs for illustrations and provided me with a list of the most suitable of Whistler's watercolors, which will be the subject of her next book. There are two indispensable publications about Whistler: his authorized life by Joseph and Elizabeth Pennell, of course, and the recently published *Paintings of James McNeill Whistler*, by Andrew McLaren Young, Margaret MacDonald, Robin Spencer, and Hamish Miles, the major reference source for my notes on the reproductions. These publications supplement the many books listed in my bibliography and have provided the framework for my biographical essay.

Turning to my former institution, the National Gallery of Art, I am indebted to Miss Ruth E. Fine for allowing me to see some of the abstracts of papers read at the symposium on Whistler that she organized. It is a great sorrow to me that I was in England when this group of Whistlerian devotees assembled, and I could therefore not attend the lectures.

I have also received help from unexpected sources. My brother-in-law, David Drummond, Lord Perth, who has taken a great interest in my book, called my attention to Whistler's account in Drummonds Bank, now part of the Royal Bank of Scotland. The archivist of Drummonds was most helpful in producing Whistler's thank-you note written more than eighty years ago to the chairman of the board, George Drummond—a most unusual communication, he must have felt, to receive from a bank depositor (see p. 118).

6

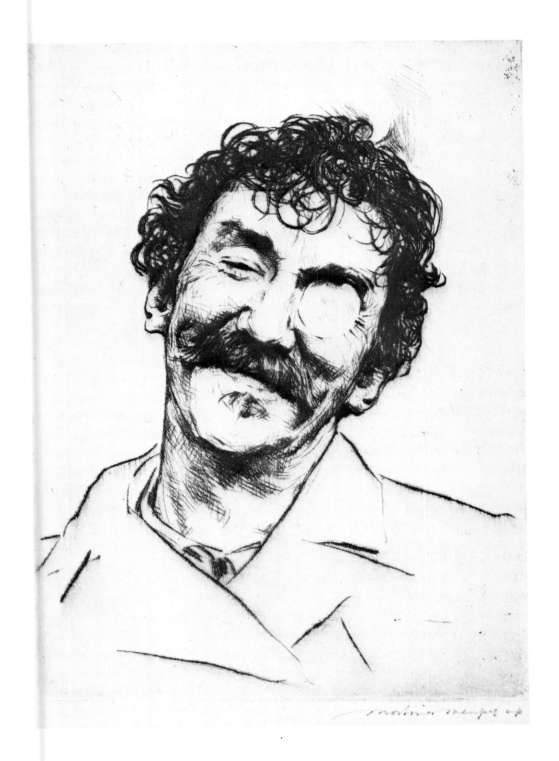

Mortimer Menpes. *Whistler Laughing*

1903. Drypoint, 7½ × 5½"
The New York Public Library
Gallatin Collection of Whistler Portraits

Most of the data in the picture captions have been taken from that monumental work of scholarship, *The Paintings of James McNeill Whistler* by Young, MacDonald, Spencer, and Miles. It proved impossible to write these commentaries without duplicating much of their exhaustive information, and I am grateful for permission to do so.

Introduction

WITH JAMES MCNEILL WHISTLER, America ceased to be provincial and came artistically of age. This is not to say that Whistler's work was accepted in America, much less understood, before it was appreciated in Europe, but rather that he was the first major American artist, apart from the so-called primitives, to establish his own style independent of European influence. He was, so far as it is possible for an artist to be, uniquely himself.

From the days of Benjamin West, John Singleton Copley, and Gilbert Stuart, painters from the New World had crossed the sea and made their mark in London, but they felt themselves provincials, insofar as they accepted the style practiced by their contemporaries abroad. They all had the provincial's lack of self-confidence when confronted with the artistic establishment. Faced with academic prerogatives, they capitulated and worked according to accepted standards. They stressed their hardships in the New World. Even West, the second president of the Royal Academy, was proud to claim he had been taught to paint by Indians; Copley had longed to leave Boston and when he arrived in London rejected the American style he had successfully developed—a hard, brusque, matter-of-fact realism—for the fashionable and flattering methods of the Royal Academicians; and Gilbert Stuart, the most suave and sophisticated of the American expatriates, produced work so like the stylish English artists that his paintings are often confused with theirs. The American painters who followed this great trio were even more imitative of the style established by the Royal Academy.

Not so Whistler. As Ezra Pound said: "He left the message almost it would seem by accident. It was, in substance, that being born in America is no excuse for being content with a parochial standard." Whistler imposed his own way of seeing on English art.

He was, as no other American artist had been, a true cosmopolite. Commuting between Paris and London, he was a major transmitter of French ideas to British colleagues. But, in spite of what he brought back from the Continent, it took many years for English painters and critics to understand what was being done by advanced artists on the other side of the Channel. Whistler, who showed in the Salon des Refusés with the Impressionists, was as independent of them as he was of the Royal Academicians. His style was his own and was to some extent unlike that of any other painter. This intense individualism caused him to be misunderstood. The hostility of contemporary critics marked but did not mar his career. They kept him poor, but they could not make him compromise. He was

8

sure of what he was doing, and his perseverance, painful as it was at times, eventually won out. He was never invited to show at the Royal Academy, though he submitted and exhibited his pictures there for a time. When he was put up for membership as an Academician, he did not receive a single vote.

At the beginning, Whistler had more unfavorable than favorable criticism. The Pennells, in their authorized biography, however, exaggerate the harshness of these attacks. Some critics realized his importance, and in 1873 the *Art Journal* wrote, "The extraordinary merit of his work is widely recognized." But after his lawsuit against the prominent art critic John Ruskin and his bankruptcy, Whistler could not sell his paintings. He was so poor that, had the Fine Arts Society not subsidized his trip to Venice, his situation would have been desperate. Nevertheless, even when he could not dispose of his paintings, there was still a market for his etchings.

British print collectors were relatively impervious to the whims of fashion. They were more scholarly and more knowledgeable than buyers of paintings, less the victims of the bad taste of the Royal Academy and the blindness of popular art critics. When Whistler completely changed the style of his etchings from the meticulous detail of the Thames Set to the abstract and calligraphic scratches of the Venetian plates, his sales continued and even increased. But in painting it was a different matter. No one would buy his Nocturnes, which were scarcely more unorthodox than his prints, and the critics made such fun of his work that it was difficult for him to get commissions for portraits.

Whistler's achievements as painter and printmaker are so remarkable that his originality as an aesthetician is apt to be overlooked. His "Ten O'Clock" Lecture affirmed the principles of modern art. We take for granted what he said and forget how startling it was at the time. Today, art for art's sake is accepted without question, but that was not always so; Whistler helped give validity to a theory now held to be fundamental.

Furthermore, he attacked anecdotage in painting, which was ubiquitous in Victorian and Edwardian art. Whistler's rejection of pictorial storytelling helped pave the way for the increasing focus on abstraction among later generations of artists. To emphasize that there were no overtones of narrative in his paintings, he gave them titles derived from music. This displeased critics and public alike, who considered calling pictures "symphonies," "harmonies," and "arrangements" to be an affectation. But Whistler believed sincerely in this nomenclature. As he wrote in the *Red Rag*: "Art should be independent of all clap-trap—should stand alone and appeal to the artistic sense of eye or ear, without confounding this with emotions entirely foreign to it—devotion, pity, love, patriotism and the like. All these have no concern with it, and that is why I insist on calling my works arrangements and harmonies."

Whistler's influence extended beyond the fine arts. Interior decorators are indebted to him for clearing away the clutter of Victorian and Edwardian rooms. Even museum directors and curators can trace to Whistler, whose exhibitions were so tastefully installed, the first efforts to show collections beautifully. After his death, nothing in the world of art was ever the same.

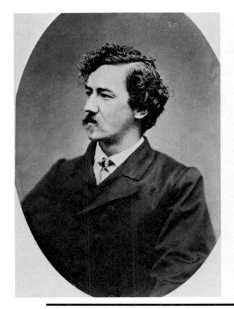

Photograph of James Abbott McNeill Whistler by Carjat

Bibliothèque Nationale, Paris

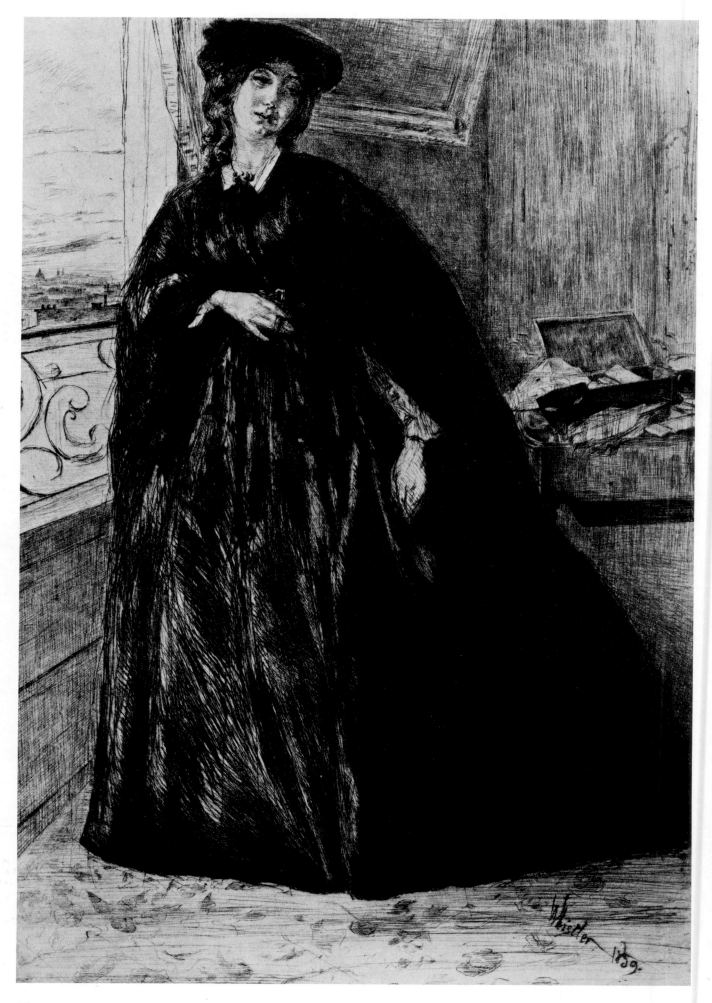

Finette

I. Youth and Early Work

WHISTLER'S OUTSTANDING CHARACTERISTIC was his ebullience, his superabundance of wit and humor. It marked him as a youth and continued all his life. It was an armor that made him impervious to ridicule, a protection he needed against the slings and arrows of hostile critics. But it was also a handicap. It prevented people, for many years, from taking him seriously.

His birthplace was Lowell, Massachusetts, because, as he commented, he felt an obligation to be near his mother. He preferred to think he had been born in Baltimore or, as he said at the Ruskin trial, in Saint Petersburg, Russia, and when either was mistakenly stated, he was delighted. The date of his birth, July 10, 1834, was a fact he accepted.

Whistler's pride in his family reinforced his assurance and self-confidence. His mother, whose portrait equals in fame that of Gilbert Stuart's *Washington*, was descended from the McNeills of Skye. She came from Wilmington, North Carolina, the daughter of a doctor. Her son James Abbott took McNeill for his middle name in 1851. He always considered himself a Southerner and the descendant of a great Scottish clan. His mother was a woman of strong character. Devoutly pious, she tried to dominate her son. She persuaded him, for example, that painting on Sunday was a sin. Whistler was constantly compelled by his mother to read the Bible, and his admirable prose may to some extent have been the result of his familiarity with the text of the King James Version.

His father, the offspring of a military family, was born in Fort Wayne and educated at West Point. Whistler once told a visitor from Chicago: "Chicago, dear me. What a wonderful place! I really ought to visit it some day; for you know my grandfather founded the city and my uncle was the last commander of Fort Dearborn." Like many of his statements, this was somewhat exaggerated—though it is true that his grandfather helped build Fort Dearborn and that Chicago was erected on the site of the fort.

In spite of his military ancestry, Whistler's father rose no higher than major, but he showed great aptitude as a civil engineer. It was in this capacity that he was put in charge of the locks and canals around Lowell. From there, he moved his family to Stonington, on the seacoast of Connecticut, where he was made chief engineer of the Stonington Railroad. Railroads were being built throughout the United States, and he became a consultant to many of the new lines.

In 1842, Czar Nicholas I of Russia sent a commission to find the best man to build a railroad from Saint Petersburg to Moscow. The Russian commission

Finette

1859. Etching, 11⅜ × 7⅞"
Print Collection. The New York Public Library
Astor, Lenox and Tilden Foundations

Whistler has made Finette, a famous Parisian dancer, the epitome of chic and elegance.

11

chose Major Whistler. The salary, $12,000 a year, was large, and he accepted. When he was presented to the czar, the monarch is said to have ordered a map to be brought out, on which he drew a straight line between the two cities. That was to be the route of the railroad. Major Whistler obeyed his orders and, to the czar's delight, finished the railroad in record time. Mrs. Whistler was less compliant. In his book on Whistler's father, Albert Parry describes her as "power grasping" and says she "reached out for power over her family, her friends, acquaintances and even strangers."

The Whistlers remained in Russia from 1843 to 1849. Mrs. Whistler kept a journal. Much of the text is devoted to "Jemmie," or "Jamie," who seems to have been his mother's favorite of the two boys who survived. Delicate as a child, he suffered from severe attacks of rheumatic fever, which weakened his heart and eventually caused his death. At eleven, Jamie began a course of drawing at the Academy of Fine Arts on the banks of the Neva. A year later he was examined and passed as first in his class.

The unsalutary climate of Saint Petersburg left him constantly ill. During one period of convalescence he was given a volume of William Hogarth's engravings, which he devoured. From then on, he maintained that Hogarth was the greatest English artist.

The family spent the summer of 1847 in England, where Deborah, Jamie's half sister, had met and fallen in love with Seymour Haden, a well-to-do surgeon whose avocation was etching. They were shortly married. The Hadens were to play an important role in Whistler's life.

The next summer Jamie had another severe attack of rheumatic fever, and Mrs. Whistler returned with him to England. While they were away, cholera broke out in Saint Petersburg, and Jamie never returned to Russia. While in London, Major Whistler commissioned Sir William Boxall to do his son's portrait. This painting was one of the few works of art, other than his own, that Whistler hung in his various houses.

The cholera epidemic claimed Major Whistler. The czar was distressed at his death and tried to persuade Mrs. Whistler to remain in Russia, but she was determined to return to America. As a farewell tribute, the czar arranged for her to sail down the Neva on the state barge, and the royal crew helped her embark at Kronstadt on a ship for England. There she found Jamie (who had stayed with the Hadens) fully recovered. On July 29, 1849, she sailed with her sons to America and returned to Stonington.

Though Major Whistler had received a large salary, he had spent it lavishly, and his wife found that she had an income of barely $1,500 a year. She would have liked to stay in Stonington but moved to Pomfret, Connecticut, because there was a good school there. Crowded together with her boys, she lived in part of an old farmhouse. The neighbors were impressed by Jamie's drawings, and especially by his maps, which a friend said "were the envy of all the rest of us— they were so perfect, so delicate, so exquisitely dainty in workmanship."

His mother, proud as she was of his drawings, never considered art as a career for him. With his military ancestry, she felt he was destined to be a soldier. If

The Title to The French Set

c. 1858. Etching, 4⅜ × 5½″
The Metropolitan Museum of Art
Harris Brisbane Dick Fund, 1917

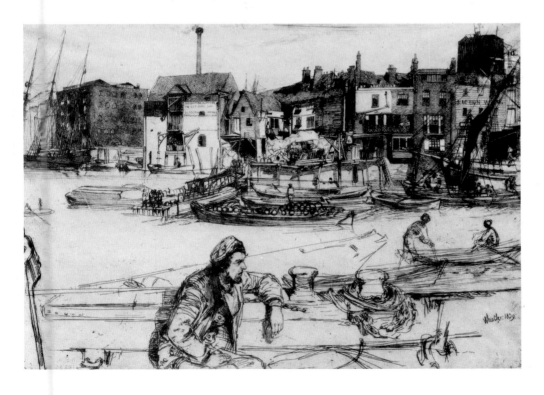

Black Lion Wharf

1859. Etching, 6 × 8⅞″
The Metropolitan Museum of Art, New York City
Harris Brisbane Dick Fund, 1917

The most famous of the Thames Set of etchings. Whistler said it took him about three weeks to do each plate, and when one considers the amount of detail in this print, he must have worked with amazing speed.

Fumette

1858. Etching (fourth state), 6⅜ × 4⅜″
S. P. Avery Collection
The New York Public Library
Astor, Lenox and Tilden Foundations

A model, she was insanely jealous and would not allow any other woman to talk to Whistler when she was present. Among her friends she was called "the Tigresse."

YOUTH AND EARLY WORK

Bibi Lalouette

1859. Etching, 9 × 6″
Print Collection. The New York Public Library
Astor, Lenox and Tilden Foundations

A restaurant where Whistler and his friends dined frequently was owned by a man named Lalouette. His daughter was the subject of this enchanting print. When Whistler left Paris, he owed Lalouette 3,000 francs, which he eventually paid.

Astruc, A Literary Man

1859. Drypoint, 11⅜ × 7⅞″
Courtesy the Freer Gallery of Art,
Smithsonian Institution, Washington, D.C.

*Whistler was industrious while in Paris.
He asked all his friends to pose for him. In
return he gave them a certain immortality.
Astruc, painter, sculptor, poet, editor of*
L'Artiste, *is remembered outside of Paris
only in Whistler's etching.*

Longshoremen

1859. Etching, 6 × 8⅞"
S. P. Avery Collection
The New York Public Library
Astor, Lenox and Tilden Foundations

Whistler frequented the pubs along the Thames, where he could see and draw the tough workmen whose weathered and scarred faces interested him. Sometimes their expressions were dreamy and indifferent, such as that of the man on the left; sometimes they were fiercely intent, like that of the roustabout in the center.

that failed, she hoped he would be a parson, but a martial life seemed more likely than a religious one. To that end, she worked to get him appointed to West Point, and, backed by Daniel Webster, he was, at sixteen, made a cadet. Among his classmates he was known as "Curly" Whistler.

Even at West Point there were art classes, for mapmaking was an important part of an officer's training. Robert W. Weir, the father of the more famous landscapist, J. Alden Weir, was the professor in charge. One day, after examining a study by Whistler, he filled his brush with India ink and started to correct a contour. Whistler shrieked: "Oh, don't, sir, don't! You'll spoil it!" Years later, when asked by another artist, William Merritt Chase, if this were true, Whistler's only answer was, "Well, you know, he would have!"

"Curly" staggered along as a cadet, accumulating so many demerits that most of the time he was on the edge of expulsion. Finally, after three years, he was examined in chemistry. According to Colonel Larned, he was asked the nature of silicon. He stood up and said: "I am required to discuss the subject of silicon. Silicon is a gas." The teacher broke in with the ominous words, "That will do, Mr. Whistler," and the chastised cadet left the class, never to return. Many years later, Whistler said, "Had silicon been a gas, I would have been a major general." There was no question in his mind that if he had completed West Point, he would have been given a high rank. He was never lacking in self-confidence.

Whistler applied for readmission and was turned down, but he realized that the authorities had treated him gently and had no choice but his resignation. He was reluctant to admit it and seems never to have fully accepted the obvious fact that he was totally unfitted to be an army officer. His horsemanship was no better than his chemistry; he often slid over the head of whatever he was riding. Once

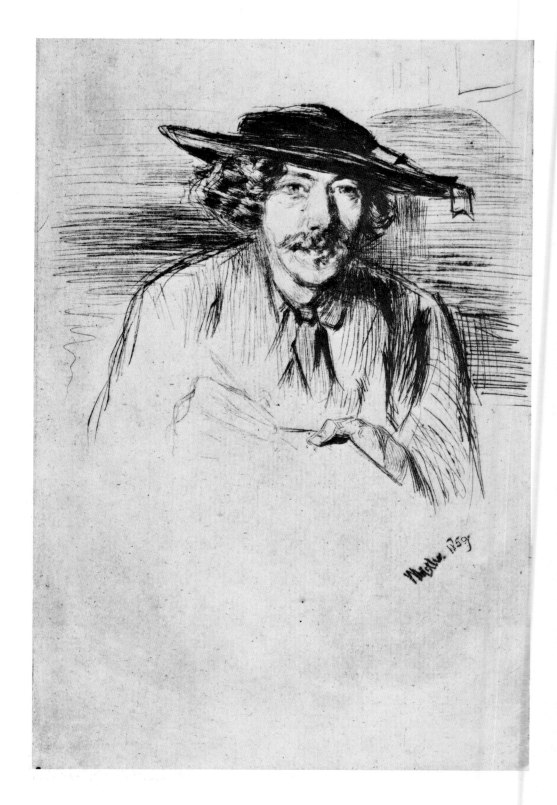

Portrait of Whistler

1859. Drypoint (second state), (8¹⁵⁄₁₆) 9? × 5⅞"
S. P. Avery Collection
The New York Public Library
Astor, Lenox and Tilden Foundations

YOUTH AND EARLY WORK

Self-portrait with White Lock

1879. 4⁹⁄₁₆ × 3⅛″
The Metropolitan Museum of Art, New York City
Harris Brisbane Dick Fund, 1917

Whistler painted and etched many self-portraits. Among the finest etchings are one done early in life (1859) and one late (1879). With time, his physiognomy changed, as did his technique. Throughout his life his work became increasingly abstract.

Venus

1859. Etching (second state), 6 × 9″
Bibliothèque Nationale, Paris

when he had tumbled, as usual, in front of his mount, the major in charge said, "Mr. Whistler, I am pleased to see you again at the head of your class." Whistler answered, "But I got there gracefully."

Nevertheless, Whistler loved and approved of West Point. He always spoke with fierce admiration of the commandant, Robert E. Lee. The Academy was the basis of his code of ethics. His black marks were due to his unwillingness to accept what he considered arbitrary rules. This self-assertive independence marked his whole life. Always retaining the mentality of a soldier, he applied to himself in every crisis the standards of West Point. His respect for the Academy never wavered. Only once was he troubled about it. The adoption of football made him anxious. As he said, when cadets would dispute with "college students over a dirty ball kicked around a muddy field West Point had deteriorated." However, he sent his alma mater a copy of *Whistler v. Ruskin* and inscribed it, "From an old cadet whose pride it is to remember his West Point days." And West Point remembers him. As a memorial to Whistler, it proudly displays a beautiful stele designed by Augustus Saint-Gaudens. This is probably the only monument ever erected by a college for one of its dismissed students.

In 1854, when Whistler was expelled from West Point, he had to face his mother's disappointment and to look for work. He refused to join his half brother, who was doing well in a manufacturing business, and, with characteristic aplomb, wrote directly to the Secretary of War, Jefferson Davis, to ask for reappointment to West Point. Davis made some effort to get him back into the Academy, but Whistler's record was too unsatisfactory for readmission. Then this attractive young man made his way to Captain Benham, the head of the United States Coast and Geodetic Survey, who had been a friend of Major Whistler. After an interview, "Curly" Whistler was employed at $800 a year and became a

draftsman in the Drawing Division. He was soon transferred to the engraving department, where he was introduced to a new technique, etching, which he was to use for many years for many of his greatest achievements.

However inefficient Whistler may have been at work, he was a great social success. It did not help office morale that he usually arrived at 10:30 in the morning, insisting he was not late: it was the office that opened too early. He lasted only four months, but during that time he received a technical education that benefited him all his life. He was taught to draw with accuracy and sharpness of line. He also learned how to bite a copperplate for an etching. With this useful knowledge, he returned home and told his family, much to their surprise, that he had decided to go to Paris to study art. Curiously and unpredictably, his mother made no difficulties, and the family (principally his half brother) scraped up money for a ticket and provided $350 a year for his living expenses.

In 1855, Whistler, at the age of twenty-one, arrived in Paris. He found himself among friends, including the Seymour Hadens, who had gone there for the Universal Exposition. He entered the studio of Marc-Gabriel-Charles Gleyre, but he was more in sympathy with the followers of Gustave Courbet, among whom were Henri Fantin-Latour and Edgar Degas. Whistler was an erratic student. As Sir Edward Poynter said of him in an address the year after Whistler died: "During the two or three years I was associated with him, he devoted hardly as many weeks to study."

Whistler much preferred the French to the British. He had at that time many friends among those studying in the various studios: Fantin-Latour, Henri Oulevay, Alphonse Legros, to name those closest to him. But his particular com-

panion was Ernest Delannoy, a painter who achieved the greatest obscurity and died in an insane asylum. Neither student had any money to speak of. Whistler was often penniless and one summer pawned his coat and went in his shirt-sleeves for days. Once when he needed shoes to wear to a smart dinner, he wandered into a hotel, walked along the corridors where the guests had put out their shoes to be polished, chose a pair he liked, and returned them early the next morning.

With his friend Delannoy, he decided to see Alsace. They set out with too little money, but in the expectation that friends would put them up. They were disappointed in this, and what little cash they had seems to have been stolen. Whistler wrote all his friends for help. Every day they would go to the post office at Cologne in the hope that a letter with money would arrive. The postmaster always shouted, *"Nichts, nichts!"* until the urchins in the town, sighting the two painters, would scream: *"Nichts, nichts!"* Finally, in desperation, Whistler offered the innkeeper, as security for his debts, his copperplates, on which he had etched what came to be known as *The French Set*. The collateral was accepted, and the two artists set out on foot for Paris. They got as far as Aix, their shoes worn out, their clothes torn, their meager food paid for by portraits done en route. At Aix the American consul, who had known Whistler's father, lent them fifty francs, and at Liège Ernest got twenty more from the French consul. The rest of the trip was made in comfort.

Whistler acted out the *vie de bohème* and thoroughly enjoyed it. According to Gordon Fleming, who has written an excellent book, *The Young Whistler*, he would gladly have accepted the title of "King of Bohemia." He had a reputation for indolence among the French and the English, but in Paris he learned all that Gleyre had to teach him about preparing his palette in advance, painting from memory, and using black as the basis of all tones; at the same time he learned the totally different approach of Courbet's realism. He even absorbed Lecoq de Boisbaudran's lectures on values, effects of night, and memory training.

The art, thought, and taste of Paris molded Whistler during his student days. His contempt for nature, his scorn of pictorial anecdote, and his use of musical terms can be traced in part to the prose and poetry of Baudelaire. This great writer's influence on him cannot be exaggerated. From Constantin Guys and Gustave Courbet he also received encouragement to paint daily life. Whistler's four years in Paris left an indelible impression. To say that he was idle during this time is absurd; to ignore the impact of Parisian culture on him is ridiculous. He was basically more French than English or American.

All the great French artists learned their trade by copying in the Louvre, and Whistler was no exception. Respect for artistic tradition was important to him, as the tradition of West Point in another way had always been. His standard was: "What is not worthy of the Louvre is not art."

His early paintings were said to be Rembrandtesque, marked by thick pigment and heavy shadows. His debt to Rembrandt is less evident in his most important picture of this period, *At the Piano*. It shows a remarkable maturity in its mastery of interval and simplification to essential elements. With exceptional sc-

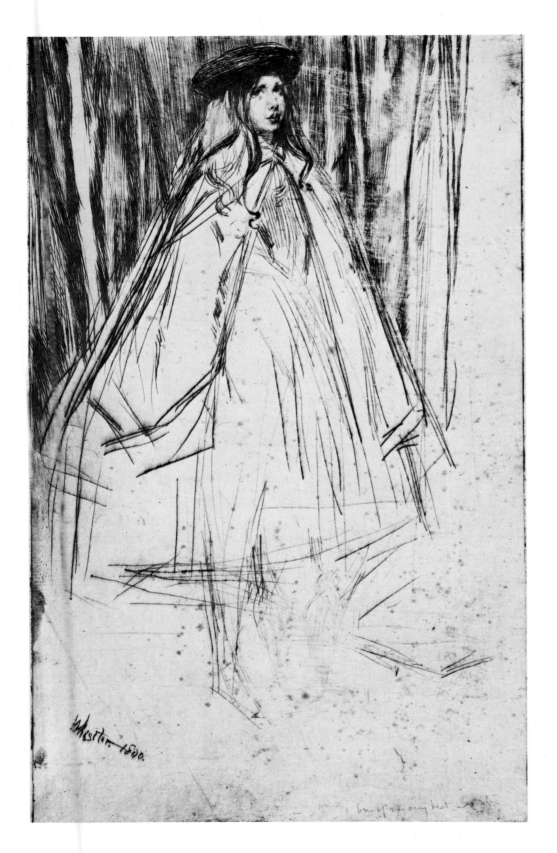

Annie Haden

1860. Drypoint, 13¾ × 8⅜″
Print Collection. The New York Public Library
Astor, Lenox and Tilden Foundations

Referring to this etching of his niece, Whistler told Kennedy that "if he had to make a decision as to which plate was his best, he would rest his reputation on An-nie Haden."

phistication, the horizontal lines of the picture frames on the wall and the dado are contrasted with the curve of the piano. Mother and daughter are beautifully placed. In everything, there is that flair for balanced design that was always to mark his work. *At the Piano* was sent to the Salon of 1859 and rejected.

At this time, Whistler was constantly traveling between Paris and London. In England he stayed with his brother-in-law, Seymour Haden, who had a private income and, as a surgeon, was constantly adding to his wealth. Whistler's friends descended on the unfortunate man, who proved to be remarkably generous. He bought copies of paintings made in the Louvre by Fantin-Latour and acquired pictures by Legros, who was "at one moment in so deplorable condition," according to Whistler, "that it needed God or a lesser person to pull him out of it." Whistler and his two friends formed what they designated "The Society of Three."

Fantin-Latour, Delannoy, and Legros all stayed with the Hadens. They had never known such luxury. Fantin-Latour wrote home: "What lunches! What roast beef and sherry! What dinners—always champagne!" Delannoy was amazed when Haden took a shower and asked Whistler, *"Mais, mon cher, qu'est-ce que c'est cette espèce de cataracte de Niagara?"*

In London Whistler's suit of linen duck and his debonair straw hat were well known. He carried two umbrellas—one white, one black—to prepare himself for any change in weather. This small figure (five feet four inches), with a shock of curly black hair, a monocle, and a swarthy complexion, was a conspicuous figure strolling down Pall Mall.

English artists were puzzled by his appearance, but they, in turn, puzzled him. Once a year painters who usually greeted him warmly refused to see him. They locked their doors and opened them only on the chain. Models became secretive. Everywhere there was an air of mystery. Then he found the explanation. As Whistler put it:

It was the moment of painting the Royal Academy picture. Each man was afraid his subject might be stolen. It was the era of the subject. And, at last, on Varnishing Day there was the subject in all its glory—wonderful! . . . The British subject! The familiar model—the soldier or the Italian—there he sat, hands on knees, head bent, brows knit, eyes staring; in a corner, angels and cogwheels and things; close to him his wife, cold, ragged, the baby in her arms; he had failed! The story was told; it was clear as day! The British subject! What.

Amid this welter of anecdotes, *At the Piano* was hung. Haden was only too pleased to point out its faults and said it would never get into the Academy. But to Whistler's delight, he was wrong. Its simplicity made it the sensation of the show. Even the newspaper critics praised it. After 1860, Whistler was never ignored in England. From then on, for most of his life, he made his home there. Though he preferred the French and their carefree manners, the appearance of London provided the basis of his originality and permitted him to reveal a charm rarely conveyed by other artists and never shown with such perception and intensity. Whistler was the first painter to disclose an unexpected urban loveliness, to unveil the beauty wrought by fog, the transformation of ugliness brought about by

At the Piano

1858–59. Oil on canvas, 26⅜ × 35⅝"
The Taft Museum, Cincinnati, Ohio
Louise Taft Semple Bequest

Shown at the Royal Academy in 1860 and acquired by John Phillip, R.A., for £30, it was the first important picture bought from Whistler. In 1867, when it was exhibited at the Salon in Paris, Manet forwarded a letter from W. Burger, the famous critic, offering to buy it, but it was no longer for sale. Manet must have admired the picture for its clarity of lighting and absence of shadow, which anticipate his later work.

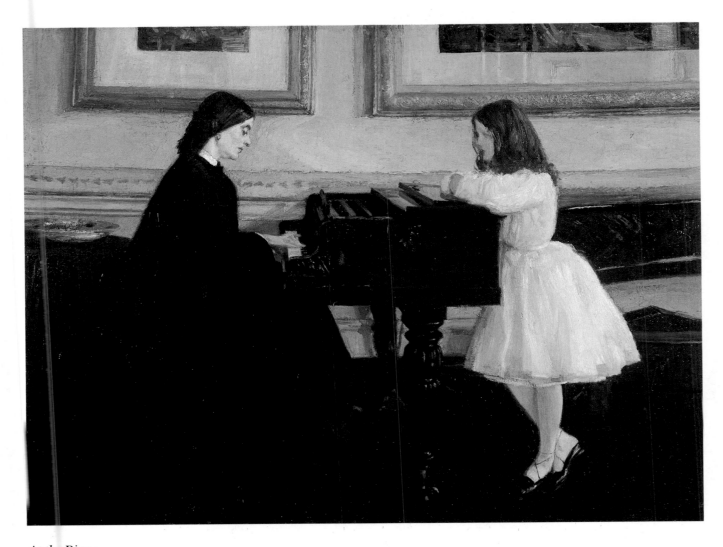

At the Piano

semidarkness. If he did nothing else, this would mark him as a genius.

The Thames fascinated him. He painted and etched its grimy waters, its grim warehouses, its forest of ships, its unending streams of barges, its docks and waterside pubs. He stayed in a small inn in Wapping, frequented by skippers and bargees, to be near his subject matter. Later, he chose houses overlooking the river. Except when he was away from London, the Thames was seldom out of sight.

In 1859, he issued his *French Set*, numbering twelve etchings, the plates for which he had retrieved from the innkeeper in Cologne. The prints from the plates were made later and are among the finest Whistler ever created. They are also among the first examples of his work in this medium. Not all of them are French subjects, nor are they really a set since nothing binds them together. Whistler regarded one of them, a portrait of his niece, Annie Haden, as his most successful achievement in black and white. The wistfulness and uncertainty of childhood have never been expressed more sensitively. With equal penetration, he conveys the melancholy of two mature women, who were among his earliest mistresses, Fumette and Finette. The same pervading sense of unhappiness appears in his treatment of tumbled-down houses and half-ruined architecture. In spite of his seeming gaiety as a person, there is often a streak of sadness in Whistler's work, elicited perhaps by the recognition that in England he was an outsider and had to use his wit in daily life to protect himself. For whatever reason, his basic melancholy seeps through many of his prints and paintings.

For artist's proofs on paper, Whistler charged two guineas, the same price as in Paris. Serjeant Thomas, a print dealer, saw the etchings, met Whistler, and arranged for their further publication. Thomas also opened a shop at 39 Old Bond Street. The family had an apartment in the upper part of the house, and in one room there was a press where much of the printing was done. Whistler used the technique he had learned in the United States Coast and Geodetic Survey.

The plate was placed in a bath of acid, supposedly Rembrandt's method. Whistler would come in the evening, arriving at ten or eleven o'clock, to bite his plates. Thomas would place a glass of port beside the bath of acid where Whistler was at work. The artist would take a sip of port and exclaim: "Excellent! Very good indeed!" and no one knew whether he meant the wine or the etching. Delâtre, at Thomas's request, came from Paris to help with the work. Whistler thought Delâtre was the only man who could print the etchings as he himself would have printed them.

In 1860, Whistler spent more time painting the Thames than printmaking. One of his most successful oils is entitled *Wapping*. It is a scene on the balcony of an inn overlooking the river. In one corner is a sailor, next to him is Legros, and on the other side, with her back to the river, is a girl with copper-colored hair. She is Jo Hiffernan, the future model of *The White Girl* and of many other pictures by Whistler as well as some by Courbet. For many years, she was to be Whistler's unofficial wife. In this early Thames-side picture, she leans back casually in her chair, her bodice partly open. Whistler was warned that this would prevent the picture from being hung in the Royal Academy, but he paid no attention. If it was rejected on that account, he said, he would open the bodice more and more every

The Thames in Ice

1860. Oil on canvas, 29⅜ × 21¾"
Courtesy the Freer Gallery of Art,
Smithsonian Institution, Washington, D.C.

This masterpiece of observation was painted in three days at Christmas, 1860. Whistler has perfectly reproduced the tones of a cold, foggy London day. The picture was reluctantly sold to his brother-in-law, Seymour Haden, who did not greatly value it.

YOUTH AND EARLY WORK

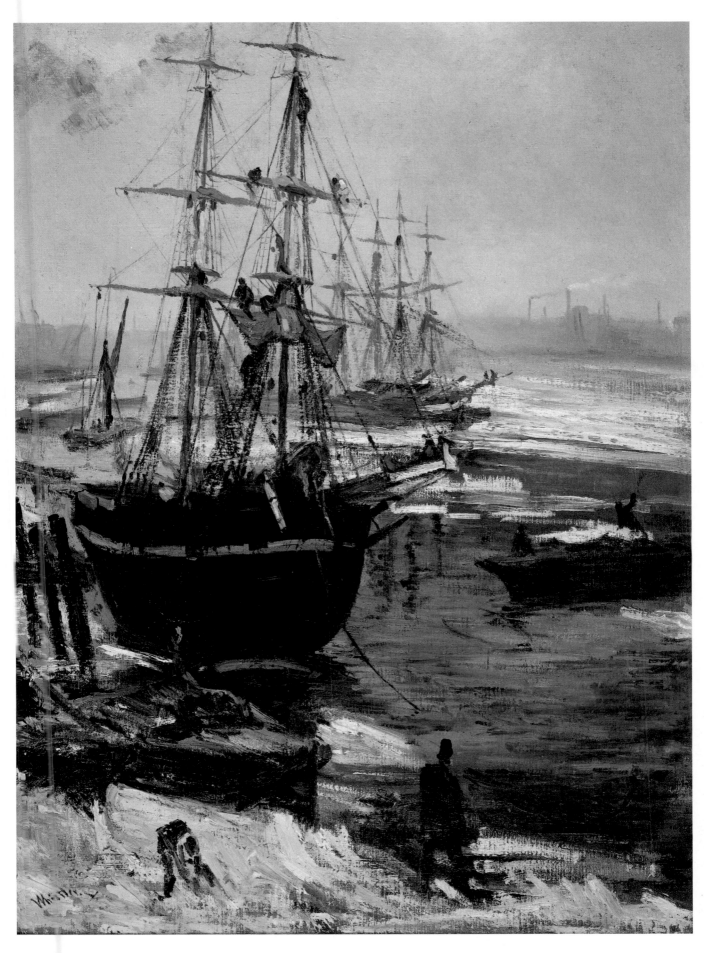

The Thames in Ice

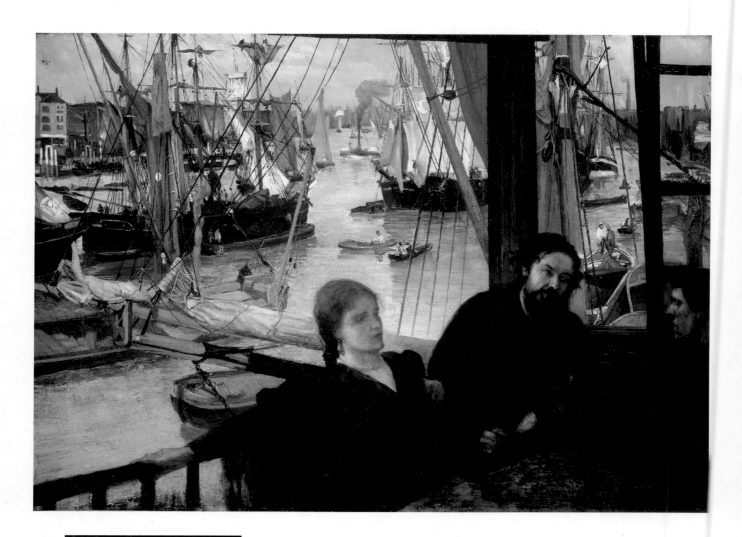

Wapping

1860–61. Oil on canvas, 28 × 40″
National Gallery of Art, Washington, D.C.
John Hay Whitney Collection

Whistler was always in love with the Thames. In an inn beside the river he has depicted three friends: Jo Hiffernan, who modeled for his early pictures and became his mistress; Alphonse Legros, a painter and printmaker who came with him from Paris and settled permanently in England; and a sailor on the right who remains unidentified. The informal composition, without a central axis, is well balanced, but to the Royal Academicians it must have seemed an unorthodox arrangement.

Rotherhithe

1860. Etching, 10¾ × 7¾″
Print Collection. The New York Public Library
Astor, Lenox and Tilden Foundations

Shown at the Royal Academy in 1862, Rotherhithe was compared with Rembrandt. Everyone agreed that Whistler's prints were the most striking and original to have been done since those by the great Dutch master.

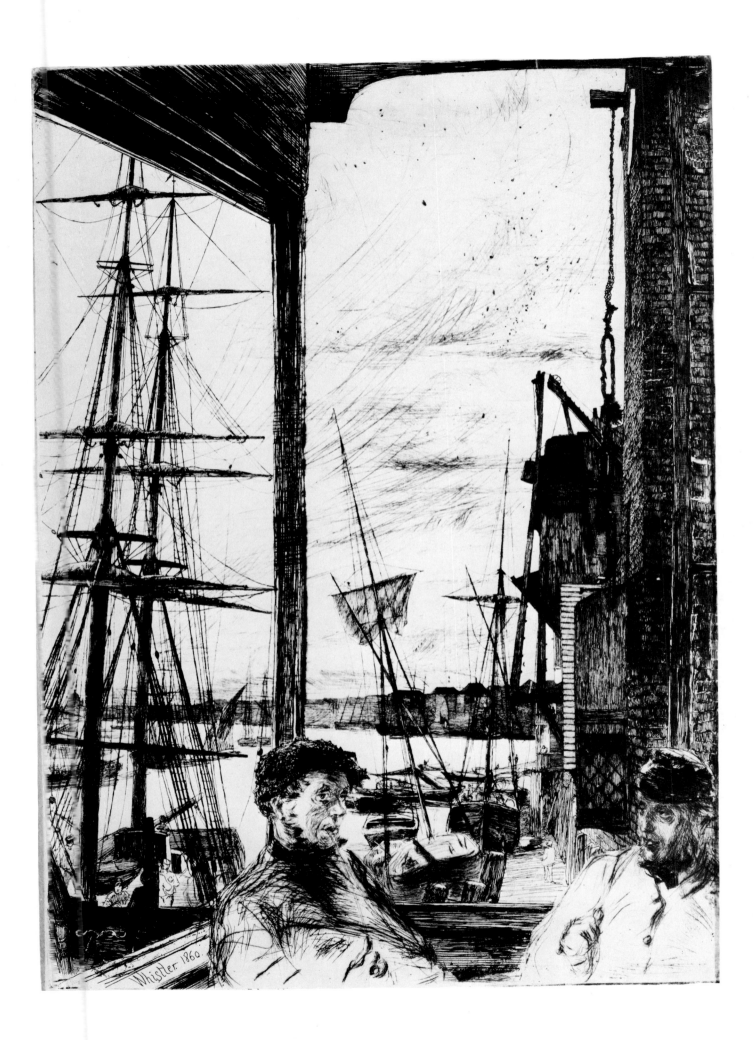

year until he was elected an Academician and then hang the painting himself. He
was never elected, deserving as he was of election.

We have no proof that Whistler was ever in love with Jo. She was an excellent
model, a practical woman keeping his affairs straightened out, and remarkably
kind to the boy Whistler had fathered. Some authors have incorrectly assumed
the child was hers. But we have Whistler's own words that the child was due to an
"infidelity to Jo." He was called Charles Hanson, using the last name of his moth-
er, Louisa Hanson, who had been a maid in the Whistler house. Jo felt sorry for
the boy, who was often ignored by his father, and helped bring him up.

There is another more serious misunderstanding. Some authors have said
that Jo's willingness to model for Courbet brought about the break between him
and Whistler. She was a professional model and as such prepared to pose for any
artist. When the break with Courbet took place, it was on purely artistic grounds.
Whistler realized that Courbet's influence was keeping him from his artistic goal.
He came to hate Realism and its principal exponent. To connect this with jealou-
sy about Jo is sentimentality.

We have Whistler's own statement about Courbet. In 1876 he wrote Fantin-
Latour: "Courbet and his influence was disgusting.... I am not complaining of
the influence his paintings had on my own. He did not have any and it can't be
found in my canvases.... All that he represented was bad for me.... Ah! If only I
had been a pupil of Ingres.... What a master he would have proved, and how he
would have healthily led us."

Whistler's eye was focused briefly on the life about him, and this he owed at
least to the indirect influence of Courbet, whatever he might say. From the same

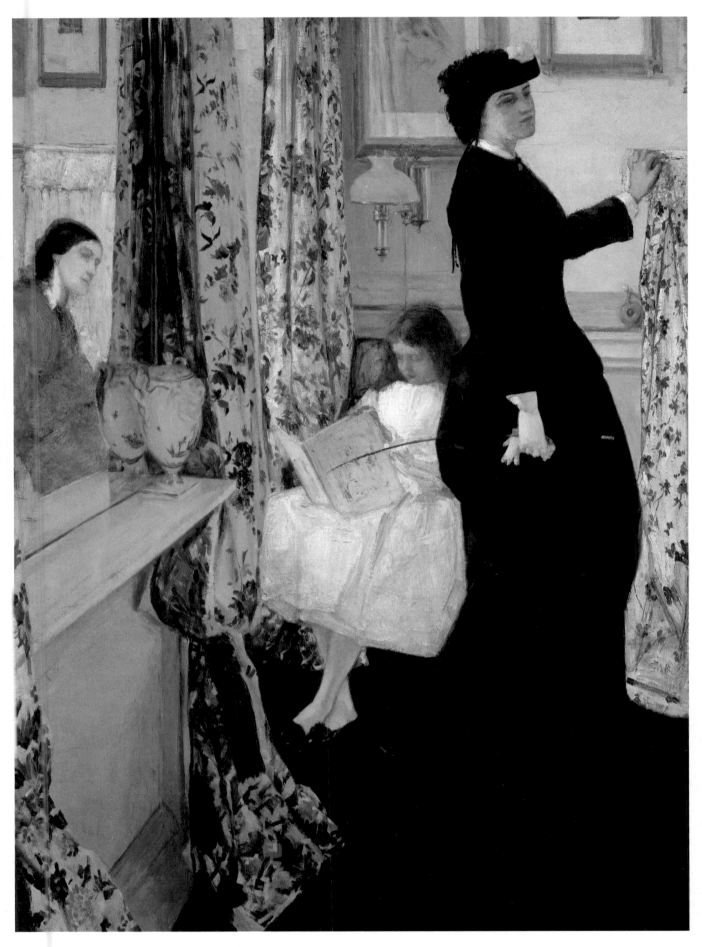

Harmony in Green and Rose: The Music Room

inn where he had painted *Wapping*, an extraordinary innovation in its informality of figure arrangement, he painted *The Thames in Ice*. He sold it to Haden for four pounds, which his brother-in-law said was ample, for it represented a pound a day for the three days it took to paint the picture, and a pound over. Whistler thought this payment far from sufficient but agreed, for, as he said, "My sister was in the house, and women have their ideas about things, and I did what she wanted, to please her!"

The Thames in Ice was his first important maritime scene. The beauty of the picture is principally the way the sky conveys the atmosphere of the river in winter. The foreshortening of the boat is not altogether successful, but the total effect is impressive, particularly as the work of a young artist.

Harmony in Green and Rose: The Music Room was his next important picture. It is an eerie scene of domesticity at the Hadens'. A child is reading to her mother, who is seen only in the reflection in a mirror. It seems a normal English interior, but then one wonders about the tall lady in a black riding habit looking pensively into the distance. She seems a spectral intruder. Her weird, almost surrealist presence startles the spectator, and suddenly the picture seems to have in it something that is bizarre and strange.

Whistler, in this early period, was apt to overload his pigment, and many of his early canvases, such as *Wapping*, have been plagued with separation cracks. But this is not true of *The Music Room* or *The Thames in Ice*. They are painted thinly, a procedure that became Whistler's subsequent method, and they have lasted well.

Whistler had a recurrent bout of rheumatic fever, and he and Jo went for his convalescence to Brittany, where he nearly drowned while swimming. When the late autumn weather worsened, they returned to Paris, where Whistler took a studio in the Boulevard des Batignolles. He was determined to paint a masterpiece for the Salon and the Royal Academy. Having removed all the furniture from the end of the room, he placed Jo against a white sheet and had her stand on a brownish white fur rug, probably a bearskin. He worked to exhaustion to get the painting ready for the deadline at the Academy.

Complicating his efforts, Whistler had invited his hopeless friend Ernest Delannoy to stay with them. Jo disliked him, and they bickered constantly. Too loyal a comrade to throw Delannoy out, Whistler escaped by painting from eight in the morning until dark. Finally, the picture was finished, and Jo and Whistler fled, returning to furnished lodgings in London.

Symphony in White, No. 1: The White Girl was turned down at the Academy but, surprisingly, *The Thames in Ice* and *Alone with the Tide* were hung, as was his etching *Rotherhithe*. As a printmaker, he was accepted at once and was often compared with Rembrandt. In spite of its rejection, he was convinced *The White Girl* would someday receive acclaim. But the rejection of this canvas, as compared with the enthusiasm for Whistler's prints, which are just as innovative, is puzzling. At the Academy, there were apparently certain pigeonholes for paintings; they had to be portraits, landscapes, still lifes, or to tell stories. *The White Girl* fitted into none of these categories; hence, it must have seemed eccentric and was re-

Blue and Silver: Blue Wave, Biarritz

1862. Oil on canvas, 24 × 34½″
Hill-Stead Museum, Farmington, Connecticut

Whistler was anxious to refute the criticism that he could not draw a turbulent sea. Looking at this picture years after it was painted, he wrote his wife, "You never saw such a sea—absolutely sculptured out of the most brilliant blue and green & violet!" This is perhaps the only painting by Whistler that Winslow Homer would have admired.

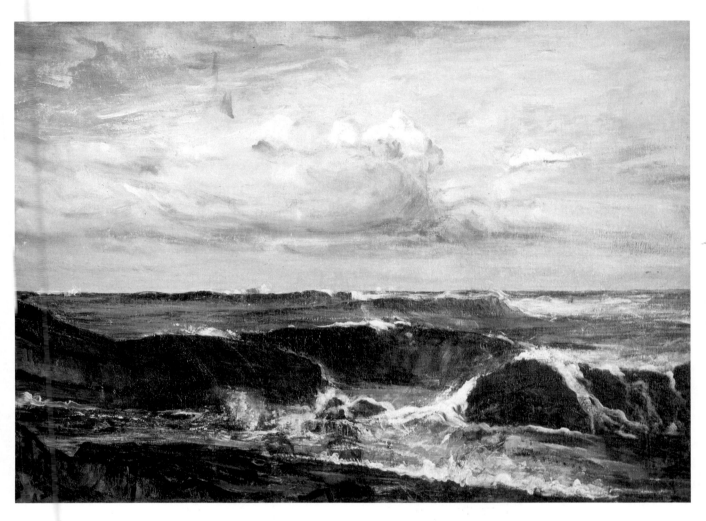

Blue and Silver: Blue Wave, Biarritz

fused. Moreover, it was a painting of white on white, a novel tonal arrangement that outraged the conventional jury.

Meanwhile, Whistler had become dissatisfied with Serjeant Thomas, who sold too few of his etchings, he thought. He told the English artist and novelist George Du Maurier, who had become a close friend, "I wrote the old scoundrel, and he died in answer by return of post—the very best thing he could do." Eventually, a company backed by another friend, Alexander Ionides, took over the sale of his etchings.

At about this time, Whistler met the two Rossettis—Dante Gabriel, poet and painter, and his brother William, writer and civil servant—introduced perhaps by the poet Algernon Swinburne. Dante Gabriel Rossetti had revolutionized black-and-white illustrations, never before considered a dignified and serious form of art. Many of the younger artists were working for the illustrated magazines. Whistler made six drawings of this type in 1862, four of which appeared in *Once a Week*. They were drawn on wood, in pen, pencil, and wash, and were engraved by the Dalziel brothers. The average price paid was nine pounds. Such illustrations had become popular with recognized artists, but Whistler outperformed them all. Seeing these woodcuts years later, he was delighted at his youthful ability. "Well, now, not bad," he said, "not bad even then."

Symphony in White, No. 1: The White Girl

1862. Oil on canvas, 84½ × 42½"
National Gallery of Art, Washington, D.C.
Harris Whittemore Collection

Whistler sent The White Girl *to the Royal Academy. As he described it, "I went on Varnishing Day, to see where they had put her. She was not in the first room, nor the second, nor the third . . . and when I came to the last of them I knew she was rejected . . . and then I went downstairs and poked around until I found her leaning against a wall . . . and I knew that she was beautiful and was consoled." Whistler's absolute certainty about the value of his work kept him from giving in to critical and financial reverses.*

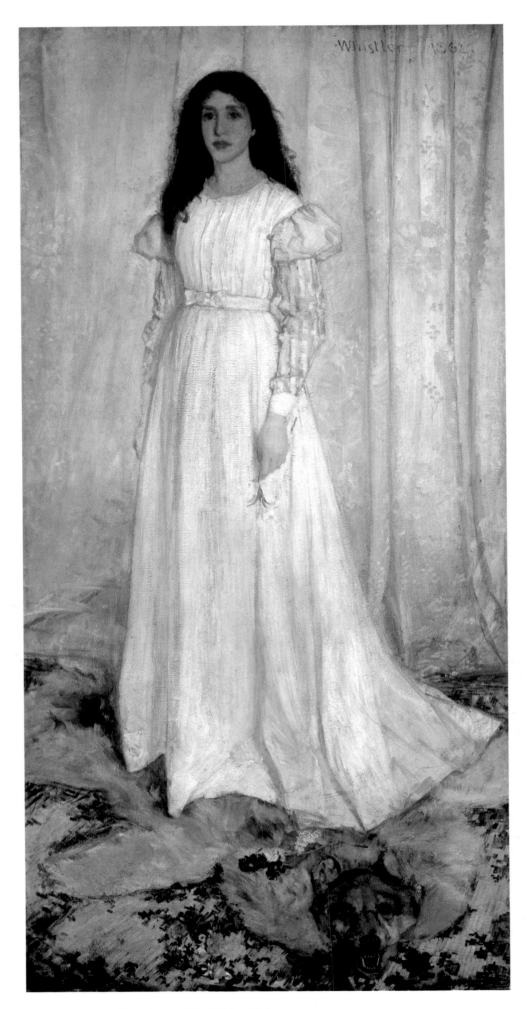

Symphony in White, No. 1: The White Girl

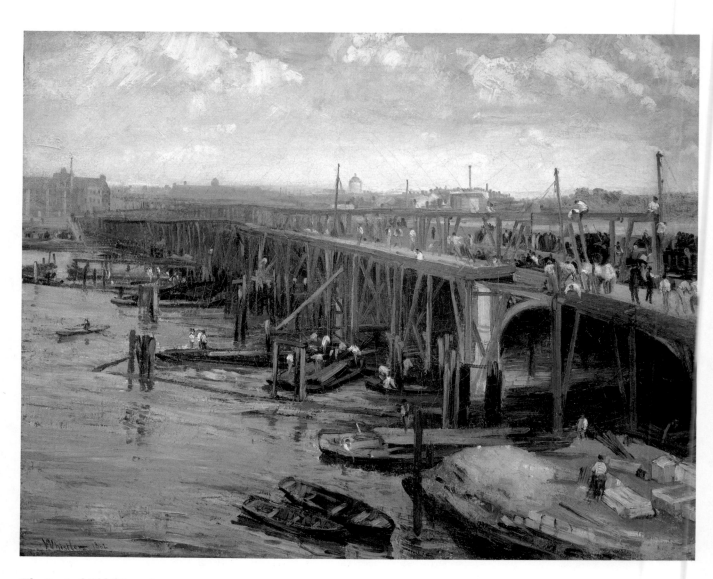

The Last of Old Westminster

II. Travels, Nocturnes, and the Peacock Room

IN 1862, the Thames also inspired an important oil, *The Last of Old Westminster*. It was painted in an apartment belonging to Arthur Severn. In Severn's words:

The bridge was in perspective, still surrounded with piles, for it had only just been finished. It was the piles with their rich color and delightful confusion that took his fancy, not the bridge, which hardly showed. He would look steadily at a pile for some time, then mix up the color, then, holding his brush quite at the end, make a downward stroke and the pile was done. I remember his looking very carefully at a hansom-cab that pulled up for some purpose on the bridge, and in a few strokes he got it perfectly.

The Last of Old Westminster was accepted for the Academy show of 1863, but it was badly hung and failed to impress the critics.

The same year, Whistler took *The White Girl* with him to Paris to show in the Salon of 1863. It was refused, along with work by Fantin-Latour, Legros, Manet, Pissarro, Bracquemond, Jongkind, Cézanne, and others. Paris was in an uproar, and Napoleon III, to show his liberalism and his interest in art, decided there should be a Salon of the rejected pictures in the same building. Many of the eligible artists withheld their work, but Whistler sent *The White Girl*. It was placed prominently so that everyone who attended was bound to see it. Emile Zola describes how the public crowded round it: "The women had stopped stifling their merriment, and the men, completely unrestrained, were holding their sides and roaring with laughter." On the other hand, the distinguished critic Théodore Duret said, "She is painted like a vision, which appears not to everybody but to a poet."

Whistler was disappointed that he could not remain in Paris to hear what was being said by the public and by his friends at the Café de Bade, but he was in Holland adding to his collection of Blue and White china and buying old books to gather a few blank sheets of antique paper on which to print his etchings. He missed the gossip, but he could read the printed comments. There was considerable praise from the French critics. Fernand Desnoyer thought *The White Girl* the most original painting in the Salon des Refusés—"at once simple and fantastic...though of a beauty so peculiar the public did not know whether to think it beautiful or ugly." Paul Mantz considered it the most important picture in the exhibition and described it as *Symphonie du Blanc* some years before Whistler adopted this designation. To eclipse, in the eyes of two critics, Manet's *Déjeuner sur*

The Last of Old Westminster

1862. Oil on canvas, 24 × 30½
Courtesy the Museum of Fine Arts, Boston
Abraham Schuman Fund

Actually this is the new Westminster Bridge with the scaffolding being removed. It was painted from the rooms of Walter Severn, an amateur artist. He thought Whistler would finish his canvas quickly; instead he took so long that the Severn family regretted lending him their apartment. Though Whistler seems to have been slow in finishing the picture, much of his time was spent in contemplating the scene. The actual painting was done with extraordinary rapidity, as Walter Severn himself noted.

Weary

Whistler's favorite model was Joanna Hiffernan. This print beautifully shows her exhaustion after the prolonged posing demanded by the artist.

La Princesse du pays de la porcelaine

This was a key picture in Whistler's oeuvre. After the death of Frederick Leyland, who owned it, Whistler took considerable interest in its sale. He urged David Croal Thomson of Goupil Gallery to buy it at auction, but another dealer got it for 420 guineas, then sold it to W. Burrell, who let Charles Freer have it for £3,750. It is hung where Whistler intended it to be hung, at the end of the Peacock Room, now in Washington, not in London.

l'herbe and the other Impressionist pictures being shown was an achievement that made Whistler very proud.

A passionate love of Blue and White brought Whistler into competition and companionship with Dante Gabriel Rossetti. It was one of the few enduring friendships in his life. On the death of the poet, Whistler wrote, in his incomplete autobiography, that Rossetti was "a Prince among his fellows. Well do I remember with strong affection the barbaric court in which he reigned with the joyous, simple, ingenuous superiority as he throned it in Chelsea."

Tudor House, Rossetti's home, was a short walk from where Whistler lived. It was a bizarre habitation. In the garden was a menagerie of exotic animals, and inside were congeries of humans equally odd. There was an Anglo-Portuguese confidence man and art connoisseur, Charles Augustus Howell; there were always several Pre-Raphaelites: John Everett Millais, Ford Madox Brown, and others; there were poets and novelists who were, in their spare time, art critics (Swinburne and Thackeray); and there was a full-time art historian, John Ruskin. In the group there was a good deal of mutual admiration, sometimes reaching extravagant lengths. Swinburne, for example, told Ruskin that Whistler went so far as to say that his (Swinburne's) verses ranked above Whistler's paintings—a statement that in itself has the ring of improbability!

Whistler spent a great deal of time at Tudor House. To go there was a remarkable experience. Apart from the exotic human beings, there were the animals: a raccoon who liked raw eggs; a wombat who delighted in cigars and was lost for a time until he (or his skeleton) was discovered in a cigar box; peacocks and a gazelle who fought with them and pulled out their feathers; and two kangaroos, who apparently killed each other, much to Rossetti's sorrow. Saddest of all were his two white mice. Once he gave a party for the actress Ellen Terry to honor the awakening of his white mice from their winter hibernation. To the assembled guests, he announced: "They are awake now. But how quiet they are! How full of innocent repose!" He poked them and said, somewhat irritably: "Wake up!" But they were dead.

Whistler, like Rossetti, was a connoisseur of beautiful women. Tom Armstrong, a friend and fellow painter, tells how, one Sunday, Rossetti, Du Maurier, Legros, and he set out from Chelsea in a four-wheeler to be introduced by Whistler to the daughters of the consul general for Greece, Michael Spartali. As he said: "We were all *à genoux* before them, and, of course, burned with a desire to try and paint them." In this desire, Whistler was successful. Christine Spartali was at once graceful, voluptuous, and spiritual, an exceptional combination. He dressed her in a Japanese robe and entitled his picture *La Princesse du pays de la porcelaine.*

This is an early example of the effect of Japan on Whistler. He never visited that far-off country, but Japanese art left a deep impression on his paintings. His color and design are impregnated with Japanese art. This single figure, for example, is posed on the long narrow panel as she might have been placed on a woodcut by Utamaro. He was in Paris when Félix Bracquemond came across a small volume of Hokusai's woodcuts that had been stuffed into a crate of china

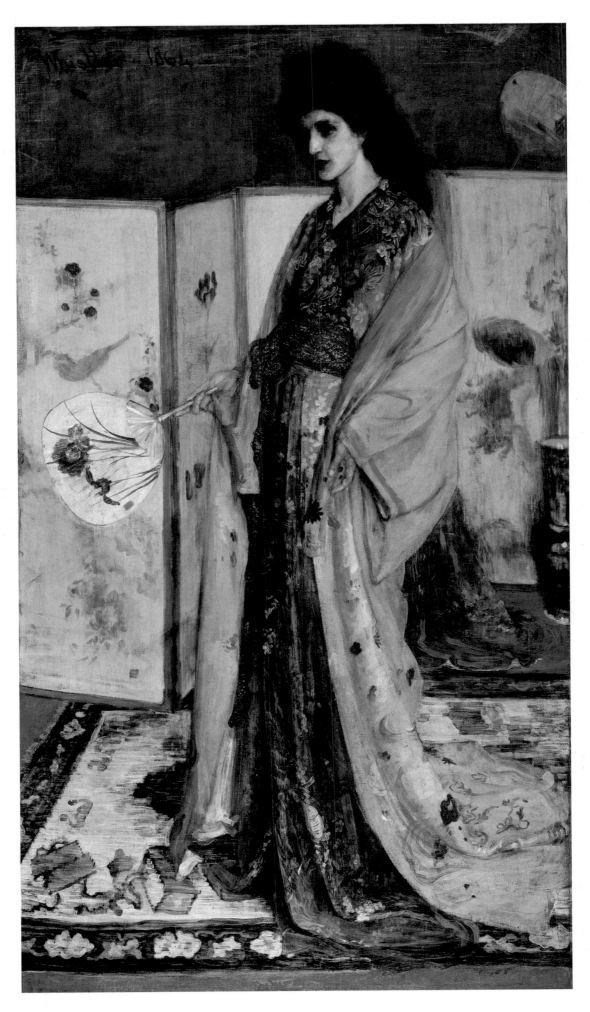

La Princesse du pays de la porcelaine

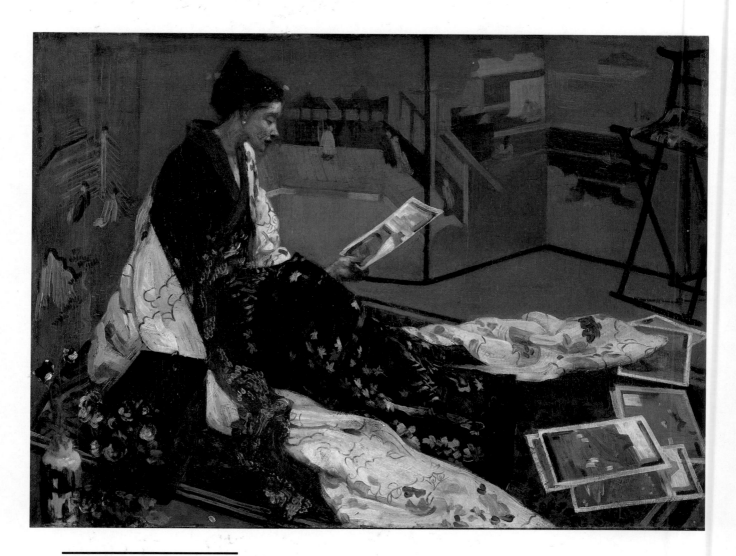

Caprice in Purple and Gold: The Golden Screen

1864. Oil on wood panel, 19¾ × 27"
Courtesy the Freer Gallery of Art,
Smithsonian Institution, Washington, D.C.

Whistler rarely lacked self-admiration. In 1865 he wrote Fantin-Latour, "J'ai fait encore un petit tableau Japonaise qui est ravissant." When the painting appeared in the Goupil Gallery Album, he complained that the reproduction made the blues and violets look "like the outside of a Spanish plumbox or a case of Cuban cigars! gold tipped Colorados!" The subtlety of Whistlerian color is difficult to reproduce, but only a disastrous error on the part of the printer could have made his tones look like a "Spanish plumbox" or a "case of Cuban cigars." Little wonder he was horrified. This is one of the earliest instances of the strong influence on Whistler of the art of Japan.

Purple and Rose: The Lange Leizen of the Six Marks

1864. Oil on canvas, 36 × 24¼"
Philadelphia Museum of Art
John G. Johnson Collection

"Lange Leizen" was the Delft name for Blue and White Chinese porcelain decorated with figures of "long ladies." The Six Marks were the potter's marks on the bottom of the pots, which gave the potter's name and the date. Collecting was an obsession with Whistler. He created a vogue for Blue and White Chinese porcelain, which rose in price and then ironically became too expensive for him to buy. Potter's marks gave him the idea of signing his pictures with his initials, which he turned into the famous butterfly.

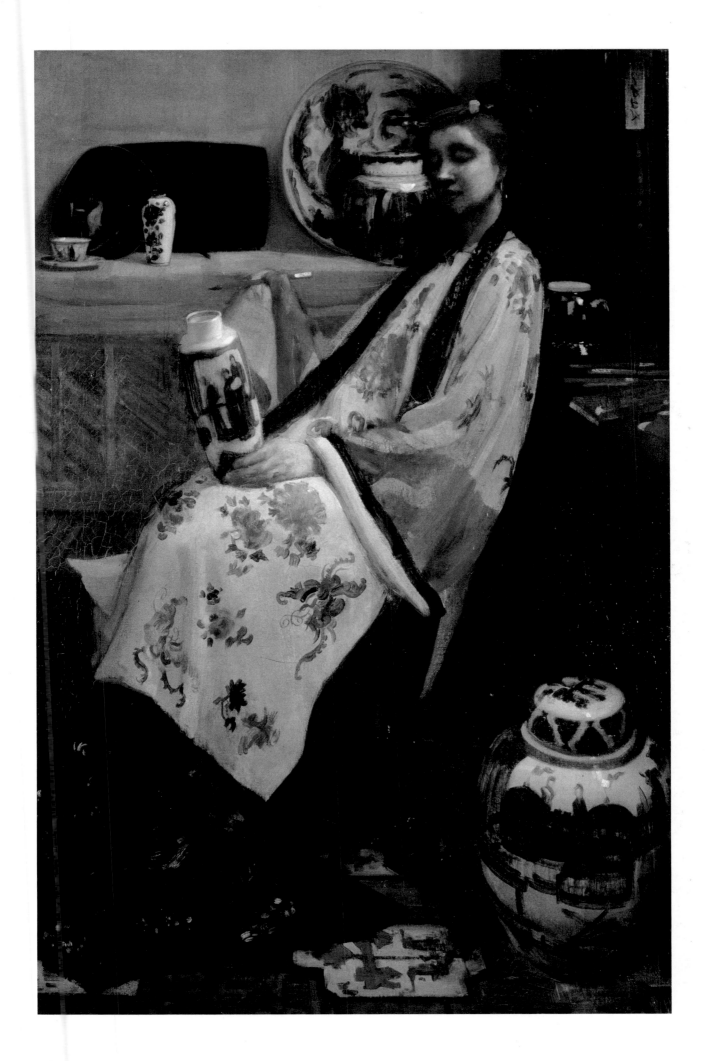

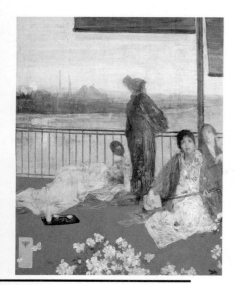

Variations in Flesh Color and Green: The Balcony

1865. Oil on wood panel, 24¼ × 19¼"
Courtesy the Freer Gallery of Art,
Smithsonian Institution, Washington, D.C.

The influence of Japanese art on Whistler was profound, but in no painting is it more explicit than in this. The artists to whom he was most indebted were the print-makers Haronobu and Kiyonaga. He may also have used Japanese dolls he owned to help with the figure arrangement. But what makes this picture unusual, gives it a certain tang, is the background. From the balcony we see in the distance the modern industrial world. Japan and England are combined to suggest a curious hybrid, a symbol, in a way, of the artist's mind.

Symphony in White, No. 2: The Little White Girl

1864. Oil on canvas, 30 × 20⅛"
The Tate Gallery, London

This portrait of Joanna Hiffernan inspired Swinburne's poem Before the Mirror: Verses Under a Picture, *one stanza of which is quoted in the text. The mirror and the mantelpiece were in Whistler's house in Lindsey Row. The picture is among the most perfect Whistler ever painted. For once he had no doubt about his goal. It was a simple one: to paint a lovely model, Jo, reflected in a mirror, and to show her aware of her own beauty.*

and rescued by Delâtre, the printer. In 1862, Madame de Soye, who had lived in Japan, opened a shop in the Rue de Rivoli, and the enthusiasm for Japanese art spread to Manet, Fantin-Latour, Tissot, Baudelaire, the de Goncourts, and others. Rossetti is supposed to have made Japanese art the fashion in London, but it had very little effect on his work, whereas it profoundly influenced Whistler's, especially his pictures painted between 1864 and 1870. His love of Japanese art explains much about him—not only his painting but also the environment he created in his house and studio. In Chelsea, he was known as "the Japanese Artist."

While painting *La Princesse*, Whistler subjected Christine Spartali to an ordeal of sittings twice a week, lasting four or five hours each, for the whole winter of 1863–64. When she finally fell ill as a result of having to stand, not sit, for hours on end, Whistler hired a model to take her place; and when Christine, though still convalescing in bed, had sufficiently recovered to receive him, he did a pencil drawing of her head. Finally, the picture was finished, and Christine and her sister wanted their father to acquire it. However, it did not appeal to him and he refused.

Rossetti then became agent for the painting. From his experience with potential buyers, he told Whistler that the bald scrawl of his signature at the bottom of the picture put clients off. He suggested something like the potter's mark on their Blue and White china. Whistler agreed and settled on J.M.W., which he gradually shaped into the famous butterfly. Later, a sting was added to the butterfly. The idea seems to have occurred to Whistler in Venice. One day he found a scorpion and impaled it on the needle he used for etching. The insect would strike out in all directions with its curved spur. "Look at the beggar now," Whistler exclaimed as he watched. "See him strike! Isn't he fine? . . . Do you see the poison that comes out when he strikes? Isn't he superb?" Combining the tail of a scorpion with a butterfly gave Whistler exactly the symbol he wished, especially for his malicious words in *The Gentle Art of Making Enemies*.

While Whistler was worrying over the rejection of *The White Girl* in London and Paris and busily continuing his career as painter and etcher, the Civil War had begun in America. As a patriot and a West Point man, Whistler took the greatest interest in it, but he did not return to fight, as one might have expected. His sympathies were with the South, as were those of most Englishmen. At the outset, his mother had been in Richmond with his brother, William, who was serving as a surgeon in Lee's army. She was a brave woman who ran the blockade in order to join her son and stepdaughter in London.

As Whistler had ceased to live in the Haden house, he and his mother decided they would take a house together at 7 Lindsey Row, Chelsea (now 101 Cheyne Walk). Jo moved into lodgings but remained nearby and continued to be mistress and model. In spite of the humiliation of her exile, no break occurred for some time. Jo never entered the house when Mrs. Whistler was at home, but when she was away often acted as Whistler's hostess.

Whistler loved the view from 7 Lindsey Row. Out his windows he could look across to Battersea Church, surrounded by factory chimneys; Battersea Bridge,

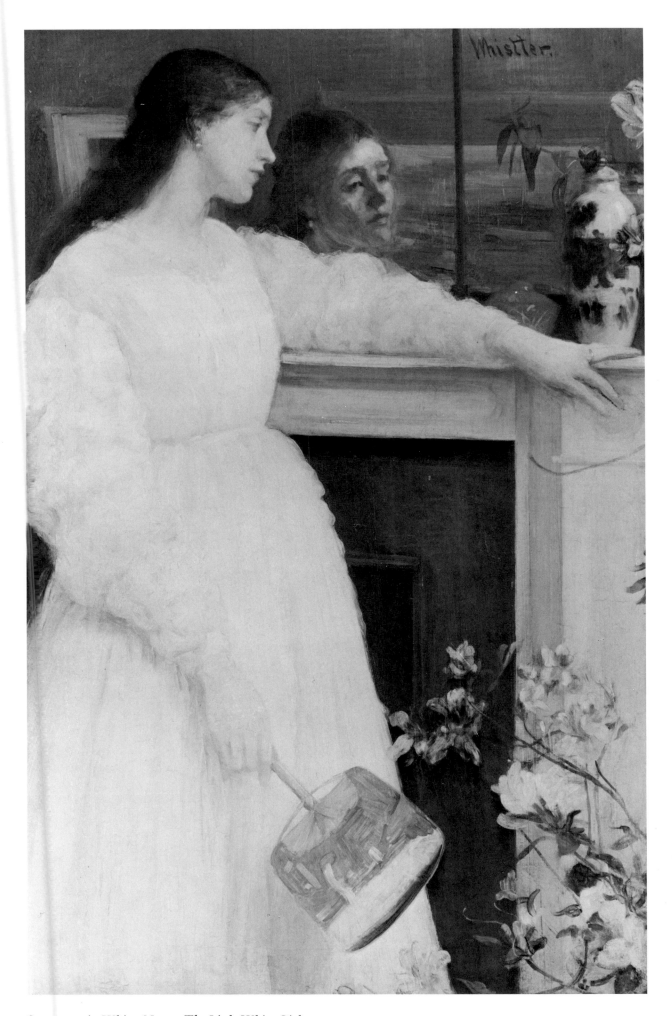

Symphony in White, No. 2: The Little White Girl

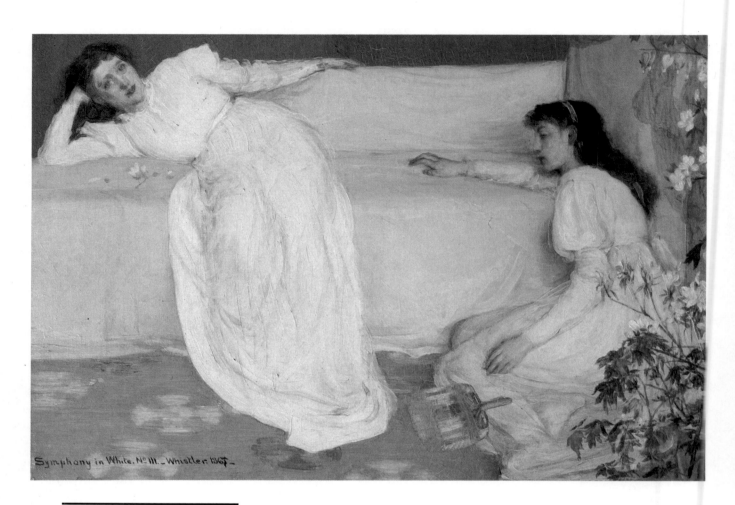

Symphony in White, No. 3

1865–67. Oil on canvas, 20½ × 30⅛"
The Barber Institute of Fine Arts
The University of Birmingham

Whistler was pleased with the relationship of the two models, especially the placing of their arms. The composition delighted Degas, and he made a drawing of it in a notebook, which he consulted frequently between 1864 and 1867. Whistler and Degas had much in common. Both looked at the kaleidoscope of visual experience until they saw a pattern emerge that seemed artistically significant. Then they seized it and gave it permanence, as here in the accidental gestures of two models.

Whistler in His Studio

c. 1865. Oil on wood panel, 24¾ × 13¼"
© The Art Institute of Chicago
Friends of American Art Collection

This was intended to be a much larger painting, similar to Fantin-Latour's Hommage à Delacroix and Hommage à la verité. But the portraits of Albert Moore and Fantin-Latour, who should have been in it, were never painted.

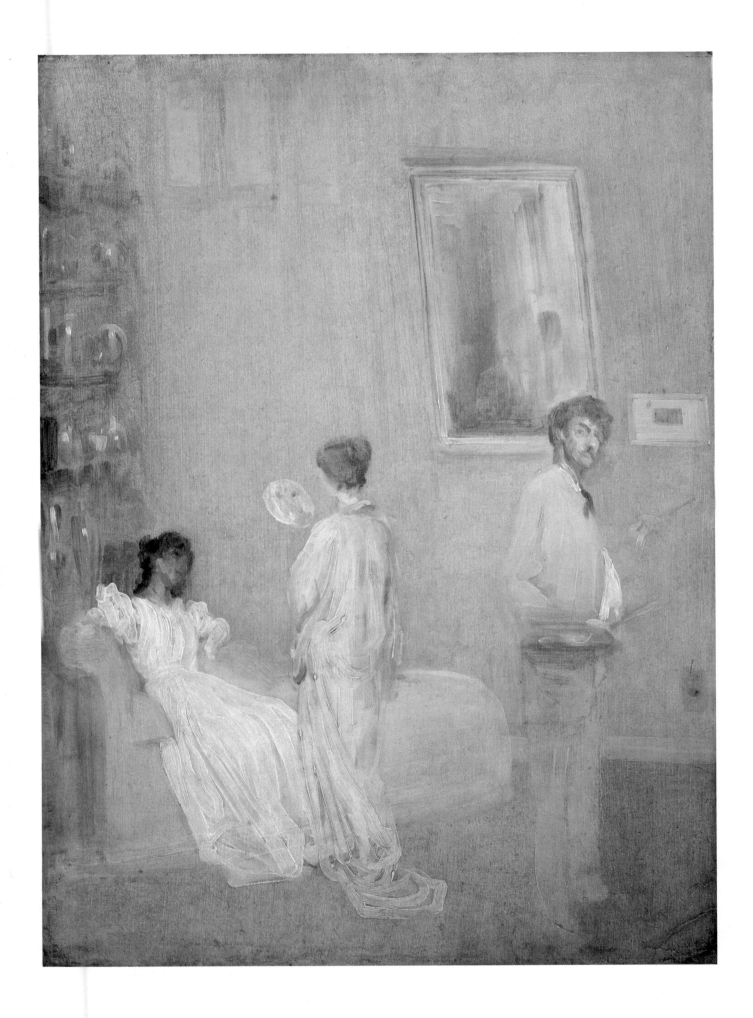

in the foreground, stretching across the river; and, at night, the lights and fireworks of Cremorne, a somewhat more elegant version of Coney Island. A neighbor was a boatman named Greaves, who had been in Chelsea for years. His two sons, Walter and Harry, painted, and Whistler let them work with him. "He taught us to paint, and we taught him the Waterman's Jirk," Walter Greaves used to say.

The brothers rowed Whistler back and forth on the Thames. At night, he would stay on the river for hours with his brown paper and black and white chalk, making notes for his Nocturnes and observing the lights of Cremorne. When they landed, he had the picture firmly in mind.

In 1865, he sent to the Royal Academy the most perfect picture he ever painted, *Symphony in White, No. 2: The Little White Girl*. Again, Jo was his model. Japanese influence is evident in the fan she holds, in the Blue and White china on the mantel, and the spray of azaleas that trails across her dress. Inspired by the beauty of the painting, Swinburne wrote a poem to *The Little White Girl*, of which one stanza was:

> Come Snow, come wind or thunder,
> High up in air,
> I watch my face, and wonder
> At my bright hair.

The most unexpected incident in Whistler's career took place the following year, 1866. He had remained passively in England during the Civil War when it was clearly his duty, as a West Point man, to join in the fighting on one side or the other—which, with his Southern sympathy, would have been unquestionably Lee's army. The fact that his brother had volunteered undoubtedly made him feel still more keenly that he had shirked his obligations. A troubled conscience is the most obvious explanation for why he impulsively decided to join with Southern friends who were jobless in London to fight on behalf of Chile and Peru against Spain. The adventure was also possibly an escape from problems at home. He got as far as Valparaiso, Chile, where, hiding in the hills, he watched the town being bombarded from the sea by the Spanish fleet.

It is difficult for anyone who has not been in Valparaiso to understand the effect this beautiful harbor had on Whistler. Its influence was principally atmospheric. Because of the effect of the Humboldt Current on the warm water of the Pacific, the town is usually veiled in mist—an effect not unlike that caused by an English fog—but the South American mist is purer and more transparent. Whistler painted this nebulosity by day and by night. From doing these pictures, which he later called his "nocturnes," the thought may have occurred to him that the indistinctness to be seen at twilight, at dawn, and even in the darkness of night was an unexplored field of painting. His eye, alerted by what he had seen in Valparaiso, gained a new appreciation of the transforming beauty of fog. When he returned to London he came back with a lifelong love of the indistinct.

Separated from the artistic communities of London and Paris, Whistler worked himself free of the influence of Courbet's realism. The compositions he

Crepuscule in Flesh Color and Green: Valparaiso

1866. Oil on canvas, 23 × 29¾"
The Tate Gallery, London

Painted at a single go, this is one of the three Valparaiso pictures that are known. The Bay of Valparaiso, for reasons explained in the text, is usually covered in a delicate, translucent mist. This veil, rose tinted in daytime, Whistler found enchanting. The blurred effect it caused led him to explore the possibility of the indistinct and was responsible for his Nocturnes.

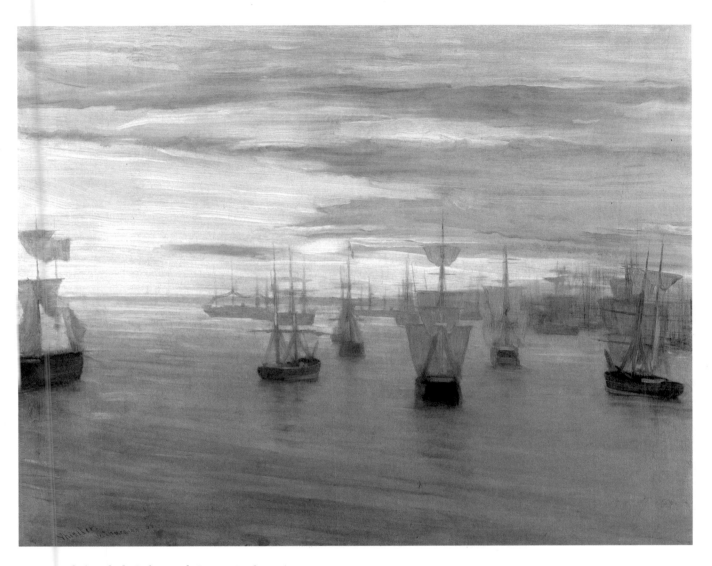

Crepuscule in Flesh Color and Green: Valparaiso

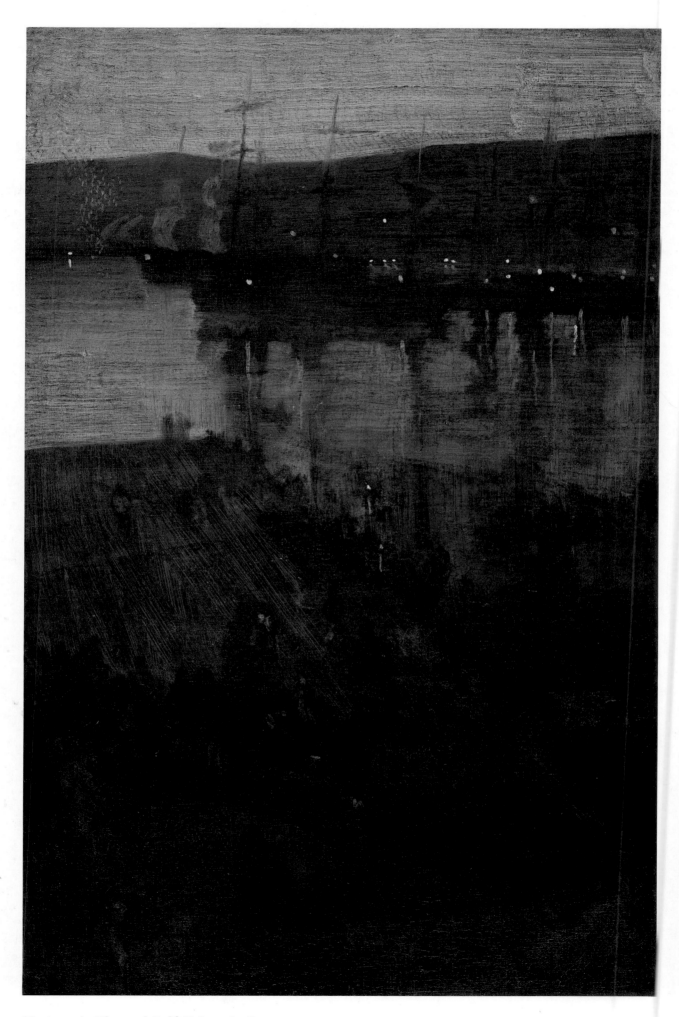

Nocturne in Blue and Gold: Valparaiso Bay

saw in Japanese woodcuts affected his sense of design. In the Nocturnes of the harbor of Valparaiso, he arranged his forms asymmetrically, in the Japanese manner. He also tilted the foreground sharply up. The effect is to make the canvas seem a flat arrangement of patterns on a picture plane, again like a Japanese woodcut. From this, his first Nocturne, all the others developed. While in Chile, he had time to paint two other pictures of the harbor, which are among his most beautiful seascapes. Then he sailed, unheroically, for home. The fighting was virtually over, and there was nothing for him to do.

On the ship, there was a black from Haiti (the marquis de Marmalade, he called himself) whose behavior irritated Whistler. One day, when he thought the marquis was being too pretentious, he kicked him across the deck and down the companionway.

Whistler was unquestionably truculent. In Paris, during an argument with his brother-in-law, he pushed Haden through a plate-glass window and was fined. On another occasion, his friend Legros said to him: "You lie!" Whistler immediately knocked him down. Mutual acquaintances tried to patch up the quarrel, but Whistler said, "A man gives you the lie to your face and you naturally strike him." Rossetti commemorated Whistler's pugnaciousness in a limerick:

> There's a combatative artist named Whistler,
> Who is, like his own hog hairs, a bristler:
> A tube of white lead,
> And a punch on the head,
> Offer varied attractions to Whistler.

On his return to England late in 1866, Whistler moved to No. 2, at the east end of Lindsey Row. Like No. 7, it looked on the river. He lived in this house longer than in any other. Many of his Nocturnes and some of his greatest portraits were painted in his studio at No. 2.

While living there with his mother, he came to know one of the most fascinating men in the Pre-Raphaelite circle, a Portuguese called Charles Augustus Howell. He was a supreme cheat and trickster, light-fingered, unreliable, but often a helpful friend. He sold letters filched from Whistler's scrap basket; he invented new types of flogging to please Swinburne; he persuaded Rossetti to exhume his wife's body to recover the poems he had buried with her and superintended the job himself; he looked after Whistler's son, Charles Hanson, whenever his father temporarily forgot him.

Ruskin, Rossetti, and Whistler all liked Howell and used him as their agent. Howell could not resist an entrepreneurial opportunity. One day he called on Whistler and asked him if he had some of the plates he had etched and also a press. Whistler said the plates were at hand, but the press, unused for some years, was rusty and unworkable. Howell said he would fix it, and the next morning he was back. "And there he was," reported Whistler, "pulling at the wheel, and there were basins of water and paper being dampened and prints being dried, and then Howell was grinding more ink, and with the plates under my fingers, I felt all the old love for it coming back."

Speke Hall

1870. Etching and drypoint, 8⅞ × 5⅞"
Courtesy the Freer Gallery of Art,
Smithsonian Institution, Washington, D.C.

This was Leyland's country place near Liverpool. Whistler stayed there frequently while painting the Leyland family.

Nocturne in Blue and Gold: Valparaiso Bay

1866. Oil on canvas, 29¾ × 19¾"
Courtesy the Freer Gallery of Art,
Smithsonian Institution, Washington, D.C.

This was Whistler's first Nocturne, painted from a window in a club at Valparaiso. According to a description of the picture written in 1890, the figures on the pier were originally more distinct and the painting has darkened. Thus, through the instability of his pigments, which he did not anticipate, night has advanced further than Whistler intended. This is the problem he faced in all of his Nocturnes. He had to find the right amount of illumination, enough to discern landscape features, yet sufficiently dark to enwrap them in the shades of evening.

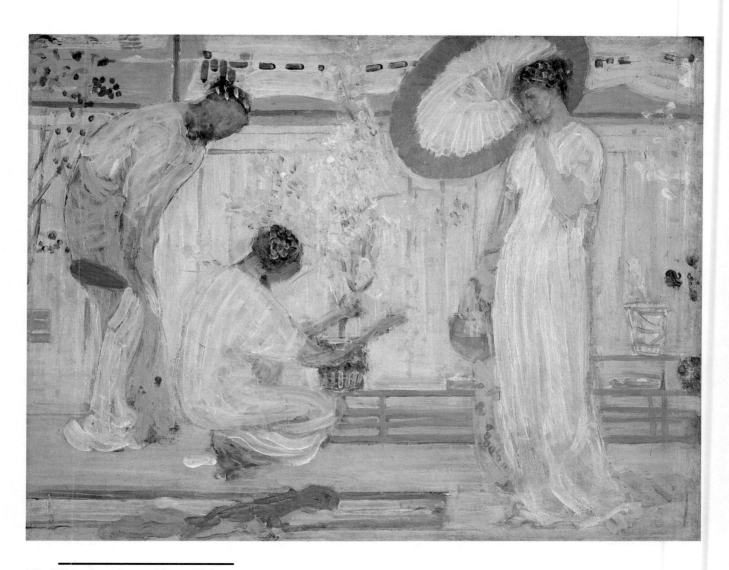

The White Symphony: Three Girls

c. 1868. Oil on millboard, mounted on wood,
18¼ × 24¼″
Courtesy the Freer Gallery of Art,
Smithsonian Institution, Washington, D.C.

One of the Six Projects done possibly for the decoration of Leyland's house, this is a good example of the diversity of Whistler's technique. The whole is freely painted with a brush, but the blossoms are added with a palette knife and the branches of the shrub scratched in with the end of the brush. Aiming at rapidity of execution, he used his fingers to suggest the women's faces. The Projects were never carried out.

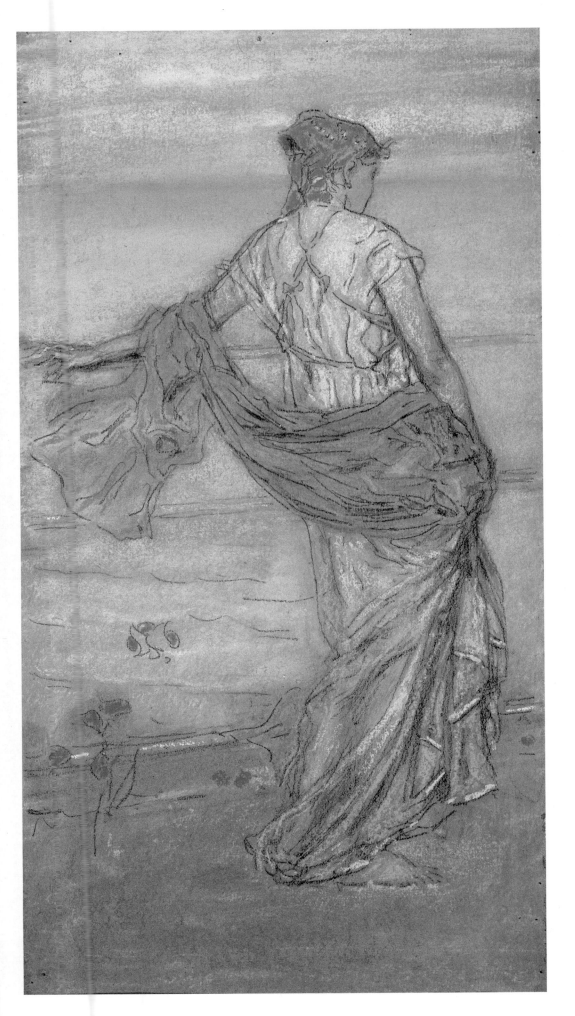

Annabel Lee

c. 1870. Crayon and pastel on brown paper,
12¾ × 7¹⁄₁₆″
Courtesy the Freer Gallery of Art,
Smithsonian Institution, Washington, D.C.

Edgar Allan Poe's poem, which was in-
spired by the death of his wife, has been
considered the subject of this watercolor.

And so, all the night tide, I lie down
　　by the side,
Of my darling —my darling—my
　　life and my bride,
In her sepulchre there by the sea—
　　In her tomb by the sounding sea.

The poem seems in some way to prefigure
and evoke Whistler sprawled on his litho-
graphic stone, holding his wife's hand as
she lay dying.

Every afternoon, with his etchings in hand, Howell would successfully solicit the print shops in Pall Mall, pocketing his commission and more; and when he returned, according to Whistler, "there were orders flying about and checks—it was all so amazing." Howell always paid himself well for his pains. Once, they had a stack of eleven prints, just pulled. During the night six disappeared. Howell was shocked. "We must have a search," he said. "No one could have taken them but me, and that is impossible."

Rossetti summed up this fascinating rogue in another of his limericks:

> There is a Portuguese named Howell,
> Who lays on his lies with a trowell,
> Should he give over lying
> T'will be when he's dying,
> For living is lying with Howell.

Eventually, he proved too crooked even for Whistler, and they parted. "Criminally speaking," Whistler said, "the Portuguese was an artist."

In 1869, the Royal Academy moved to Burlington House. The folly of the Academy's selection and rejection was nothing new, but, fortunately, dealers rescued those artists of quality who were rejected. Whistler showed often at the Dudley Gallery and the French Gallery. He began to use musical titles to explain his intentions in his pictures. In 1871, *The White Girl* and *La Princesse* were shown in the International Exhibition at the South Kensington Museum as *Symphony in White, No. 1* and *Variations in Gray and Rose*. In the Programme of Reception, he wrote that they were "the complete result of harmonies obtained by emphasizing the infinite tones and variations of a limited number of colors." This is also the explanation of his Nocturnes, the first of which he exhibited in 1872.

Whistler's name was submitted for election as an Academician. He would have accepted, but he had no support. He expected to be a Royal Academician as a deserved honor. He knew he was far more distinguished than any Academician of his generation. However, not only was he ignored, but when he was almost destitute and needed sales, the Academy never purchased any of his work but bought a surfeit of second-rate pictures. There was plenty of money in the Chantry Fund. The trustees paid as much as £1,000 to Sir Edward Poynter, £3,000 to Sir Hubert von Herkomer, £3,000 to Lord Leighton, £2,000 to Sir W. Q. Orchardson, all members of the council that administered the Chantry bequest. Yet they never even offered £60 for *Old Battersea Bridge*. Years later, it was hung in the National Gallery by Sir Edward Poynter when he became director of that august institution. It was then incorrectly labeled, its frame hung upside down, and the painter's name misspelled.

Yet Whistler was one of the most original artists ever to work in England. He was among the first to explore in paint all the potential beauty of evening: half-light, twilight, dawn, all the indistinctness of failing illumination. Hiroshige's prints may have suggested the idea of the Nocturnes, but Whistler translated Japanese art into his own idiom. From the printmakers he learned that many of the rules established for generations by Western artists could be broken with in-

Nocturne: Blue and Gold—Old Battersea Bridge

1872–73. Oil on canvas, 26¼ × 19¾"
The Tate Gallery, London

Here Whistler was clearly inspired by Hiroshige, whose designs were often based on the curve of a bridge. Oscar Wilde wrote that Whistler's painting was "worth looking at for about as long as one looks at a real rocket, that is, for somewhat less than a quarter of a minute."

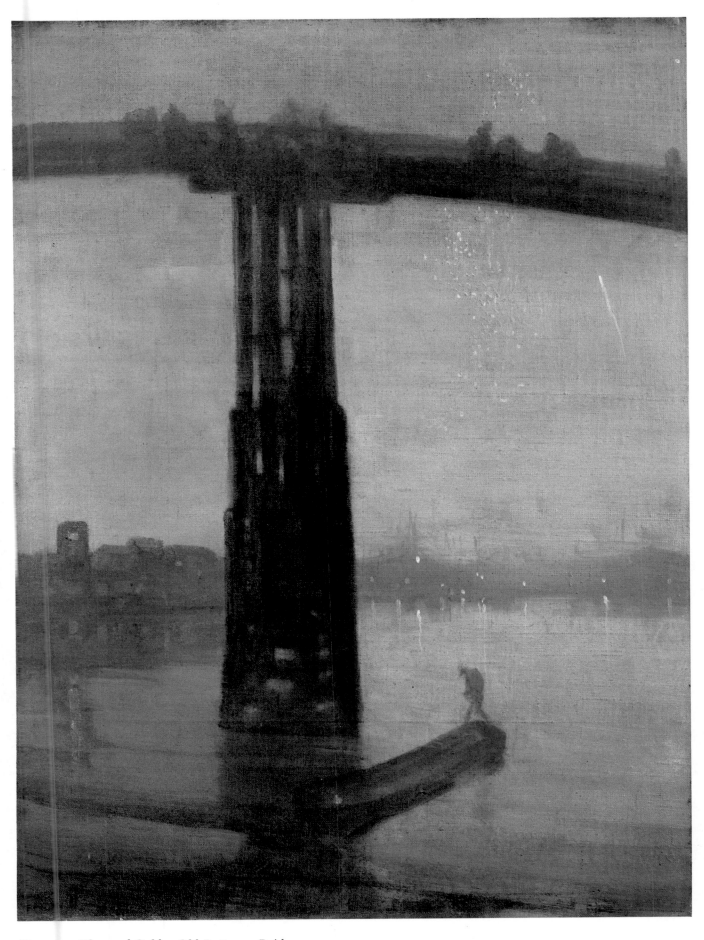

Nocturne: Blue and Gold—Old Battersea Bridge

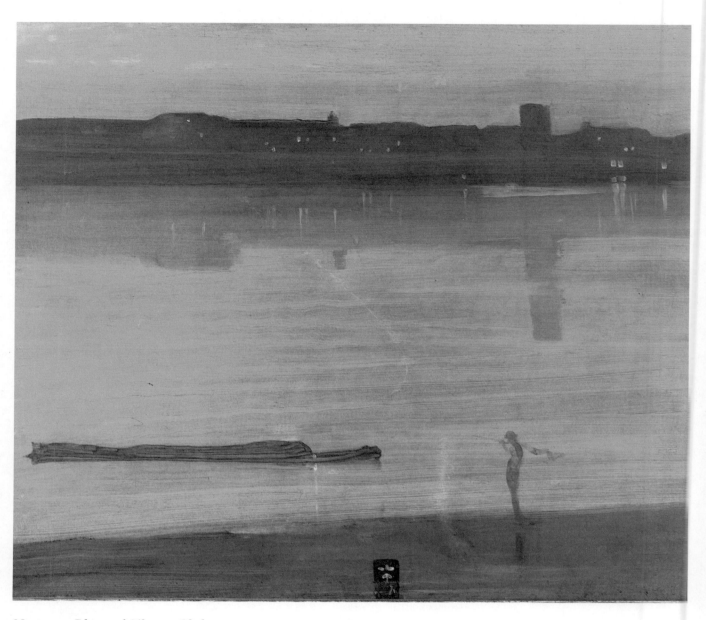

Nocturne: Blue and Silver—Chelsea

punity. Perspective need not be a matter of converging lines; color could be pure without chiaroscuro; design could be asymmetrical; tonal balance was all important. As a cadet he had received demerits for breaking rules he felt unreasonable; as a painter he provoked the enmity of the establishment by disregarding what they considered unbreakable tradition. He was by nature lawless, and he was looked on as an insolent and unseemly revolutionary.

When he asserted the superiority of beauty over truth he antagonized most English artists. It was taken for granted that a picture represented a subject. Whistler felt this was not necessarily so. He never became as abstract as Joseph M. W. Turner, whose work he curiously did not admire, but he agreed with his French friends, Baudelaire particularly, that for the artist "it is not a matter of copying but of interpreting in a simpler more luminous language."

Whistler's Nocturnes are his most original work. They are not always of night: sometimes they are of twilight or of dawn. They have taught us to see beauty in the darkness of evening, to appreciate the fitful illumination of moon and stars, to delight in the subtle changes of light between late afternoon and earliest morning. Caught up in this Whistlerian vision, we have learned to find a new loveliness in the world about us. Such an enhancement of visual joy is the gift of only the greatest artists.

The Nocturnes were difficult to paint. Whistler would go out at night, stand before his subject, scrutinize it, then turn around and describe to anyone who was with him what he had seen. The listener pointed out errors if they had occurred, and Whistler would then go to bed with the image of this nocturnal scene in his mind. The next morning he would face the bare canvas and see on it the completed picture. If satisfied, he painted it; if not, he spent another night contemplating the same subject.

Whistler heated his brushes, warming them over a candle till the glue melted and then pushing the hairs into the shape he wanted. As a medium, he used a mixture of copal, mastic, and turpentine. The colors were then arranged on a rectangular palette on a table. Quantities of the prevailing color were mixed and so much medium used that sometimes the canvas, or other ground, had to be placed on the floor to keep everything from running off. For blue Nocturnes, there was a red ground. Or if the sky was gray, Whistler said, "The sky is gray and the water is gray, and therefore the canvas must be gray."

Sometimes he painted a Nocturne in a day; sometimes there were endless failures. If the tones were right, he scraped them off his palette and kept them in saucers or pots so that he might use them again the next day. When finished, many of the Nocturnes were laid out on the garden wall to bake in the sun, but some were kept in the studio to dry slowly. They were painted in many places, but most were painted looking out the windows of Lindsey Row. Essentially, however, they were the product of the many nights on the river, being rowed up and down by the Greaves brothers.

In the years 1871–74, apart from the Nocturnes, Whistler was working on large portraits. Of these, *The Mother* became the most famous. He had been deeply influenced by Frans Hals's *Old Ladies* (the regentesses of the Haarlem alms-

Nocturne: Blue and Silver—Chelsea

1871. Oil on canvas, 19¾ × 23½"
The Tate Gallery, London

The London Times *wrote sensitively of Whistler's Nocturnes: "They are illustrative of the theory that painting is closely akin to music . . . that [painting] should not aim at expressing dramatic emotions . . . but should be content with molding our moods and stirring our imagination by subtle combinations of color." The* Times *critic has stated briefly and lucidly the doctrine of Abstract Expressionism. It is interesting that his comments were written nearly a century before the movement appeared in New York.*

Nocturne: Black and Gold—The Fire Wheel

1872–77. Oil on canvas, 21 × 29¾"
The Tate Gallery, London

Whistler wrote to a prospective purchaser, "This . . . always has been one of my favourite pictures. I want fifteen hundred guineas for it. . . . The days when 'two hundred pounds was charged for a pot of paint flung in the face of the public by Mr. Whistler' have gone." Ruskin's jibe continued to rankle, but the price Whistler asked, years after the trial, was only a small fraction of the picture's present value.

Nocturne in Black and Gold: The Falling Rocket

1875. Oil on wood panel, 23¾ × 18⅝"
The Detroit Institute of Arts
Gift of Dexter M. Ferry, Jr.

This painting of fireworks in Cremorne Gardens was the main target of Ruskin's attack on Whistler, which led to the trial for libel. Though the critics disagreed, Whistler said, "It's the finest thing that ever was done." It was certainly among the most original, representing a tremendous leap forward in the direction of Abstract Expressionism. Apart from its novelty, it is a work of extraordinary beauty.

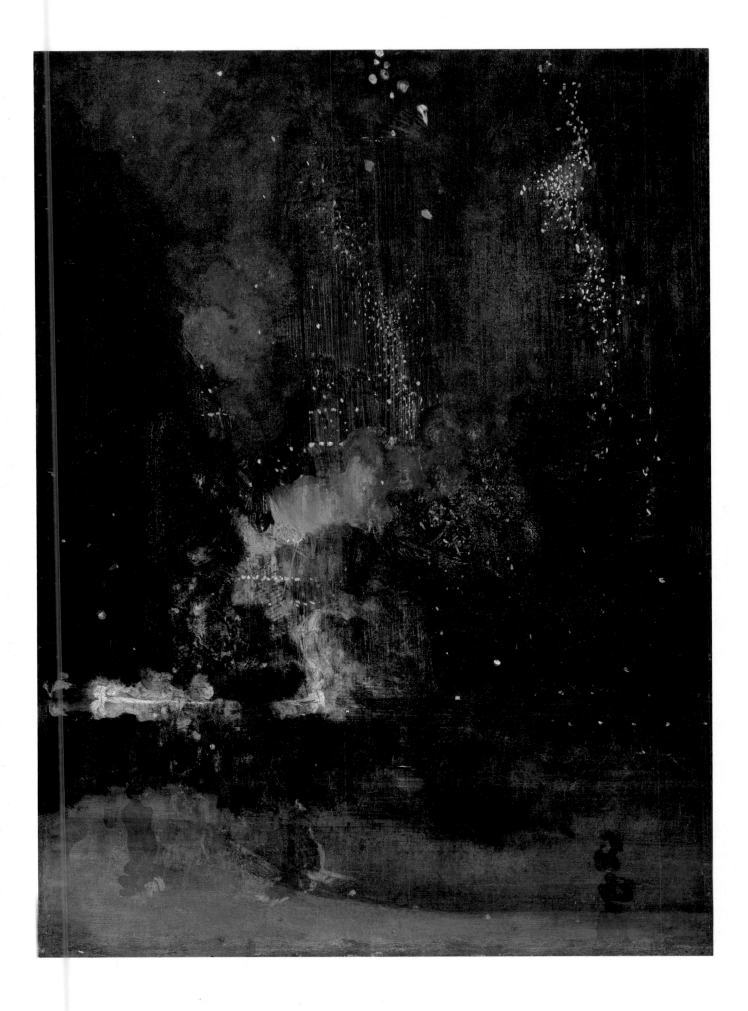

houses), the most beautiful portrait the Dutch artist ever did. Like Hals, he wanted his model painted at a single go, though to do this, unlike Hals, he might need scores of sittings; he used the same restrained line and color as the Dutch artist. He gave the portrait of his mother the title *Arrangement in Gray and Black*, for, as he said, "To me it is interesting as a picture of my mother; but what can or ought the public to care about the identity of the portrait?" The public, instead, should focus its interest on the composition and the beautiful intervals of space; also, it should admire the pathos and depth of feeling in the face. A friend came to see the painting and exclaimed over its beauty. Whistler looked at the picture for several minutes before he said, "Yes," very slowly and very softly. "Yes, one does like to make one's mummy just as nice as possible."

He sent his "mummy" to the Royal Academy, and she was rejected. Upon learning of the rejection, Sir William Boxall, himself a greatly honored Academician who had painted Whistler's portrait as a boy, demanded to see the painting. Reluctantly, it was brought out of the cellar. After looking at it, Sir William said that if it were not hung, he would resign. Recognizing the scandal this would cause, the committee reversed itself, retrieved the picture from storage, and hung it in the worst place they could find. It had no greater success with the art critics of the *Times* and the *Examiner*, who thought the painting too large and most of it vacant. Whistler's pictures were experiments and certainly not Art, the critics agreed.

Whistler was introduced to Thomas Carlyle, who wished to see the *Mother*. The historian admired its simplicity and seemed to feel in it, as Whistler said,

a certain fitness of things, and he said he would be painted. And he came one morning soon, and he sat down, and I had the canvas ready and the brushes and palette, and Carlyle said: "And now, mon, fire away!" That wasn't my idea of how work should be done. Carlyle realized it, for he added: "If ye're fighting battles or painting pictures, the only thing to do is to fire away!" One day he told me of others who had painted his portrait. "There was Mr. Watts, a mon of note. And I went to his studio, and there was much meestification, and screens were drawn round the easel, and curtains were drawn, and I was not allowed to see anything. And then at last, the screens were put aside and there I was. And I looked. And Mr. Watts, a great mon, he said to me, 'How do you like it?' And then I turned to Mr. Watts, and I said, 'Mon, I would have ye know I am in the hobit of wurin' clean linen!' "

William Allingham wrote of the sittings in his diary: "Carlyle tells me he is sitting to Whistler. If C. makes signs of changing his position, W. screams out in agonized tones: 'For God's sake, don't move!' C. afterwards said that all W.'s anxiety seemed to be to get the coat painted to ideal perfection; the face went for little."

It is not true, as Carlyle thought, that "the face went for little." In the historian's expression there is an unforgettable melancholy tinged with bitterness. To see the portrait in the Glasgow Art Gallery and Museum is an enriching and moving experience. It ranks as one of the finest modern portraits.

Arrangement in Gray and Black: Portrait of the Painter's Mother

1871. Oil on canvas, 56¾ × 64"
The Louvre, Paris

When the French government bought the picture for the Luxembourg Museum, Count Robert de Montesquiou held a soirée and composed a poem for the occasion. Whistler was moved to tears. Over the years the fame of Whistler's Mother *has increased so greatly that it can claim to be the best-known American portrait—something Montesquiou would never have dreamed of, nor would its celebrity have pleased him.*

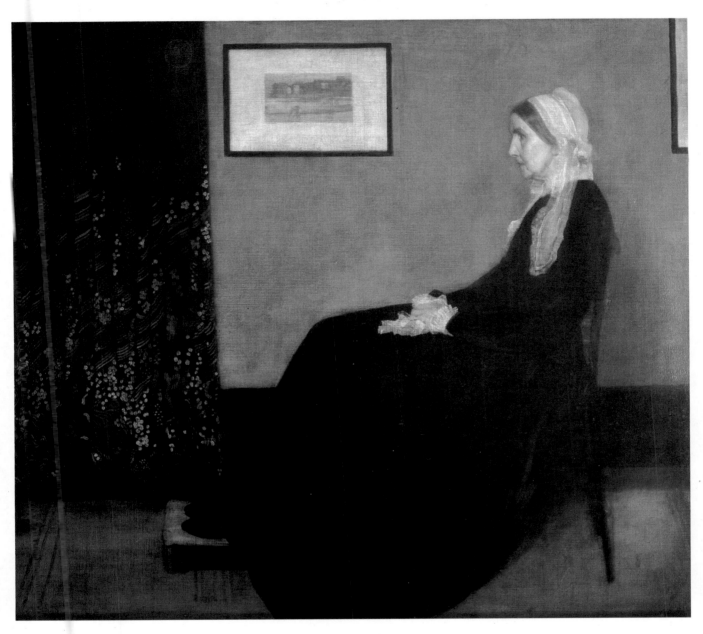

Arrangement in Gray and Black: Portrait of the Painter's Mother

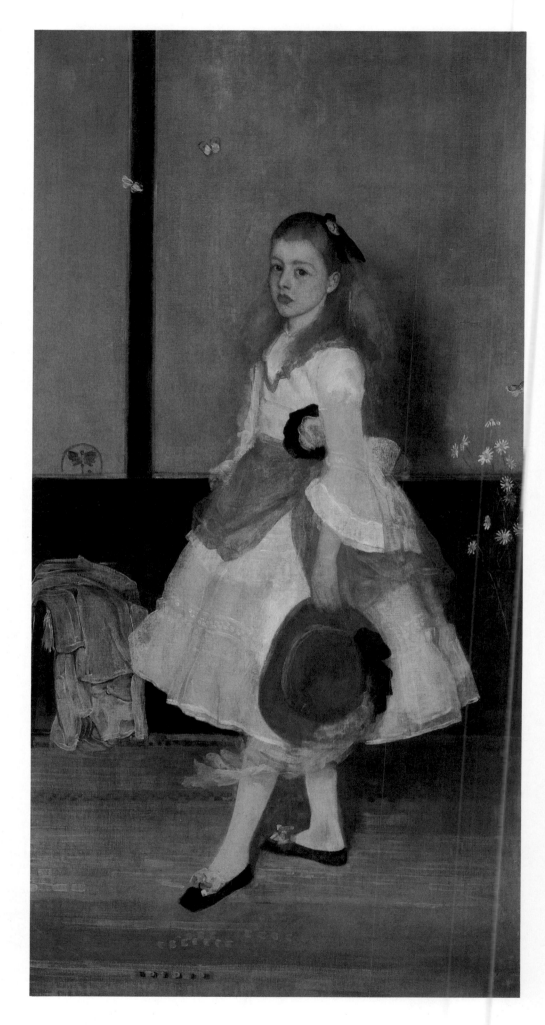

Harmony in Gray and Green:
Miss Cicely Alexander

1872–73. Oil on canvas, 74¾ × 38½″
The Tate Gallery, London

After seventy sittings, his young model be-
came disgruntled, but she and the painter
remained good friends. "He used to come
to my father's house and make at once for
the portrait with his eye-glass up," she later
recalled. Whistler's interest in his own
work never diminished, nor did his belief
in its importance and value.

While Whistler was working on Carlyle, he was painting Cicely Alexander. Once, the two passed each other on the way to their sittings. Carlyle asked the maid who the child was. She answered, "Miss Alexander. She is sitting to Mr. Whistler." Carlyle looked even more melancholy than usual and murmured, "Puir lassie! Puir lassie!" His sympathy was not misplaced. Cicely said years later:

He never let me change my position, and I believe sometimes I had to stand for hours at a time. I know I used to get very tired and cross, and often finished the day in tears. . . . He was most kind in other ways. If a blessed black fog came up from the river, and I was allowed to get down, he never made any objection to my poking about among his paints, and I even put charcoal eyes to some of his portraits done in colored chalks, and he also constantly promised to paint my doll, but this promise was never kept.

If Cicely had tears in her eyes, so did Whistler. It took him seventy sittings to finish the picture, which he entitled *Harmony in Gray and Green.* He had taken great pains with the portrait, even choosing the muslin for the skirt and having it constantly laundered under his supervision. He was striving, once more, for absolute perfection. The portrait was condemned by all the critics. According to the Pennells, Tom Taylor, art critic for the *Times,* went to see it in Whistler's studio. He said, " 'Ha yes, um,' then remarked that the upright line in the panelling was wrong, adding, 'Of course, it's a matter of taste.' To which Whistler replied, 'I thought that perhaps for once you were going to get away without having said anything foolish; but remember, so that you may not make the mistake again, it's not a matter of taste at all, it's a matter of knowledge. Goodbye.' "

To paint a portrait requiring so many sittings and yet to maintain the freshness that distinguishes *Miss Cicely Alexander* is miraculous. All appearance of the reworking, which must have taken place, has vanished. The surface is clean and the texture of the paint delightful. Like a work by Velázquez, it seems a masterpiece of direct observation. It is in many ways the finest portrait Whistler ever created.

About this time, Frederick Leyland, a rich shipowner, commissioned Whistler to paint Mrs. Leyland, their children, and himself. Leyland was painted against a dark background, in evening dress and ruffled shirt. Whistler called it *Arrangement in Black.* Few portraits ever gave him more trouble. His problem was to put the model into an atmospheric envelope without accessories, as far within the frame as the artist was from his sitter when he painted. It was a problem that he worked on as long as he lived. Leyland was willing to pose but had little time, and a model was necessary. Whistler could not get the legs right. The stance, with one leg advanced, baffled him, and finally he had a male model pose nude. In the end, though he had to paint the trousers over the nude legs, he got the position he wanted.

Mrs. Leyland had more time, the sittings amused her, and the artist was companionable and potentially a lover. It seems unlikely that Whistler ever conquered Mrs. Leyland's remoteness, though she told Mrs. Pennell that she regretted Whistler was unable to marry her, for it would have been better for him. A clever woman, she would have managed his affairs admirably. She was beautiful,

At the Piano

1875. Etching, 9⅛ × 6⅛"
Courtesy the Freer Gallery of Art,
Smithsonian Institution, Washington, D.C.

A portrait of Tinny Greaves, whose brothers were pupils of Whistler and acted as his factotums.

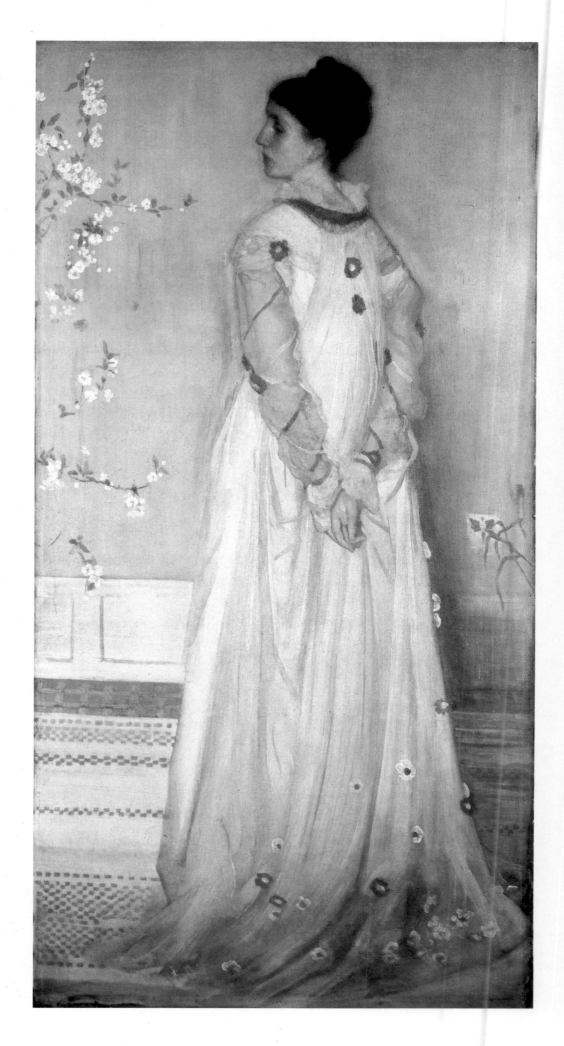

Symphony in Flesh Color and Pink:
Portrait of Mrs. Frances Leyland

1871–74. Oil on canvas, 77⅛ × 40¼″
Frick Collection, New York City

Whistler had as many difficulties with this
portrait as he had with the portrait of Ley-
land. Begun in 1871, it was worked on
until 1878. In spite of endless sittings,
Whistler never got the hands the way he
wanted them. If he had drawn them me-
ticulously, as he was capable of doing,
they would have been inconsistent with
his handling of the rest of the portrait.
This was a problem he rarely solved
satisfactorily.

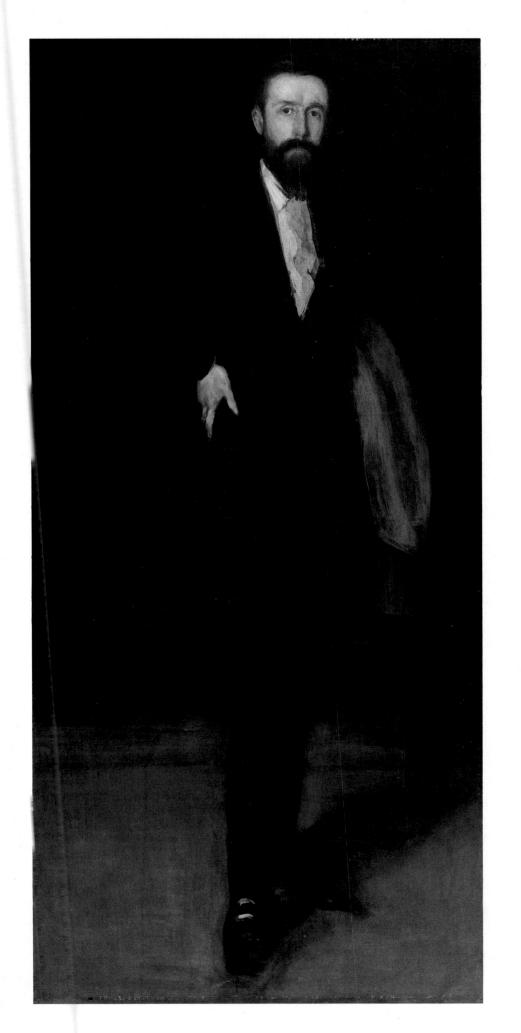

*Arrangement in Black: Portrait of
F. R. Leyland*

1870–73. Oil on canvas, 75⅞ × 36⅛″
Courtesy the Freer Gallery of Art,
Smithsonian Institution, Washington, D.C.

*The portrait was begun in 1870. Eight
years later, after innumerable revisions,
Whistler wrote Watts-Dunton that he had
meant to deliver the portrait but had not
done so because Leyland did not seem to
appreciate it. He did not mention that he
had been paid in advance. Whistler was
not dishonest, but occasionally he was
careless about contractual obligations.*

with an abundance of red hair. He ignored her wish to be painted in black velvet, choosing instead a material of rose hue he felt would be more in harmony with her coloring. Surviving costume studies show he designed her dress himself. He placed her against a rose-tinted wall, with a spray of almond blossoms at her side. She has turned her back to the spectator, her hands clasped behind her, her face in profile. There were many sittings; everything would seem virtually finished, and then Whistler would rub it out and begin over again. The portrait, in his opinion, was never completed. He could not get the hands right.

Whistler could etch hands, but he always had trouble painting them. In some of his pictures they are perfect; but, when possible, he adroitly avoided showing them, and the skill with which he did this is remarkable.

The portrait of Mrs. Louis Huth belongs to these years. She wears the black velvet Mrs. Leyland wanted. Her hands are virtually invisible. Whistler had no trouble finishing the picture, but, as always, there were innumerable sittings. Mrs. Huth was not very strong, and in the end a model had to take her place. Sometimes Whistler asked Mrs. Huth to stand for three hours at a stretch. She rebelled and told him that George Frederic Watts, who had painted her, had not treated her so cruelly. Whistler's answer was, "Still, you know, you came to me""

One of Whistler's great gifts was his ability to make his portraits stylish. His sitters always have elegance. Whether they were distinguished ladies or common models, he could dower them with grace and smartness. What is the difference then between a Whistler portrait and one by John Singer Sargent or Giovanni Boldini? One difference is Whistler's insistence on the length of time the sitter had to pose. He would not release a portrait until it satisfied him. In the end he *finished* less than two dozen full-length portraits, whereas Sargent and Boldini completed scores. All three artists repainted a good deal, but only Whistler insisted on scraping out all he had done and beginning again, sometimes starting over and over. He felt repainting spoiled the perfection of the surface he wished to achieve.

The likenesses painted by many Royal Academicians and many Salon painters were, it is true, chic. Whistler's sitters, on the other hand, were not only fashionable in appearance but also possessed an inherent dignity and distinction. Society women were blind to these qualities. They thought it was sufficient to be portrayed as handsome and fashionably dressed. They felt that Whistler's endless sittings were exhausting. Accepting this sacrifice of time and suffering often extreme physical weariness, Whistler's sitters were ultimately given more than mere smartness: he gave them an inherent look of superiority.

In 1874, Whistler decided—like Courbet in 1855 and Manet in 1867—that he would organize his own one-man show. He took a gallery at No. 48 Pall Mall. The exhibition consisted of several large portraits, a few Nocturnes, one or two earlier paintings, and one or two of the Projects designed for Leyland's house but never carried out, which were important to Whistler. As he said, "The painter must also make of the wall upon which his work is hung, the room containing it, the whole house, a Harmony, a Symphony, an Arrangement, as perfect as the picture or print, which becomes a part of it."

Arrangement in Gray and Black, No. 2: Portrait of Thomas Carlyle

1872–73. Oil on canvas, 67⅜ × 56½"
Glasgow Art Gallery and Museum

In 1891, Whistler wrote of Carlyle: "He is a favourite of mine. I like the gentle sadness about him!—perhaps he was even sensitive—and even misunderstood—who knows!" It is this gentle sadness the portrait so beautifully conveys.

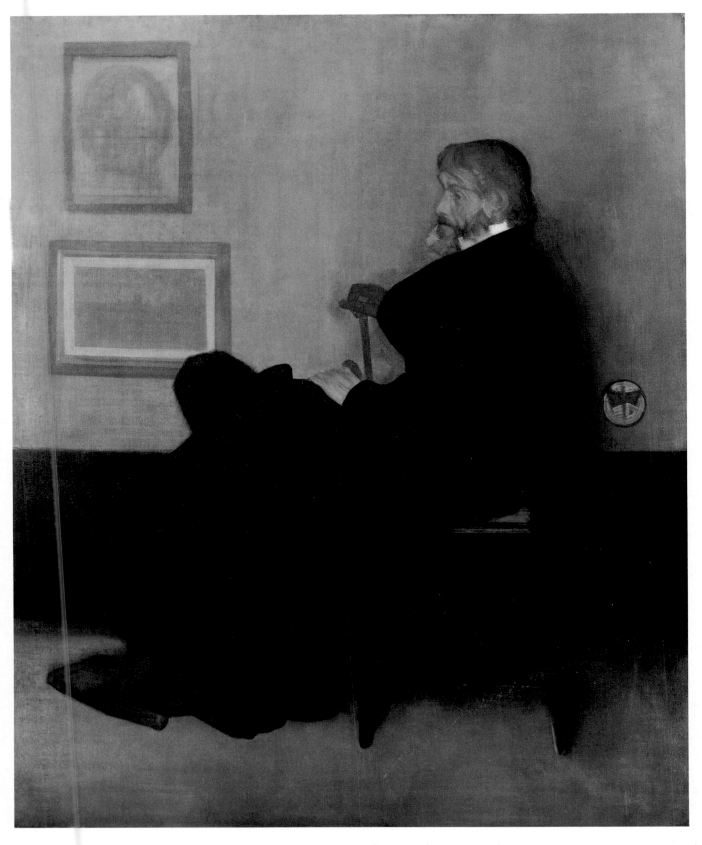

Arrangement in Gray and Black, No. 2: Portrait of Thomas Carlyle

Four Studies of Hands

c. 1870. Pastel, chalk on brown paper
laid down on card, 11 × 7⅛″
Hunterian Art Gallery, University of Glasgow
Birnie Philip Gift

In his paintings Whistler had difficulties with hands. These, in a pastel, are beautifully realized. Walter Gay, a fellow painter, says he once saw Whistler work for two weeks drawing a hand and then give up in disgust.

The setting was so different from Royal Academy shows that London was shocked; but, more important, the paintings seemed extremely eccentric. The flat modeling and low flesh tones, as in Velázquez, appeared too unorthodox to be accepted. And there were only Arrangements and Nocturnes, not an anecdote, not an evocative title. Whistler might say, "As music is the poetry of sound, so is painting the poetry of sight, and the subject matter has nothing to do with harmony of sound or of color." But this was not the popular opinion. His theories were too far ahead of his time and anticipate Abstract Expressionism and Color-Field painting.

Whistler disliked solitude. His door was always open. One man came to dinner and stayed three years. "Well, you know, there he was," Whistler said.

He was a genius, a musician. . . . He hadn't anything to do—he didn't do anything but decorate the dinner table, arrange the flowers, and then play the piano and talk. He hadn't any enthusiasm; that is why he was so restful. He was always ready to go to Cremorne with me. At moments my mother objected to such a loafer about the house. And I would say to her, "Well, my dear Mummy, who else is there to whom we could say, 'Play,' and he would play, and 'Stop playing,' and he would stop right away!" Then I was ill. He couldn't be trusted with a message to the doctor or the druggist, and he was only in the way. But he had the good sense to see it and to suggest it was time to be going; so he left for somebody else! It never occurred to him there was any reason he shouldn't live like that.

Whistler also depended on female companionship. He liked to have models around the studio, so he could watch their movements until they suggested a group or arrangement. There is a painting of him in his studio in the white coat he wore at work, with his palette and brushes in one hand. One model is seated; the other, seen from behind, holds a fan and is standing. It was to have been part of a large picture, like the *Hommage à Delacroix*, with Fantin-Latour, Albert Moore, and himself, but no more than this fragment was painted.

People amused him, and he delighted in social life. He always wanted to make a suitable appearance but one that was unique. No man was ever more meticulous about his toilette. He admired his curly hair and took pains to keep it in order. He was particularly proud of his lock of white hair. Like West Point men of his generation, he wore a mustache and a little imperial. Even his bushy eyebrows were trimmed, and they increased the mocking expression of his eyes. His linen was exquisite, and on his handkerchiefs were embroidered little butterflies. Being nearsighted, he always wore a monocle. His handwriting showed the same careful elegance. He was an excellent cook, and his breakfasts and dinners were the delight of gourmets, especially his buckwheat cakes. A cookbook has been published, entitled *Whistler's Mother*, containing the recipes of mother and son.

Academicians, as a rule, were afraid of Whistler. He said, "Well, you know, they want to treat me like a sheet of notepaper and crumple me up." This he fought against fiercely. In 1875, he showed his pictures at the few galleries that would hang them. One, *Arrangement in White and Black*, is a portrait of Maud Franklin, who originally posed for the portrait of Mrs. Leyland when Whistler's sitter was exhausted. It is a good example of how a commonplace model, dressed

Florence Leyland Seated

c. 1870. Chalk on brown paper laid down on card,
11⅛ × 7¼″
Hunterian and Art Gallery, University of Glasgow
Birnie Philip Gift

Leyland wanted himself and his whole family painted by Whistler. In the Hunterian Art Gallery there are six studies of his daughter Florence as a young girl. These are among his finest pastel portraits.

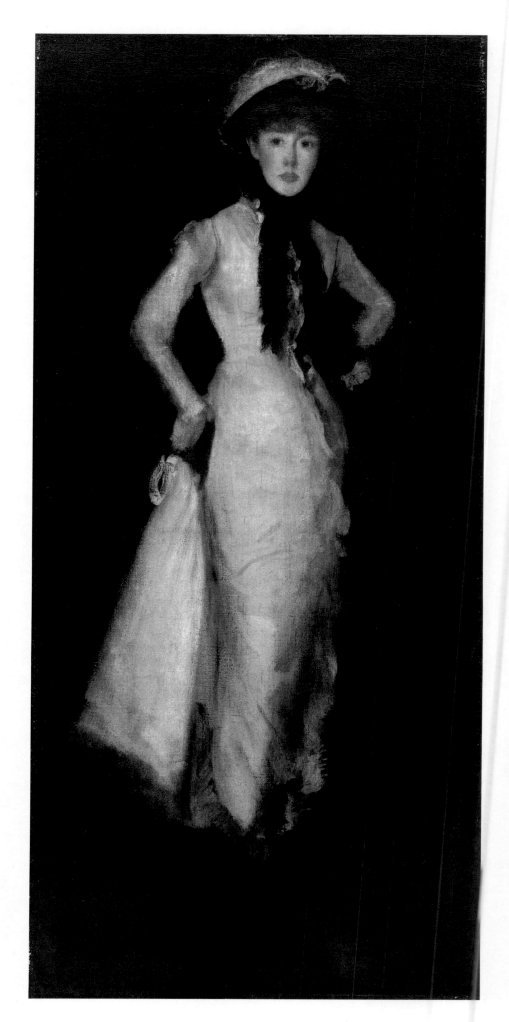

Arrangement in White and Black

c. 1876. Oil on canvas, 75⅜ × 35¾"
Courtesy the Freer Gallery of Art,
Smithsonian Institution, Washington, D.C.

This is a portrait of Maud Franklin, Whistler's model and mistress, who called herself Mrs. Whistler without benefit of clergy. The German owner of the portrait referred to her as "Amerikanerin," and she looks as though she might have stepped out of a novel by Henry James. She has the beauty and spontaneity of Daisy Miller and suggests the impulsiveness of an ingenuous American girl.

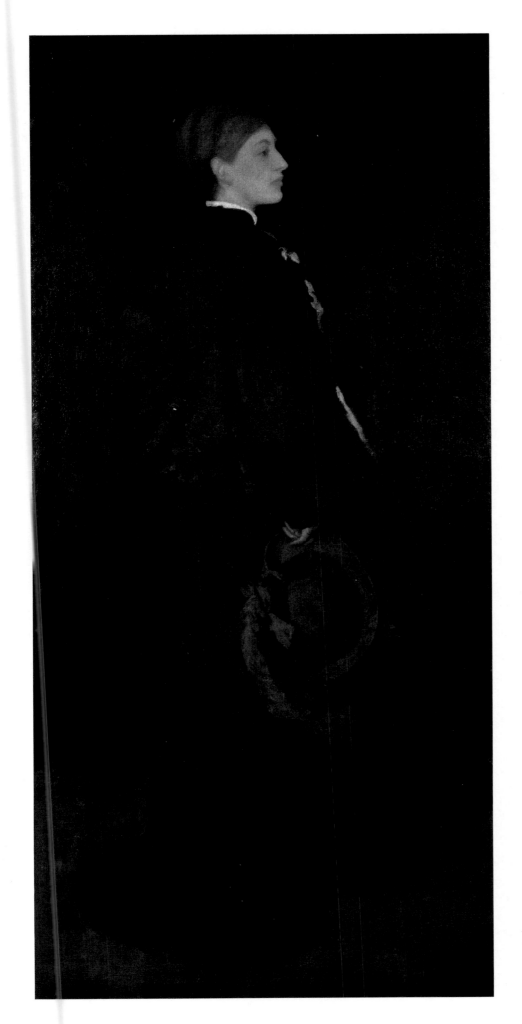

**Arrangement in Brown and Black:
Portrait of Miss Rosa Corder**

1876–78. Oil on canvas, 75¾ × 36⅜″
Frick Collection, New York City

*Whistler got the idea of the color scheme
from seeing Rosa Corder in a brown dress
pass a black door. He had her pose in a
doorway "with the darkness of a shuttered
room behind her," according to Graham
Robertson, who once owned the portrait.
She was the mistress of Whistler's friend
Charles A. Howell—a woman of fascina-
tion and of ability in bed, at her easel, and
as a forger. Whistler was delighted to por-
tray her, even though he was sure he would
never be paid what he asked.*

Maud Franklin

c. 1878. Chalk on brown paper, 12½ × 7⅝"
Hunterian Art Gallery, University of Glasgow
Birnie Philip Gift

*At Whistler's bankruptcy sale, this pastel
was sold as a portrait of Sarah Bernhardt.
Oscar Wilde bought it for five guineas,
then sold it back to Whistler for fifteen.*

in nondescript, late-Victorian clothes, could be transformed by the painter's innate sense of elegance into a smart and charming girl who might be mistaken for a pretty debutante.

Maud was to become very important in Whistler's life and his art. When his mother was ordered by her doctor to leave London, where the fog and the cold were killing her, she moved to Hastings. Maud, who called herself Mrs. Whistler, took her place. Jo and Whistler had drifted apart after his return from Chile. Maud kept house, posed for Whistler's pictures, and tried to bring order to the shambles resulting from his loans and infrequent commissions. He was being dunned by bailiffs, and his studio was filled with unfinished and unsalable paintings. It was a bad time, and there were frequent quarrels. In the end, Whistler's tangled affairs and mountain of debts were too much for Maud.

The indomitable Howell, in the midst of this chaos, commissioned a portrait of his mistress, Rosa Corder. She had been at one time a pupil of Rossetti's and had turned her apprenticeship to good account by making a living for herself and Howell by forging her master's paintings (to which she sometimes added his signature). Whistler was delighted to paint Rosa, who was the embodiment of sex appeal, even if he was never paid the promised one hundred guineas.

In 1876, Whistler painted few portraits. Leyland absorbed all his time. The Leyland shipping company had made a great deal of money, and Rossetti, always with an eye for a good thing, urged the magnate to build a fine gallery for pictures. This would provide space for more Rossetti masterpieces. Leyland bought a large but nondescript house at 49 Princes Gate and employed the architect Norman Shaw to refurbish it. He, in turn, asked Thomas Jeckell, who had designed a Japanese-style billiard room for Alexander Ionides, to provide the decor for a room to hold Leyland's sizable collection of Blue and White china. At the end of the gallery, Whistler's *La Princesse du pays de la porcelaine* was to have the place of honor. The walls, Leyland insisted, should be covered with Cordova leather, floral embossed, which he had purchased at a great price. To harmonize Spanish leather and Blue and White pots was impossible in itself. Architect and interior decorator decided, however, that a pendant ceiling might be the necessary catalyst, with gaslight coming out of each pendant. This dreadful combination soon became apparent to the Leylands, and Mrs. Leyland, who always had a weakness for Whistler, persuaded her husband to call him in for advice. He immediately said the room had an oppressive feeling—the gentlest criticism he could have made. Moreover, the red flowers on the leather and the red border on the rug clashed with the delicate tonality of *La Princesse.*

The Leylands, who had remained in London for the season, eventually left for the summer and stayed out of town for several months. During that time Leyland had to travel on business, but before departing, he told Whistler to cut off the red border on the rug and tone down the red flowers. All he wanted was to get the job completed so he could use his dining room and entertain in his house.

Removing the border from the carpet and daubing at the flowers on the leather were not enough. The dining room remained a mess, and Whistler admitted he was disappointed, but he assured Leyland that more gilt would bring

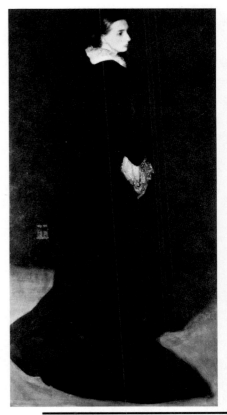

Arrangement in Black, No. 2:
Portrait of Mrs. Louis Huth

1872–73. Oil on canvas, 75 × 39″
Viscount Cowdray in Midhurst, West Sussex
Courtauld Institution of Art

Pennell wrote that in this portrait "Whistler carried out his method of painting the whole portrait at once. The background was as much a part of the picture as the face.... The tones, made from a very few colors of infinite gradations, were mixed on the great palette with black as the basis." Pennell's statement that Whistler painted the whole portrait at once implies a single sitting. What he means instead is that after innumerable sittings Whistler knew what he wanted to do, and he put on the canvas without changes his likeness of Mrs. Huth. Meanwhile, his subject was so exhausted from posing that a model had to take her place.

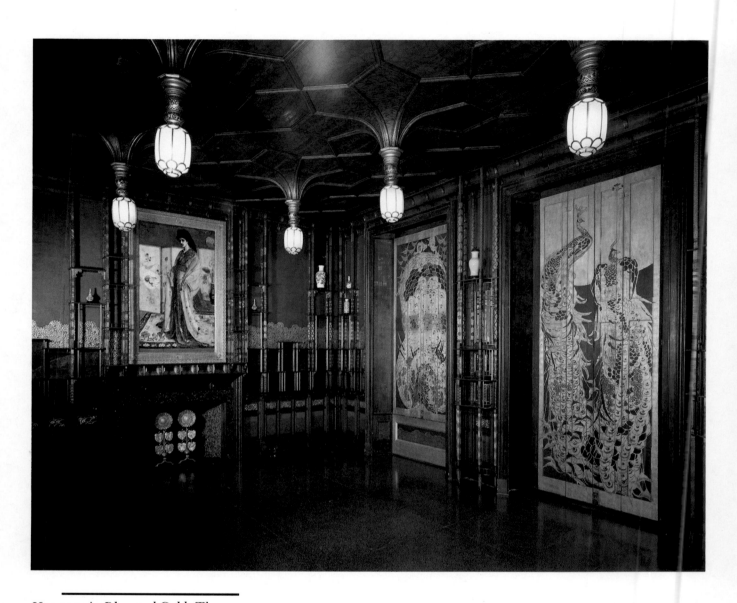

*Harmony in Blue and Gold: The
Peacock Room*

1876–77. Oil paint and gold leaf on leather and
wood, 167⅝ × 398 × 239½″
Courtesy the Freer Gallery of Art,
Smithsonian Institution, Washington, D.C.

*Whistler wrote from Venice, "I went to a
grand high mass in St. Marc's and very
swell it was—but do you know I couldn't
help feeling that The Peacock Room is
more beautiful in its effect! . . . That was a
pleasant frame of mind to be in . . . and I
am sure you are not surprised at it." Nor
are we! Whistler at times could be inane!*

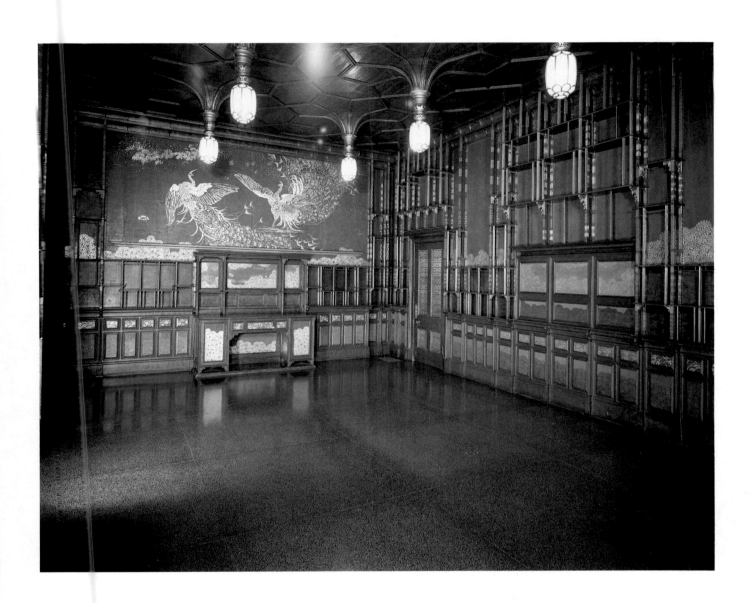

*This drawing for the painting at one end
of Leyland's dining room shows a rich pea-
cock on the right clutching gold sovereigns
between his legs and driving away a poor
peacock on the left. The prosperous bird
stands for Leyland, the impoverished one
for Whistler.*

everything into harmony. He was willing to continue the work and agreed to a re-
muneration of 500 guineas.

Whistler told the Pennells: "Well, you know, I just painted on. I went on—
without design or sketch—it grew as I painted. And toward the end I reached
such a point of perfection—putting in every touch with such freedom—that
when I came round to the corner where I started, why, I had to paint part of it
over again, as the difference would have been too marked. And the harmony in
blue and gold developing, you know, I forgot everything in my joy in it."

Whistler bought more and more gold leaf, charging it to Leyland, and the
Greaves brothers helped him lay it on—until, as one brother said, their faces
were covered with it. Then Whistler began to paint peacocks. They inspired him,
he said, and the design of the room was invented from the eyes on the peacocks'
tails combined with the markings on their breast feathers. He repeated these two
patterns throughout the room—sometimes gold on blue, sometimes blue on
gold. He devised a way of painting the ceiling with a long bamboo fish pole so that
he could work lying on his back. Finally, early in 1877, the room was finished.

On February 9, Whistler received the critics. Before that, there was one un-
fortunate guest who had seen the room. He was Thomas Jeckell, the original
decorator. He took one look at what had happened to his work, was grief strick-
en, returned home, and was found gilding his bedroom floor and talking inco-
herently of fruit, flowers, and peacocks. He was sent to an asylum, where he died
four years later without regaining his sanity.

Meanwhile, Whistler had enjoyed a striking success. The press, for the first
time, praised him highly. When, in a euphoric state, he was told what had hap-
pened to Jeckell, he smiled and said, "To be sure, that is the effect I have upon
people."

Leyland was furious. His room, he thought, had been ruined, and his Blue and White collection would be virtually invisible in the dazzle of gold and blue. "Ah," Whistler said, "you should be grateful to me. I have made you famous. My work will live when you are forgotten. Still, perchance, in the dim ages to come you will be remembered as the proprietor of the Peacock Room." And, unfair as it may seem, Whistler was dead right.

His compensation remained to be discussed. Whistler conveniently forgot he had agreed to 500 guineas and asked instead for 2,000 guineas. Leyland consulted Rossetti, who told him to pay nothing. He rejected this advice, offering Whistler £1,000 to get him out of the house. Whistler, deeply in debt, was compelled to accept this offer, though he felt he had been insulted. Only tradesmen, he pointed out vociferously, were paid in pounds; professionals received the extra shilling in a guinea. On the wall opposite to where *La Princesse* was to hang, he painted two enormous peacocks fighting: one, on the left, symbolized poverty; the other, on the right, riches. The latter was covered with gold coins, while under its claws is a pile of silver—the extra shillings Whistler thought he should have been paid.

His remark that the Leylands were nothing but parvenues and that what had happened might have been expected of them was overheard by Mrs. Leyland, and Whistler was forbidden to enter the house. During Leyland's lifetime, he never again saw the Peacock Room. The room was eventually removed from the house in Princes Gate and ended up almost exactly as it had existed in London in the Freer Gallery in Washington. The Blue and White porcelain had been sold, and recently a few pieces from the Freer's own collection have been installed, but compared with what it must once have been, the effect is dismal.

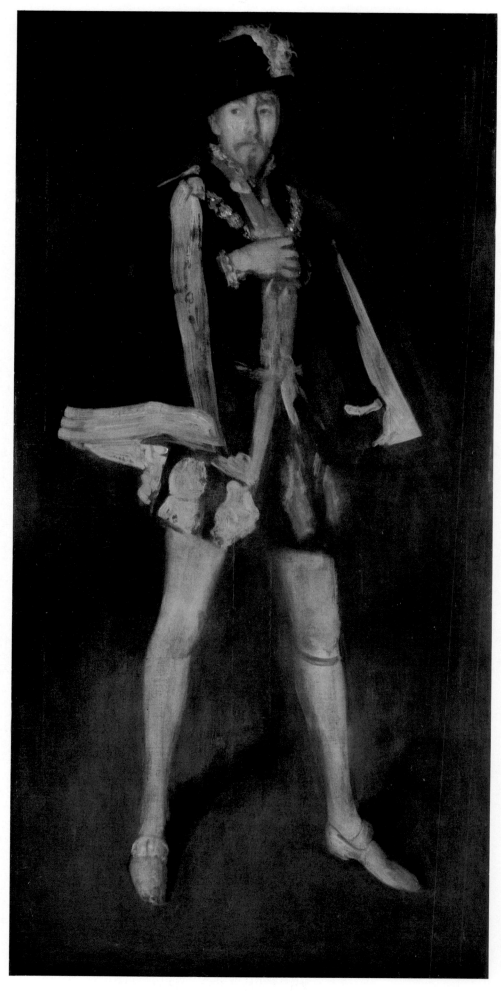

Arrangement in Black, No. 3: Sir Henry Irving as Philip II of Spain

III. Years of Discord

WHILE WHISTLER was at work on the Peacock Room, many exhibitions in opposition to the Royal Academy had been organized in smaller galleries in London. But the art dealers who ran them were too poorly financed and had too little prestige to affect the Academy's monopoly. Sir Coutts Lindsay, however, was determined to change this. He had the money, the talent for organization, and the determination to establish an important gallery, which became the Grosvenor Gallery. He gave small dinners for the artists he invited to show, and those who attended were a strange lot, or so it seemed to Lindsay's servants. One night, his butler whispered to him, "There's a gent downstairs as says 'e 'as come to dinner, wot's forgot his necktie and stuck a fevver in his 'air." It was Whistler, who never wore a necktie when in evening dress. The "fevver" was his white lock.

The first Grosvenor Gallery show was a loan exhibition. Whistler sent eight pictures. The overly sumptuous decoration of crimson silk damask and green velvet hangings did not show his paintings to advantage. At the private view, the crowd gathered before the work of Lawrence Alma-Tadema, Edward Burne-Jones, John Everett Millais, Frederick Leighton, Edward J. Poynter, and George Richmond—the usual Royal Academy artists. Their flamboyant work harmonized with the vulgarity of the setting. The critics continued to sneer at Whistler. The *Times* critic said: "Mr. Whistler's full length arrangements suggest to us a choice between materialized spirits and figures in a London fog."

But Ruskin's criticism was the most venomous of all. The chief object of his malevolence was a Nocturne, *The Falling Rocket*, a painting that would hang well today in any show of Abstract Expressionists. Against the blue of night, a shower of golden fireworks falls on the Thames. "I have seen and heard much of cockney impudence before now, but never expected to hear a coxcomb ask two hundred guineas for flinging a pot of paint in the public's face," Ruskin wrote in *Fors Clavigera*. Critics in the past had exasperated Whistler by their stupidity, but never had they outraged him by such poison. His only recourse was a suit for libel.

Before the trial began, Whistler added interior decoration to his vocation of painting. He began with the house he was building, in Tite Street, Chelsea, which came to be known as the White House. He showed one room similar to those in it at the Paris Universal Exposition in 1878 and designated it *Harmony in Yellow and Gold* (also known as the Primrose Room). The peacock pattern was again used, but this time in gold on yellow and yellow on gold. There was simple furniture,

Arrangement in Black, No. 3: Sir Henry Irving as Philip II of Spain

1876–85. Oil on canvas, 84¾ × 42¾"
The Metropolitan Museum of Art, New York City

When asked at the Ruskin trial whether this was "a finished picture," Whistler replied, "It is a large impression—a sketch; but it was not intended as a finished picture. It was not exhibited as for sale." Henry James called it an "exquisite image," having "the charm of a certain degree of melancholy meditation." Philip II was a subject who appealed to actor and artist. The greatest king on earth, yet the saddest, inspired them both. To portray the ruler's dignity and imply his tragedy was a challenge wonderfully met by Irving and Whistler.

77

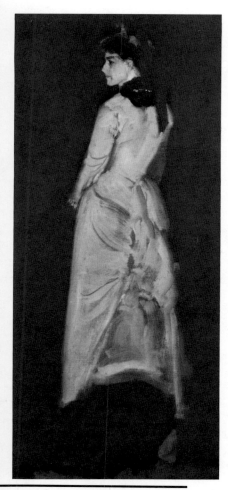

Harmony in Flesh Color and Black: Portrait of Mrs. Louise Jopling

1877. Oil on canvas, 75¼ × 39″
Hunterian Art Gallery, University of Glasgow
Birnie Philip Gift

The architect E. W. Godwin said, "Saw Whistler paint full length of Mrs. Jopling in an hour and a half. An almost awful exhibition of nervous power and concentration." Sometimes the painter needed one sitting—sometimes seventy. Mrs. Jopling was a close acquaintance of Whistler and his wife.

also in yellow but darker than the walls. It was a sensation. Sophisticated society soon took up Whistler as a decorator, and he was responsible for five or six London houses. He would choose a color scheme and mix the colors himself to get the exact shade he wanted. For example, in the house of Mrs. D'Oyly Carte, he painted the entire staircase light pink, the dining room a different and deeper shade, the library a primrose yellow, as though the sun were blazing no matter how gray the day. The woodwork was painted green.

Whistler believed in the use of flat color for walls so that the pictures would look their best and have no competition from patterns. Distemper, which consists of pigment mixed with egg or size, was the medium he preferred, thus reviving an ancient tradition. This had a dual virtue: low cost and utility. He believed in the application of scientific method in all decorative work and repeatedly said that the whole scheme should be thought out in advance.

His own house exemplified his style of interior design, which was to be so influential in England. The dining room was blue, with dado and doors a darker blue. Purple Japanese fans were tacked on the walls and ceiling. Matting took the place of Oriental rugs. His studio was gray, as it had been before, with the doors and dado black; and, as can be seen in the *Portrait of Carlyle* and *Portrait of the Artist's Mother*, Japanese hangings and prints were the other decorations. He slept in a large Chinese bed.

The drawing room of his Tite Street house was not painted until the day of Whistler's first party. He and the two Greaves brothers worked like mad to cover the walls with flesh-color, pale yellow, and white. Some of the guests took samples of the paint home on their clothes. "What matter!" said Whistler. "It was beautiful!"

This Whistlerian method of decorating houses—austere, uncluttered, with large empty spaces, having on the whole a Japanese appearance—created a style as distinctive as, say, Chippendale. For the first time, an American had influenced European taste. But it must be admitted that Whistler owed much of his interior designing to an Englishman, E. W. Godwin, who was the architect of the house he built and whose widow he was to marry. Professional interior decorators did not exist in Victorian and Edwardian England. Artists assumed this role—Whistler and William Morris, to name two—but much of the evidence that would enable us to assess their ability is no longer available. By a fluke, Whistler's Peacock Room has been preserved, but it is not characteristic of the style with which he came to be associated. The rooms he designed for Pablo de Sarasate and other friends have vanished, as have the decorations of art galleries where he showed his work.

Whistler decided before the Ruskin trial that he would open an atelier for students. This required a new house, which he proceeded to build. The painting room at 2 Lindsey Row was too small for an art class, and he felt he needed a studio, something he had never had. He always painted in a room where his sitter was illumined from a window, not from a skylight, which seemed to him more natural. Even when he had a skylighted studio, he managed, with blinds and screens, to obtain the same type of side illumination. However, his new house

would provide everything he wanted for himself and his pupils.

In June, 1878, Whistler's tenancy of Lindsey Row came to an end, but he did not leave until the autumn. It was for him a trying time. His mother was ill at Hastings; he had just broken his engagement with Leyland's sister-in-law; he had quarreled with Leyland; and he had found that adverse criticism had ruined the sale of his pictures. He was compelled to borrow even a few shillings. Howell helped out; Whistler's solicitor, Anderson Rose, lent him considerable sums. Money for his new house had to be found. In desperation, he gave his pictures as collateral. His checks were not honored and writs were threatened. Algernon Graves, the print dealer, came to his temporary rescue. He arranged for the *Mother* to be engraved and, later, he had prints made of *Rosa Corder*. These mezzotints sold well for a time, but eventually they could be purchased for less than they had brought when they were issued. Howell purchased *Arrangement in Black, No. 3: Sir Henry Irving as Philip II of Spain* in an extraordinary but characteristic deal involving ten pounds and a fur coat. Whistler was on the edge of bankruptcy when the Ruskin trial finally began.

Anderson Rose prepared his case, although he knew he would never be paid, and Serjeant Parry acted as counsel for Whistler; the attorney general, Sir John Holker, appeared for Ruskin. The judge was Baron Huddleston, and a special jury was summoned.

It was a case of considerable significance. Was a critic limited to giving his opinion on an artist's work, or could he also insult the artist? Ruskin had a great reputation as a serious art historian, and he was also the arbiter of the reputations of painters, sculptors, and architects. Whistler was looked upon by many as a Yankee buffoon. The cards were stacked against him. Ruinous as the lawsuit turned out to be, he did as well as might be expected.

Ruskin had not been well and was not at the trial. He could not be subjected to the strain of cross-examination, though it was said he had overcome his most recent attack of lunacy. Witnesses were Whistler's problem. Artists, he discovered, were not a brave lot. Those he expected to help him were frightened of what the critics might do to them after the battle of brush versus pen was over. Whistler had repeatedly described Charles Keene as the Hogarth of the day and counted on his assistance, but Keene begged off. Even Queen Victoria inadvertently aided Ruskin. She bestowed a knighthood on Frederick Leighton, Whistler's principal witness, and on the morning the trial began he had to appear at Windsor.

Whistler's counsel opened the case with a mild statement in which he said Ruskin held "the highest position in Europe and America as an art critic." The compliment might have been expected from Ruskin's defense lawyers. It was surprising from Whistler's side and weakened his case from the beginning.

Called to the box and the oath administered, Whistler started off with a lie; he said he was born in Saint Petersburg. It would have been easy to prove him guilty of perjury on the spot, but the defense lawyers let it go. The rest of his autobiography was truthful. He then defined what he meant in calling his picture a Nocturne: "I have perhaps meant rather to indicate an artistic interest alone in

St. James's Street

c. 1878. Lithographic reproduction of the fourth state of etching, 11 × 6″
The Metropolitan Museum of Art, New York City
Harris Brisbane Dick Fund, 1917

This etching was published in Vanity Fair *in 1878. The street with St. James's Palace at the end looks much the same today. Whistler was a master at suggesting the movement of crowds.*

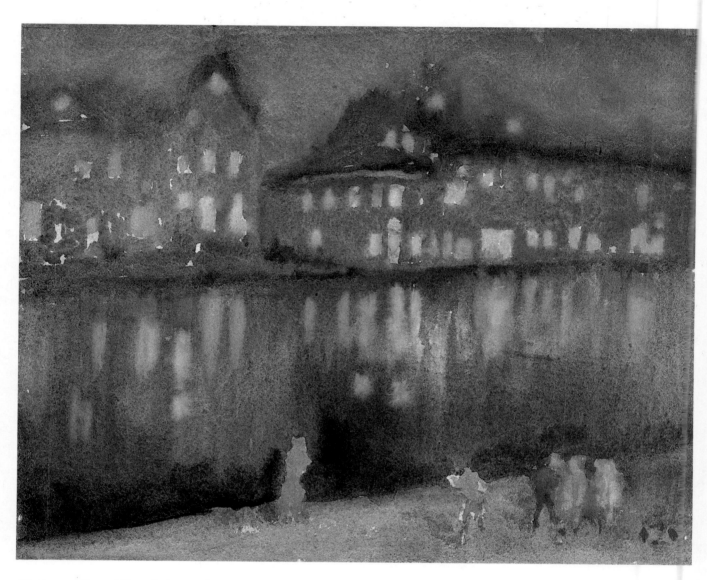

Nocturne: Grand Canal, Amsterdam

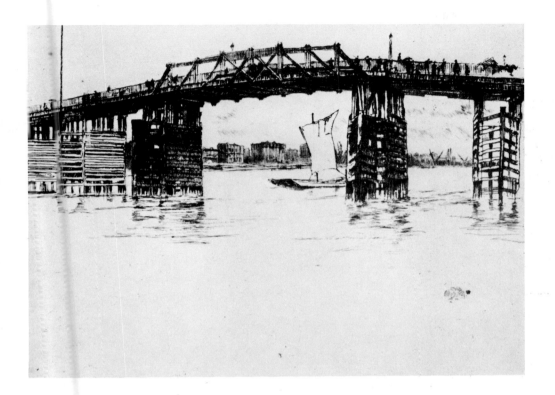

Old Battersea Bridge

1879. Etching, 8 × 11⅝″
Print Collection. The New York Public Library
Astor, Lenox and Tilden Foundations

Early impressions lack the butterfly, Whistler's hallmark. If this is removed, however, the plate is unbalanced. The last impression has a smaller butterfly farther to the left. Does this seem an improvement?

the work, divesting the picture of any outside anecdotal sort of interest.... Among my works are some night pieces, and I have chosen the word Nocturne because it generalizes and simplifies the whole lot of them."

Actually the term Nocturne was suggested to him by Leyland. He was delighted with it and wrote to his patron: "I say, I can't thank you too much for the name 'Nocturne' as a title for my moonlights. You have no idea what an irritation it proves to the critics and consequently pleasure to me—besides, it is really charming and does so poetically say all I want to say and *no more* than I wish."

Whistler expected more questions from his lawyers, but after his recital of famous patrons and sitters and his mention of the curtailment of his sales, they turned him over to Sir John Holker.

The defense produced *The Falling Rocket* and showed it to the jury upside down. To laughter, Whistler pointed out the mistake and said the Nocturne represented the fireworks at Cremorne.

SIR JOHN: Not a view of Cremorne?
WHISTLER: If it were called a view of Cremorne, it would certainly bring about nothing but disappointment on the part of the beholders. [Laughter] It's an artistic arrangement.

The trial proceeded after a discussion of why the *Portrait of Sir Henry Irving*

was entitled *Arrangement in Black.*

SIR JOHN: I suppose you are willing to admit your pictures show some eccentricities. You have been told that over and over again?
WHISTLER: Yes, very often. [Laughter]

Nocturne: Grand Canal, Amsterdam

1883–84. Watercolor on paper, 9 × 11¼″
Courtesy the Freer Gallery of Art,
Smithsonian Institution, Washington, D.C.

Fog envelops these strollers on the bank of an Amsterdam canal in which are reflected the lights of buildings on the opposite side. With repeated washes of dark colors, Whistler creates a mood sinister and menacing.

Little Venice

1879–80. Etching, 7¼ × 10½″
The Metropolitan Museum of Art, New York City
Harris Brisbane Dick Fund, 1917

SIR JOHN: You send them to the Gallery to invite the admiration of the public?

WHISTLER: That would be such a vast absurdity on my part that I do not believe I could. [Laughter]

SIR JOHN: Did it take much time to paint the *Nocturne in Black and Gold*? How soon did you knock it off?

WHISTLER: I beg your pardon. [Laughter]

SIR JOHN: I'm afraid I used a term that applies perhaps rather to my own work. I should have said, "How long did it take you to paint that picture?"

WHISTLER: Oh, no! Permit me. I am too greatly flattered to think that you apply to a work of mine any term you are in the habit of using with reference to your own. Let us say, then, how long did I take to "knock it off"—I think that's it—to knock off that Nocturne. Well, as well as I remember, about a day. I may have put a few more touches to it the next day if the painting were not dry. I had better say, then, that I was two days at work on it.

SIR JOHN: The labor of two days, then, is that for which you ask two hundred guineas?

WHISTLER: No. I ask it for the knowledge of a lifetime.

At this, there was warm applause. Many of Whistler's other replies had occasioned laughter, and it was evident that he had his audience with him. After further questions about his reaction to criticism, the subjects of his Nocturnes, whether he put his paintings in the garden to dry, and so forth, Sir John continued his cross-examination.

SIR JOHN: You have made the study of art your study of a lifetime. What is the peculiar beauty of that picture?

WHISTLER: It is impossible for me to explain to you the beauty of harmony in a particular piece of music if you have no ear for music.

SIR JOHN: Do you think that anybody looking at the picture might fairly come to the conclusion that it had no particular beauty?

WHISTLER: I have strong evidence that Mr. Ruskin did come to that conclusion. [Laughter]

SIR JOHN: Do you think it fair that Mr. Ruskin should come to that conclusion?

WHISTLER: What might be fair to Mr. Ruskin I cannot answer. But I do not think that any artist would come to that conclusion. I have known unbiased people express the opinion that it represents fireworks in a night scene.

SIR JOHN: You offer that picture to the public as one of particular beauty, as a work of art, and which is fairly worth two hundred guineas?

WHISTLER: I offer it as a work which I have conscientiously executed and which I think is worth the money. I would hold my reputation upon this, as I would upon any of my other works.

The attorneys on both sides agreed that three witnesses would be presented for either party. Whistler's were William M. Rossetti, Albert Moore, and an obscure artist (the best he could dig up), William G. Wills. Ruskin produced Burne-Jones, William P. Frith, and Tom Taylor, the critic of the *Times*, who was also editor of *Punch*. Their testimonies were predictable, except that Burne-Jones said, "You know I must speak the truth.... I think *Nocturne in Blue and Gold* is a work of art, but a very incomplete one."

The judge, in summing up, hurt Whistler badly. He said: "The question for the jury is...whether the insult offered—if insult there has been—is of such gross character as to call for substantial damages. Whether it is a case for merely contemptuous damages to the extent of a farthing, or something of that sort, indicating that it is one which ought never have been brought into court, and in which no pecuniary damage has been sustained; or whether the case is one which calls for damages in some small sum as indicating the opinion of the jury that the offender has gone beyond the strict letter of the law."

The jury was out an hour. Their verdict was in favor of Whistler, but they appraised the damages at one farthing. This was all very well, for he had won; but the tragedy was that the judge then acted unfairly. He divided the costs of the trial between the two litigants. Whistler could ill afford to pay £386.12s.4d in costs, plus his lawyers' fees. Bernard Shaw said the case had been mishandled. Whistler's lawyers should have based the case on financial loss to their client, not the loss of his artistic reputation. "But in talking about his Artistic Conscience, he could only raise a farthing—that being all that conscience is worth in the eyes of the law," Shaw said.

If Whistler was disappointed at the outcome of the trial, he kept it to himself. It was distressing not to have gotten his costs and damages, but he had had a moral triumph. The suit was not intended to gain him money but to vindicate his principles. This he explained in a pamphlet, *Whistler v. Ruskin: Art and Art Critics*. Ironically, the pamphlet sold many editions and made money.

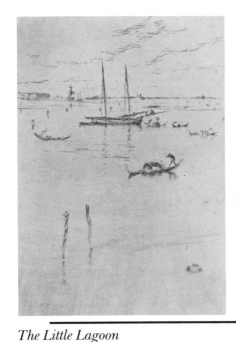

The Little Lagoon

1879–80. Etching, 8⅞ × 16″
Courtesy the Museum of Fine Arts, Boston

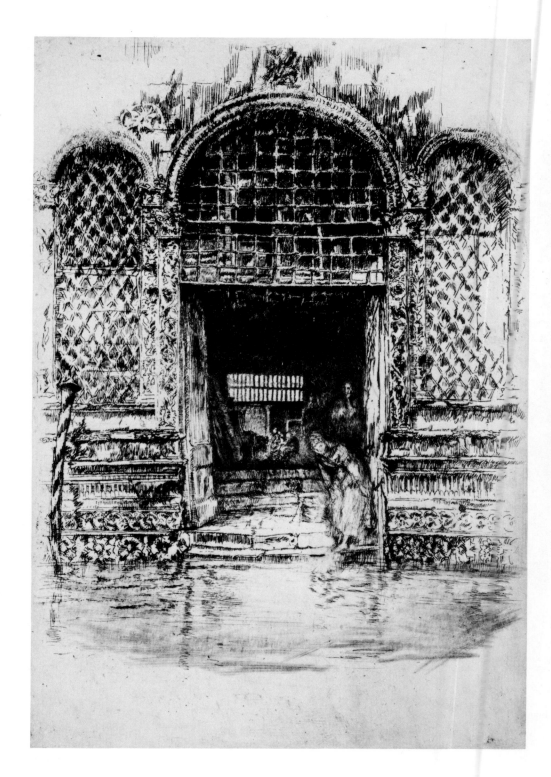

The Doorway

1879–80. Etching (third state), 12 × 8"
Courtesy the Freer Gallery of Art,
Smithsonian Institution, Washington, D.C.

This may be the doorway discussed in the text, where Whistler and Harry Quilter argued over who had the right to draw from his gondola.

There was also satisfaction in Ruskin's resignation as Slade Professor at Oxford. "I cannot hold a Chair from which I have no power of expressing judgment without being taxed for it by British Law," he wrote. Criticism was something he could not stand. The trial, he thought, made his professorship a farce. Whistler suggested he might fill a chair of ethics, for which he was admirably fitted.

Friends of Ruskin's immediately started a fund to pay his costs, as did Whistler's. But the well-to-do Ruskin was taken care of, whereas the impoverished

Whistler was not. His financial affairs were in total disarray. To make matters worse, the builder's estimates for the White House were exceeded. There were also the legal costs to be met; no pupils appeared; and there were many debts remaining from the past. As much as possible, he avoided his creditors, throwing them an occasional picture to keep the pack at bay.

To a grocer to whom he owed £600, he said: "How—what—why—why, of course you have sent these things—most excellent things—and they have been eaten, you know, by most excellent people. Think what a splendid advertisement. And sometimes, you know, the salads are not quite up to the mark, the fruit, you know, not quite fresh. And if you go into this unseemly discussion about the bill—well, you know, I shall have to go into a discussion about all this—and think how it would hurt your reputation with all these extraordinary people. I think the best thing is not to refer to the past—I'll let it go—and in the future we'll have a weekly account—wiser, you know." The grocer left without his money but received two Nocturnes in payment.

Early in May, 1879, Whistler was declared bankrupt. In June, the creditors met at the Inns of Court Hotel. Leyland was the chief creditor. Whistler spoke at length about plutocrats, men with millions, and what he thought of them. Efforts to make him stop failed, and he continued to the end of his discourse, to the discomfort of his audience.

Leyland was his archenemy. He painted three pictures showing his hate. The first was *The Loves of the Lobsters*, an *Arrangement in Rats*, the most prominent lobster wearing the shirt frills associated with Leyland. "Whom the gods wish to make ridiculous, they furnish with a frill," Whistler wrote. The second was *Mount Ararat*, Noah's ark on a hill, with little figures conspicuously dressed in frills. The third was *The Gold Scab*, depicting a creature breaking out in an eruption of golden sovereigns, wearing Leyland's frill, seated on Whistler's White House, playing the piano. These caricatures were in the studio when Leyland, with the rest of the committee, made an inventory.

On September 18, the White House and most of its contents were sold at auction. The *Times'* art critic, Harry Quilter, whom Whistler hated, bought the house for £2,700. The furniture brought only £449. He owed £4,641.

Before his house was sold, Whistler had one final fling. With the help of his son, Charles Hanson, he placed a ladder against the wall of the White House; while Charles held a candle, he climbed high enough to write his parting words above the door: "Except the Lord build the house, they labor in vain who build it. E. W. Godwin, F.S.A., built this house." Then Whistler said good-bye to his son and left for the Continent. Penniless, he had the good fortune to be given by the Fine Arts Society £600 and the expenses for his trip to Venice. This was in return for twelve etchings he promised to do. They also offered him ten shillings for each proof he pulled himself.

When he left, he had with him only some clothes, copperplates, etching equipment, and some of his favorite paper. Maud was in Paris, and they met there. Two days later, he was in Venice looking for rooms for the two of them. They finally settled above a shop near the Frari. He became entirely dependent

The Gold Scab

1879. Oil on canvas, 73½ × 55″
California Palace of the Legion of Honor
The Fine Arts Museums of San Francisco
Gift of Mrs. A. B. Spreckels to
Patrons of Art and Music

A caricature of Leyland as a peacock seated on Whistler's White House and playing the piano, which he did admirably. Whistler blamed Leyland for his bankruptcy, which could have been avoided, he felt, had he been paid the 2,000 guineas he asked for the Peacock Room. An additional £1,000 to what he was eventually paid would not have kept the bailiffs away, or not for long.

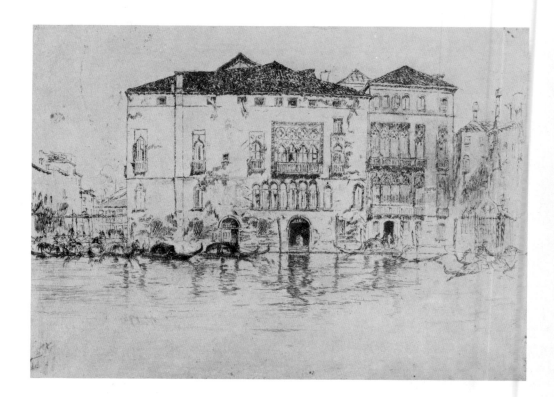

The Palaces

1879. Etching, 9¹⁵⁄₁₆ × 14″
The Metropolitan Museum of Art, New York City
Gift of Felix M. Warburg and His Family, 1941

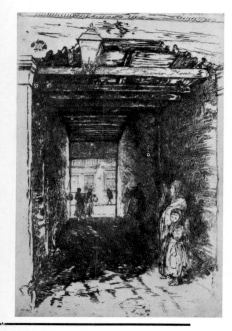

The Beggars

1879–80. Etching (second state), 12 × 8⅜″
Courtesy the Freer Gallery of Art,
Smithsonian Institution, Washington, D.C.

After Whistler's bankruptcy, the Fine Arts Society gave him money to go to Venice. In return he was to provide them with twelve etchings. Five of the most beautiful are reproduced. They have always been among his most admired work.

on Maud. Once, when he was biting a plate on his bureau—the only place he had to work in his cramped quarters, where meals were cooked on a spirit lamp—he spilled acid; and when it began to run onto his socks and shirts, instead of mopping it up, he shouted for Maud. She was out; but, fortunately, a friend watching him at work took his clothes out of the bureau and poured water on the acid on the floor.

Whistler longed to return to England. What made Venice miserable for him that first winter was the cold. It was difficult to hold a copperplate or an etching needle with numbed fingers. The Venetian old masters, however, delighted him. Tintoretto, Veronese, and Titian were "great swells," and Canaletto and Guardi "great painters." Still, he thought the ceiling of the Peacock Room more splendid than the dome of San Marco!

He was not inspired by the grand Venetian buildings. As in London, where he had avoided Westminster and St. Paul's in favor of Battersea and Wapping, so in Venice the crumbling houses in the little back canals appealed to him more than the great palaces and churches. As far as possible, he deliberately stayed away from the motives of Canaletto and Guardi, but as they had painted Venice so completely, to do so always was impossible.

Whistler simplified his prints as he had simplified his paintings. He concentrated on luminous shadows. He found dark doorways leading to interiors where nothing could be seen, intersections of minor canals, suggestions of light reflected from water, churches and palaces seen across the lagoon in light so dim that they became mere shapes. The style developed in Venice was totally different from that of his earlier work—more abstract and dependent on a minimum of calligraphic lines drawn with a few scratches of his needle.

The back canals he frequented were narrow. In the spring of 1880, Whistler came on a perfect subject: a beautiful doorway in a dilapidated house. Harry Quilter, the art critic of the *Times* hated by Whistler and purchaser of the White House, told how, quite by chance, he was at the scene drawing the same doorway.

For a few minutes we wrangled, but seeing that the canal was very narrow, and that there was no room for two gondolas to be moored in front of the chosen spot, mine being already tied up exactly opposite, I asked him if he would not come and work in my gondola. He did so, and I am bound to say he turned the tables on me cleverly. For, pretending not to know who I was, he described me to myself and recounted the iniquities of the art critic of the Times, *one 'Arry Quilter. He always wrote my name 'Arry in his letters—and this at great length with much gusto. And so he sat and etched and we chatted, and to the best of my remembrance I enjoyed the situation, and certainly bear him no ill will.*

Poor as he was, Whistler again started his Sunday breakfasts, cooking the food on a spirit lamp. Fish were cheap and plentiful, and there was a serving woman who fried them admirably. At sixpence a quart, plenty of thin red wine of the country was available. For the few guests he could accommodate at one time, these parties were as enjoyable as those he had given in London.

At this time, Whistler began using pastels more frequently. The technique was a convenient one, for he needed only a little portfolio and some varnished paper to cover the drawing when finished. He could walk around Venice and look for his subject, then make a sketch with black chalk, putting in color between the black lines. There was only a hint of the tone of the wall, the shutters, the women's clothes. For a time, partly due to the beauty of these Venetian sketches, pastels became all the fashion with collectors, but eventually their popularity died out.

Etchings, on the other hand, remained popular. From the plates done in Venice, Whistler produced prints that sold well all his life. For the first time, he was doing most of the printing himself. It required his knowledge and his eye to bring out of a mass of scratches exactly what he wanted. He used ink in a variety of ways, experimenting endlessly to get the effect he wished. While pulling his etchings, he continued to work on his plates. In the Venetian Set, no two proofs are alike. He was continually strengthening lines or lightening them.

In these prints, Whistler developed what he called "the Japanese method" of drawing. The system—scientific, as he said, like all his systems—required him to find the exact spot where the focus of interest in the etching, lithograph, or watercolor was to be. Having selected the point of interest, he drew and completed this part of the picture. It might be a bridge, a window of a house, a doorway, or the sitter's head. Then he drew whatever came next in importance. But the most significant step was the placing of the subject. The procedure seems simple, but he used to say, "The secret is in doing it."

By the end of November, 1880, Whistler was back in London. He arrived at the Fine Arts Society, which was holding a show, "Twelve Great Etchers." "Well, you know," he said, "I was just home; nobody had seen me. In one hand I held my long cane; with the other I led by a ribbon a beautiful little white Pomeranian

Lobster Pots

1880–81. Etching (first state), 4¾ × 8″
The Metropolitan Museum of Art, New York City
Harris Brisbane Dick Fund, 1917

Whistler was always feeling his way toward complete abstraction. Originally this print had figures and sailing vessels. They were burnished out in the final state.

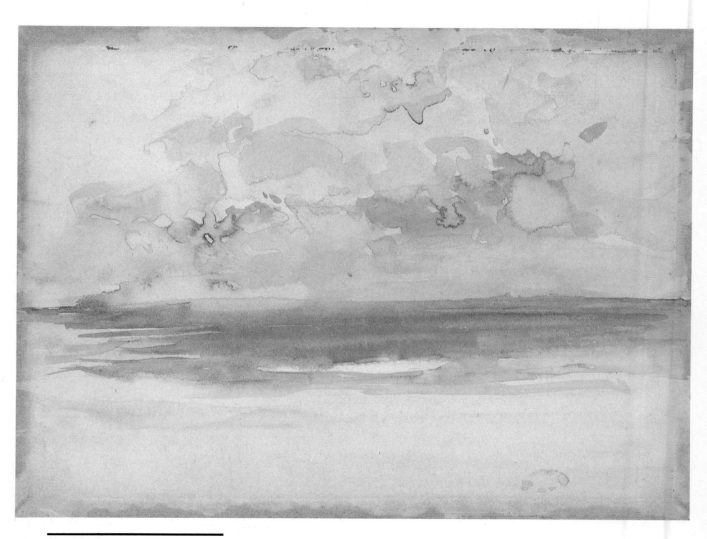

The Ocean Wave

c. 1883. Watercolor on paper, 5 × 7″
Courtesy the Freer Gallery of Art,
Smithsonian Institution, Washington, D.C.

Whistler's search for complete abstraction reaches a climax in this watercolor. Three horizontal bands of color—tones of yellow, green, and blue—represent shore, sea, and sky. One hundred years ago modern painting can be said to have begun.

Note in Pink and Purple: The Studio

Early 1880s. Watercolor on paper, ₂2 × 9″
Courtesy the Freer Gallery of Art,
Smithsonian Institution, Washington, D.C.

Whistler's studio is depicted with paintings stacked against the wall. Mingling the two colors pink and purple, he creates an atmosphere of rich mauve. "Mauve?" he used to say. "Mauve is just pink trying to be purple."

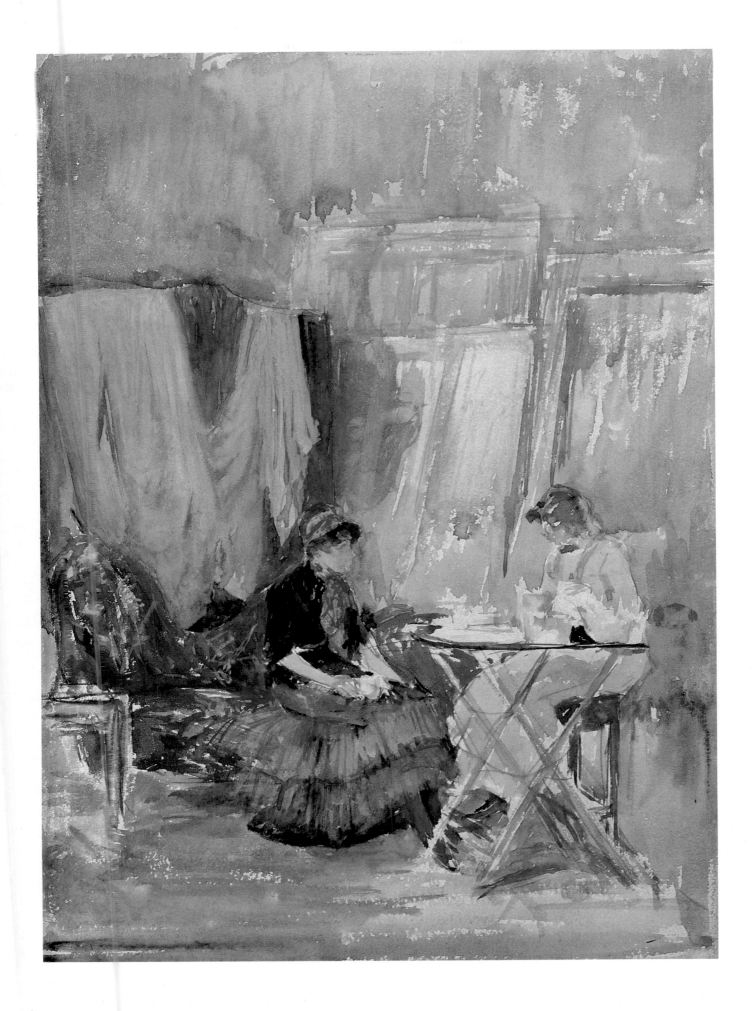

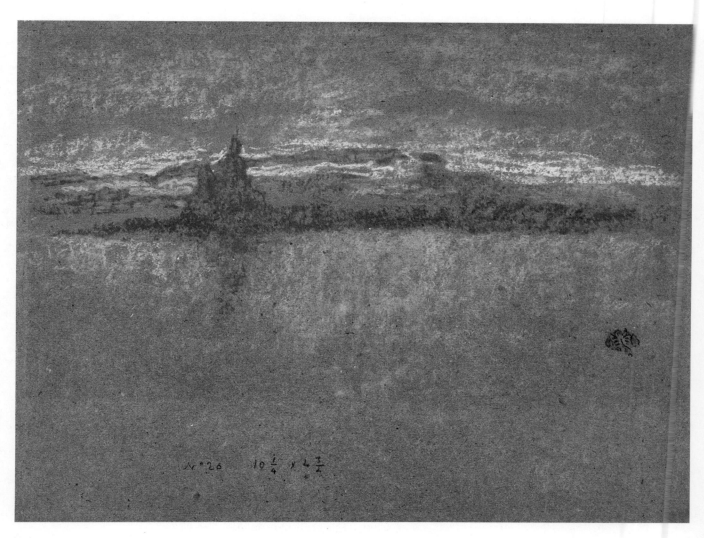

Salute: Sundown

Flower Market: Dieppe

1885. Watercolor on paper, 5¹⁄₁₆ × 8¼"
Courtesy the Freer Gallery of Art,
Smithsonian Institution, Washington, D.C.

Whistler visited his pupil Walter Sickert in September, 1885, in Dieppe. He viewed the flower stalls with joyous exuberance and made this quick watercolor, which he gave Sickert in return for his hospitality.

dog; it too had turned up suddenly. As I walked in I spoke to no one, but putting up my glass I looked at the prints on the wall. 'Dear me! Dear me!' I said. 'Still the same old sad work.' Haden was there talking hard to Brown, and as he said, 'Rembrandt,' I said, 'Ha!' and he vanished."

The first series of twelve etchings was shown in December, 1880, at the galleries of the Fine Arts Society. The critics repeated what had been heard at the Ruskin trial. The consensus was that Whistler was amusing but had not fulfilled his early promise. His prints were shown in New York with no greater success.

Then Whistler prepared an exhibition of his pastels. He redecorated the gallery. According to Godwin, writing for *The British Architect*:

First there was a low skirting of yellow gold, then a high dado of dull yellow-green cloth, then a moulding of green-gold, and then a frieze and ceiling of pale reddish-brown. The frames are arranged in a line; but here and there one is placed over another. Most of the frames and the mounts are of rich yellow gold, but a dozen out of the fifty-three are in green-gold, dotted about with a view of decoration, and eminently successful in attaining it.

The etchings and pastels might be denigrated by the critics, but Whistler as an interior decorator was unsurpassed. A number of people, undeterred by the criticism they read, bought the pastels. The show was financially successful. The total receipts were £1,800, more than Whistler had earned at one time since he was paid for the Peacock Room.

Whistler's pleasure at being once more solvent was overshadowed by the death of his mother. Although she had been domineering and had tried unsuccessfully to mold him, she had always been loving, and he was devoted to her. He had confided in her his successes and failures, his hopes and disappointments. He had written her at Hastings and come to see her often. But her death filled him with remorse. He told his brother, "It would have been better had I been a parson, as she wanted."

Salute: Sundown

1880. Pastel on brown paper laid down on card,
7⅞ × 10⅝"
Hunterian Art Gallery, University of Glasgow
Birnie Philip Gift

The large number of pinholes at the top of the paper represents the number of sessions Whistler spent drawing this scene. According to Otto Bacher, a fellow artist, Whistler always had several pastels and etchings under way simultaneously.

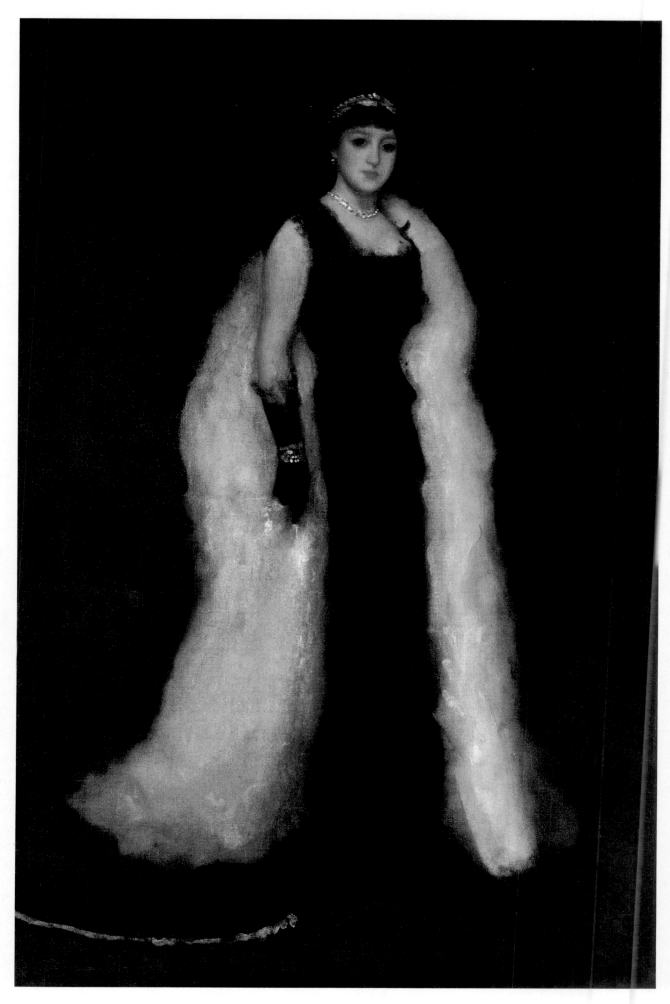

Arrangement in Black, No. 5: Lady Meux

IV. A King with a Court: Beginnings of Appreciation

GRADUALLY, with increasing sales, Whistler was able to redeem the pictures he had left as collateral with Graves. In May, 1881, Alan Cole, who had known Whistler since he was fifteen and constantly referred to him through the years in his diary, wrote: "Met Jimmy, who is taking a new studio in Tite Street, where he is going to paint all the fashionables; views of crowds competing for sittings; carriages along the street." His new residence was close to the White House. Whistler decorated it in yellow. Howell said, "You felt in it as if standing inside an egg."

The only problem was that, in spite of the crowds who came to see him, he had few commissions. In the seventies, it took pluck to be painted by Whistler; in the eighties, it was to risk notoriety and derision. Lady Meux, a handsome, self-assured woman, gave him a commission. The portrait that resulted has a solidity and a firm modeling rare in his work. Lady Meux was pleased and posed again for a painting he called *Pink and Gray*. A third portrait was begun but never completed.

From a description by Mrs. Julian Hawthorne, who watched Whistler paint Lady Meux, one can visualize the artist at work.

On his left was the easel, supporting the tall canvas; beyond at a distance of some twenty feet, stood the "sitter," on a dais, with her splendid fur trimmed cloak falling off her white shoulders. This side of the easel, still more to the left, was a table as large as a five-o'clock tea tray, the top of which consisted of a palette, fixed at a slight inclination. Whistler held in his right hand a sheaf of brushes, with monstrous long handles; in his right the brush he was at the moment using. His movements were those of a duellist fencing actively and cautiously with the small sword. . . . He advanced; he crouched peering; he lifted himself, catching a swift impression; in a moment he had touched the canvas with his weapon and taken his distance once more. This would go on for an hour or two, most of it in silence.

Lady Archibald Campbell has also left a commentary on sitting for her portrait

He made a sketch of me in the dress [her court dress]. The fatigue of standing with the train was too great, and he abandoned the idea. . . . A picture he called The Grey Lady *. . . was almost complete when my absence from town prevented a continuation of the sittings. When I returned, he asked to make a study of me in the dress in which I called on him. This is the*

Arrangement in Black, No. 5: Lady Meux

1881–82. Oil on canvas, 76½ × 51¼"
Honolulu Academy of Arts, Hawaii
Purchase with Academy Funds and donations
from the community, 1967

Sir Henry Meux, a brewer, offered Whistler 1,500 guineas for three portraits of his wife. But, as Montesquiou wrote, "Les Meux, au moment de payer leur portrait, s'étant mis en route pour un voyage que leur peintre denommé La Fuite en Egypte." *In the end Whistler agreed to accept 1,200 guineas for the three—but never completed the third.*

93

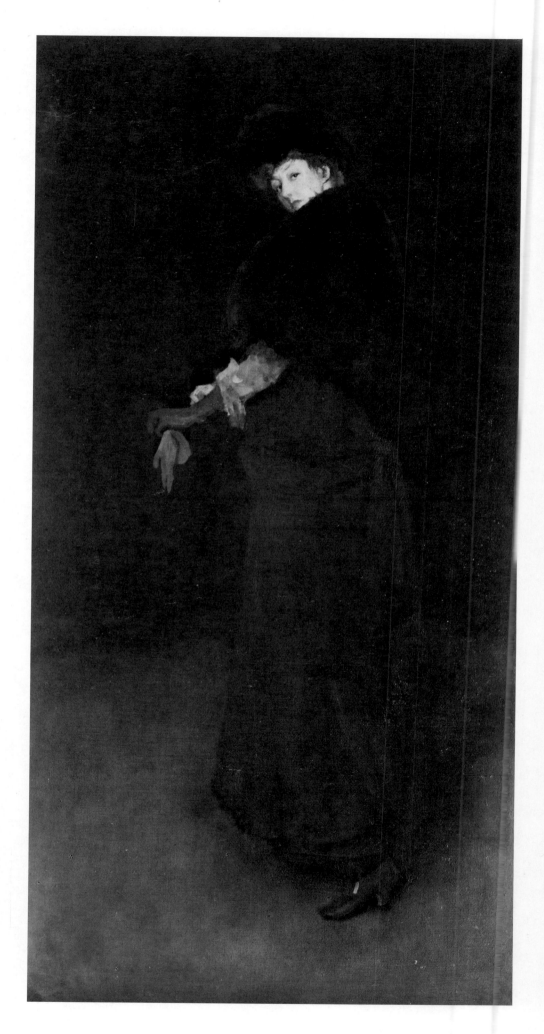

Arrangement in Black: La Dame au brodequin jaune—Portrait of Lady Archibald Campbell (The Lady with the Yellow Buskin)

1882–84. Oil on canvas, 84 × 43″
Philadelphia Museum of Art
W. P. Wilstach Collection

Of the three portraits painted by Whistler of Lady Archibald Campbell, this is the only one completed. According to Walter Sickert, Degas admired it greatly, but the Campbell family refused to buy the painting, saying it made her look like a street-walker encouraging a shy follower with a backward glance.

picture which he exhibited under the title of The Brodequin Jaune, *or* The Yellow Bus-
kin. *As far as I remember, it was painted in a few sittings. When I saw him shortly before he
died, I asked after* The Grey Lady. *He laughed and said he had destroyed it.*

The number of his portraits Whistler destroyed seems appalling. Sickert
said he painted them over and over again till they were "finished—or wrecked, as
often happened, from the sitter getting tired, or growing up, or growing
old.... He wanted always to do the portrait at one sitting, either the first or the
hundredth." Whistler used to say paint should not be applied thick. It should be
like breath on a pane of glass. To achieve this, any reworking had to be rejected.

Théodore Duret has left us a further indication of how Whistler worked.
According to him, the artist marked with chalk where he wished the figure
placed on the canvas and then began at once to color it. He had no difficulty in
beginning a portrait; his problem was to finish it. Duret said it was a question not
of drawing but of bringing the color into harmony; and in order to preserve this
harmony, if any repainting had to be done, the whole picture had to be begun
afresh.

In his portrait of Duret, the rose of the domino, the fan, and the flesh are so
carefully arranged that on the cold gray of the background there seems to be
reflected a rosy glow. Duret is in evening dress, with a rose-colored cape over his
arm. Whistler was attracted by the contrast of black and white, which suited his
absorption in tonal painting. From Gleyre, he had learned that ivory black is the
basis of tone. He was also taught, and practiced, a careful arrangement of colors
on his palette. Whistler never forgot these two principles—black on black, "the
universal harmonizer," and a precisely laid-out palette—both learned from
Gleyre. Evening clothes offered the blacks, and a rose domino provided the oth-
er colors, which had been carefully prepared. Whistler chose evening clothes or
dark suits for his masculine portraits. Perhaps he recalled what Baudelaire had
said: "The true painter we are looking for ... can make us see and understand
with brush and with pencil how great and poetic we are in our cravats and our
patent leather boots." Contemporary dress, the poet meant, was not to be de-
spised by artists.

Early in the winter of 1883, Whistler gave the second exhibition of fifty-one
of his Venetian etchings. He chose white and yellow for the decoration of the gal-
lery. The wall was white, but there were yellow hangings, the floor had yellow
matting, and the chairs were painted yellow. Whistler wore yellow socks, and
there were yellow flowers in yellow pots. Even the attendants wore white and yel-
low livery. Before the show opened, he said: "Well, you know, a source of con-
stant anxiety to everybody and of fun to me. On the ladder, when I was hanging
the prints, I could hear the whispers, 'No one would be able to see the etchings.'
And then I would laugh. 'Dear me, of course not! That's all right. In an exhibi-
tion of etchings the etchings are the last thing people come to see!' And then
there was the private view, and I had a box of Butterflies; everybody was eager to
be decorated. And when the crowd was greatest Royalty appeared, quite unprec-
edented at a private view."

The next winter, 1884, Whistler worked a great deal out of doors, spending long periods of time at Saint Ives in Cornwall, where he went on a sketching trip with Sickert. His interest in landscape was minimal. "There are too many trees in the country," he used to say. But he loved the sea. The Cornish sketches were shown in May, the first exhibition of his watercolors. It was a medium he mastered after some difficulty. He used it more and more. Again, he decorated the gallery, this time pale rose on the walls, white dado, white chairs, and pale azalea in jars of delicate rose. To the critics, Whistler's decoration was a new affectation.

There was, however, a beginning of appreciation. Whistler sent his *Carlyle* to a loan exhibition of Scottish national portraits at Edinburgh. Duret tried to sell it to the British National Portrait Gallery, and all he got was the laughter of the director at the thought of buying it. Letters from two Scots in the *Scotsman* proposed fund-raising to acquire it for the National Gallery in Edinburgh. But when the *Scotsman* disclaimed approval of Whistler's theories and his art, the painter raised the price from £400 to £1,000, and negotiations ended.

Whistler used to say he could never afford to keep a friend, but he had many who put up with his jokes and an occasional insult. For some years, Oscar Wilde was a constant companion. Du Maurier, when he saw them together, asked, "I say, which one of you two invented the other, eh?" Their remarks, friendly or hostile, were constantly quoted. Whistler was flattered by Wilde. Also, he liked to associate with someone brilliant, who would make his Sunday breakfasts scintillate, who could talk enthusiastically to visitors at his private views. There were few functions at which they were not both present. Wilde borrowed Whistler's ideas about art; he imitated his epigrams; he had "the courage," as Whistler said, "of the opinions of others." The interaction of their wit is summed up in the well-known exchange: "I wish I had said that, Whistler." "You will, Oscar, you will." The great difference between them was that Wilde, before his imprisonment, was serious about very little. Where art was concerned, Whistler was always deadly serious. In Whistler's opinion, Wilde was something of a clown. In Paris, Whistler called him a "*bourgeois malgré lui.*" Such remarks ended their companionship. Whistler confessed, "My nature needs enemies."

When he returned from Venice, aged forty-six, a younger generation believed in him and was at his command. They fought for him, ran his errands, spied out the land, read his letters to everybody. They formed a court around their monarch and imitated him to the point of caricature. In all this, their devotion was excessive. Finding them willing to squander their time, Whistler took advantage of their eagerness to work for him. There was plenty for everyone to do in the studio, and he made use of his followers.

To be a king with a court was to Whistler highly enjoyable. But like any ruler, he feared that his authority might be undermined, and that is what he thought Wilde was doing. The writer gave a lecture at the Royal Academy, using all of Whistler's ideas; in doing so without acknowledgment, he made it difficult for Whistler to claim his rightful ownership. These were theories that his followers accepted as their bible, and Whistler could not afford to have them plagiarized. He, therefore, felt the need to repeat publicly once more what he had been

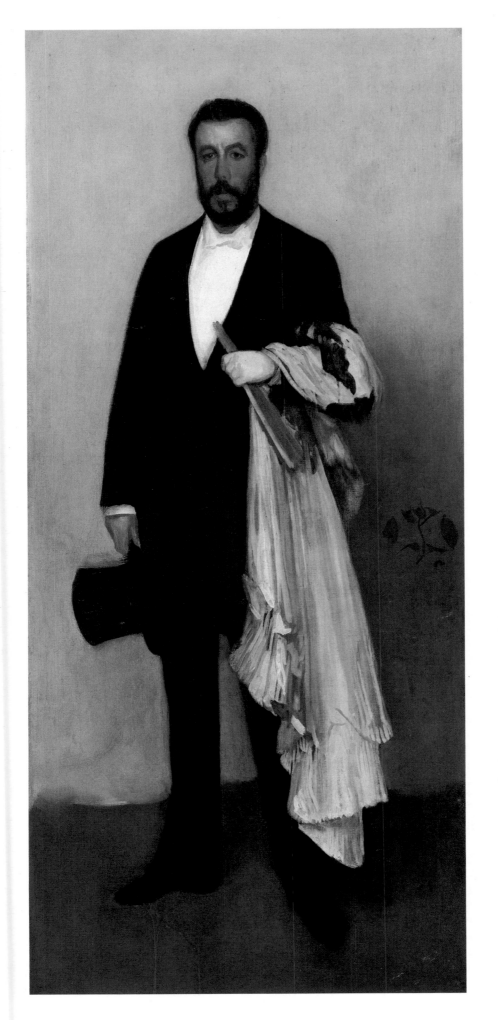

Arrangement en couleur chair et noir: Portrait de Théodore Duret (Arrangement in Flesh Color and Black: Portrait of Théodore Duret)

1883–84. Oil on canvas, 76⅛ × 35¾″
The Metropolitan Museum of Art, New York City
Wolf Fund, 1913

In 1880, Whistler was introduced to Duret by Manet. They became close friends, and Duret helped in the sale of several paintings. He was also an art critic and published a monograph and important articles on Whistler. The pink of the silk domino, the fan, and the flesh are so skillfully balanced that the neutral background seems to have a rosy glow. Duret used to show the portrait to friends and make them look at the background through a hole in a piece of cardboard to prove that there was no pink in the cold gray tone of the wall.

preaching for many years in pamphlets, catalogues, and letters to the editor. He wished to copyright his theories in a lecture of his own.

Always unpunctual himself, he was determined to have his audience come on time and unhurried from the dinner table. He therefore scheduled his lecture at Prince's Hall in February, 1885, for ten o'clock in the evening, an unheard-of hour. He was nervous, for he knew he had a rasping voice and was inexperienced in public speaking. His theatrical friends, especially Mrs. D'Oyly Carte, coached him; and his delivery, if not admirable, as was Wilde's, was at least acceptable.

The "Ten O'Clock" Lecture, as it came to be known, is a masterpiece of English prose. To reduce it to a series of topics is like pulling the wings off a butterfly. But these are the points (partly directly quoted and partly paraphrased) that Whistler made:

1. Art proposes in no way to better others. There never was an artistic period. There never was an art-loving nation.

2. The dreamer, who took no part in the ways of his brethren, who designed quaint patterns, who devised the beautiful, was the first artist. Others joined him, and with the power of creation they went beyond the slovenly suggestions of Nature—from the gourd to drink out of, for example, the first vase was born in beautiful proportion.

3. And time brought more capacity for luxury and the people lived in marvels of art—and ate and drank out of masterpieces, for there was nothing else to eat or drink out of, and no bad buildings to live in . . . and the people questioned not, and had nothing to say in the matter. And the Amateur was unknown and the Dilettante undreamed of. And conflict accompanied civilization, and Art spread. So that all people continued to use what *the artist alone produced.*

4. And centuries passed and the world was flooded with all that was beautiful, until there arose a new class, who discovered the cheap, and foresaw fortune in the facture of the sham. And the taste of the tradesman supplanted the science of the artist. And Birmingham and Manchester arose in their might—and art was relegated to the curiosity shop.

5. Nature contains the elements, in color and form, of all pictures, as the keyboard contains the notes of all music. But the artist is born to pick and choose, and group with science, these elements, that the result may be beautiful—As the musician gathers his notes and forms his chords, until he brings forth from chaos glorious harmony. To say to the painter that Nature is to be taken as she is, is to say to the player that he may sit on the piano. That Nature is always right is an assertion, artistically, as untrue as it is one whose truth is universally taken for granted. The sun blares, the wind blows from the East, the sky is bereft of cloud, and without all is of iron. The holiday maker rejoices in the glorious day, and the painter turns aside to shut his eyes.

Arrangement in Black: Portrait of Señor Pablo de Sarasate

1884. Oil on canvas, 85½ × 44″
Museum of Art, Carnegie Institute, Pittsburgh
Purchase

Oscar Wilde saw the sitter standing by his portrait and commented that "he looked shockingly ordinary by the side of it." Whistler's great gift was to dower his models with a distinction they often lacked. Bought for the Museum of Art, Carnegie Institute, in Pittsburgh, this is one of the first works by Whistler to enter the collection of an American gallery.

Then follow several of the finest paragraphs in English prose, more beautiful than anything written by Ruskin. By contrast with the "glorious day" described above:

And when the evening mist clothes the riverside with poetry, as with a veil, and the poor buildings lose themselves in the dim sky, and the tall chimneys become campanili, and the warehouses are palaces in the night, and the whole city hangs in the heavens, and fairy-land is before us—then the wayfarer hastens home; the working man and the cultured one, the wise man and the one of pleasure, cease to understand, as they have ceased to see, and Nature, who for once has sung in tune, sings her exquisite song to the artist alone, her son and her master—her son in that he loves her, her master in that he knows her.

To him her secrets are unfolded, to him her lessons have become gradually clearer. He looks at her flower, not with the enlarging lens, that he may gather facts for the botanist, but with the light of the one who sees in her choice selection of brilliant tones and delicate tints, suggestions of future harmonies.

A KING WITH A COURT

Green and Silver: The Devonshire Cottages

1884. Oil on canvas, 12⅝ × 24¾"
Courtesy the Freer Gallery of Art,
Smithsonian Institution, Washington, D.C.

In 1895, Whistler offered the canvas to the dealer David Croal Thomson for 200 guineas on two conditions: "1st. It must be sold to Scotsman American German Frenchman whoever you please—but not *to an Englishman—. 2nd. There must be an undertaking written to allow the picture to be exhibited . . . where I please." Though Whistler had lived most of his life in England and had many English friends, he passionately hated English collectors for their failure to understand or support him, and he did not wish his picture to go to the English artistic establishment.*

He does not confine himself to purposeless copying, without thought, each blade of grass, as commanded by the inconsequent [an allusion to Ruskin], but, in the long curve of the narrow leaf, corrected by the straight tall stem, he learns how grace is wedded to dignity, how strength enhances sweetness, that elegance shall be the result. . . . In all that is dainty and loveable he finds hints at his service, and to him is naught refused.

Through his brain, as through the last alembic, is distilled the refined essence of that thought which began with the Gods, and which they left him to carry out.

Set apart by them to complete their works he produces that wondrous thing called the masterpiece, which surpasses in perfection all that they have contrived in what is called Nature, and the Gods stand by and marvel, and perceive how far away more beautiful is the Venus of Melos than was their own Eve.

These paragraphs are the high point of Whistler's lecture. After this, his inspiration somewhat flagged. He returned to his vituperation against critics, curators, and archaeologists, false preachers like Ruskin (whom he does not mention

by name), and dilettanti in general. He speaks out against literary pictures, poetic symbolism, and those who seek to find ubiquitous anecdotes: "While the artist, in fulness of heart and head, is glad, and laughs aloud, and is happy in his strength and is merry at the pompous pretension—the solemn silliness that surround him."

And he concludes: "Therefore have we cause to be merry.... We have then but to wait—until, with the mark of the Gods upon him—there come among us again the chosen—who shall continue what has gone before. Satisfied that, even were he never to appear, the story of the beautiful is already complete—hewn in the marbles of the Parthenon—and broidered, with the birds, upon the fan of Hokusai—at the foot of Fusiyama."

The same lecture was given at Cambridge and at Oxford. The doctrine of art produced for its own sake was novel, but it has become the basis of the aesthetics of modern times. The elitist principle laid down by Whistler has also been generally accepted. The lecture was influential among the young, and when read today still is.

But two of Whistler's best friends were critical. Wilde acknowledged the beauty of the lecture, but he was unwilling to accept the statement that only a painter is a judge of painting, which ruled him out as a critic. He disagreed that the artist is an isolated fact. The artist, he held, is the resultant of a certain milieu and a certain entourage and can no more be born of a nation that is devoid of any sense of beauty than a fig can grow from a thorn or a rose blossom from a thistle. Furthermore, he said, the supreme artist is the poet, "who is lord over all life and all arts."

None of this criticism was enjoyable to Whistler, but Wilde ended by saying that the lecturer "is one of the very great masters of painting, in my opinion. And I may add that, in this opinion, Mr. Whistler himself entirely concurs."

Swinburne's attack was more vicious and, coming from so close a friend, unexpected. He said: "It is a cruel but an inevitable Nemesis, which reduces a man of real genius, keen witted and sharp eyed ... to the level of the *dotard and the dunce*, when paradox is discolored by personality and merriment is distorted by malevolence." Even Whistler's beautiful prose offended Swinburne. "Such abuse of language is possible only to the drivelling desperation of venomous or fangless duncery."

Whistler headed his reply: "*Et tu, Brute.*" "How have I offended! and how shall you, in the midst of your poisoned page, hurl with impunity the boomerang rebuke? ... Do we speak the same language? Are we strangers, then, and in our Father's house are there so many mansions that you lost your way, my brother, and cannot recognize your kin?" And, later, he added sadly: "Thank you, my dear! I have lost a *confrère*; but, then, I have gained an acquaintance—one Algernon Swinburne— 'outsider'—Putney."

In the autumn of 1884, Whistler surprised everyone by becoming a member of the Society of British Artists. It was an ancient but moribund institution established in opposition to the monopoly of the Royal Academy. Its fortunes were at a low ebb, its exhibitions filled with the work of tiresome hacks and inexperi-

An Orange Note: Sweet Shop

1884. Oil on wood panel, 4¾ × 8½"
Courtesy the Freer Gallery of Art,
Smithsonian Institution, Washington, D.C.

A contemporary critic wrote, "The shop is probably the most perfect little thing of its kind that was ever wrought.... It is without detail, without apparent labor, without dramatic interest, but it is exquisite in color, faultless in tone, and its well considered mystery has, at least, the interest of suggestiveness." One of a series of intimate street scenes Whistler painted, somewhat as a pianist might exercise his fingers, this casual sketch has an abiding beauty that will always delight the connoisseur of painting.

A KING WITH A COURT

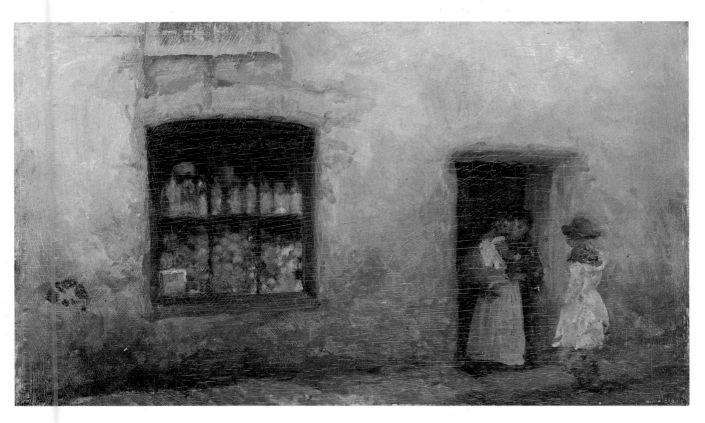

An Orange Note: Sweet Shop

Harmony in Red: Lamplight

enced, though aging, amateurs. The committee who asked Whistler to join said that they hoped he would waken their somnolent institution. As he said, "They were there to pay me a compliment. I accepted the offer with appropriate courtesy . . . and then almost as soon as I was made a member I was elected President."

Whistler had never joined any society in England. At fifty, he should have been asked to be a member of the Royal Academy, but the Academicians, with their characteristic inability to discern quality, ignored him. Wilkie expressed their goals when he said, "To know the taste of the public—to learn what will best please the employer—is, to an artist, the most valuable of all knowledge." Such ideals were anathema to Whistler. His style, with its capricious mixture of French, Spanish, and Japanese elements, puzzled artists and critics alike. All they could be sure of was that he wasn't British; rather, he seemed to them an exotic Yankee. And then, suddenly, he was the head of British Artists, a most unlikely choice.

Time proved their instincts correct. But meanwhile he did what he had been asked to do. He woke up the Society, but he had to work hard to arouse it from its somnolence. Claude Phillips, in the *Gazette des Beaux-Arts*, in the July, 1885, number, wrote: "The eccentric Mr. Whistler has gone to a neglected little gallery, the British Artists, which he will probably bring into fashion." And he did. To the first summer exhibition after his election, he sent his full-length portrait of Sarasate, which had never been exhibited and was originally intended for the Royal Academy. He proposed Sunday receptions in the gallery and the awarding of medals. In the winter exhibition, he showed *Portrait of Mrs. Cassatt* and *Blue and Violet*, a pastel of a nude.

In spite of all Whistler could do, the revenue of the Society had continued to decline, and a deficit of £500 had to be faced. The president proposed various economies, including discontinuing luncheons for the press; instead, there were to be Sunday breakfasts, at which members would pay for themselves and guests. His motion was defeated.

To the summer exhibition of 1886, he sent one work, *Harmony in Blue and Gold*, a full-length painting of a girl leaning against a railing and holding a parasol. Her draperies were transparent and elicited a letter to the *Court and Society Review*, which is such a period piece that it is worth quoting at length.

I am invited to gaze at an unfinished rubbishy sketch of a young woman, who, if she is not naked, ought to be, for she would then be more decent. . . . For my part, Sir, I will not believe in Mr. Whistler; my daughters have commanded me to admire him. How they can quietly stare at the ill-painted, sooty-faced young woman in "blue and gold" passes me. But things are altered now, and my girls gaze with critical calmness and carefully balanced pince-nez on that which would have sent their grandmother shrieking from the gallery.

Such pictures were influenced by Albert Moore, who, in approximately 1865, showed a series of arrangements—young women, clad in transparent draperies, reclining on marble seats or displaying their diaphanous clothes amid spring blossoms. Whistler was, for a time, captivated by this Neoclassicism, and he came to like Moore so much that he proposed to Fantin-Latour that the Brit-

Harmony in Red: Lamplight

1884–86. Oil on canvas, 75 × 35¼"
Hunterian Art Gallery, University of Glasgow
Birnie Philip Gift

This is a portrait of Beatrice Philip Godwin, whom Whistler married in 1888. It is painted with ineffable tenderness, expressive of the deep love he felt for her.

Dipping the Flag

c. 1887. Etching, 3⅛ × 6⅞″
Courtesy the Freer Gallery of Art,
Smithsonian Institution, Washington, D.C.

Whistler went to Spithead to see the naval review honoring the Jubilee of Queen Victoria. The prints he made there were placed in a beautiful box and given to the queen. They were later sold by Edward VII.

ish painter replace Legros (then out of favor) in the Society of Three. Whistler's *Symphony in White, No. 3* blends Moore's style with lingering traces of Japanese influence. In color and design, this painting of Jo and another model is far superior to anything by Moore, even if the draftsmanship is weak. Whistler also made designs for six Schemes, or Projects, compositions under Moore's influence. All depict the same slender and seductive models, who have the elegance of Tanagra figures, a type of Greek sculpture both artists studied in photographs and at the British Museum. As Whistler eventually recognized that Moore was a minor artist, his influence decreased.

Whistler intended to go to America in the autumn, but the trip was postponed. There was too much to do at the Society of British Artists, though, as he wrote to *The World*, "One cannot continually disappoint a Continent." But first he had to redecorate the galleries for the winter exhibition. He put up a velarium (an awning hung above the gallery to diffuse the light), which he patented, and he covered the walls with muslin. He wanted the walls uncrowded, the pictures well spaced and well hung. This meant reducing the number of works shown, thereby offending many members. To assuage them, Whistler offered £500 to pay the Society's more pressing debts, even though to do this he had to pawn his large gold Salon medal. In his efforts to improve the Society's standing, he persuaded distinguished artists to become members: Charles Keene, Alfred Stevens, and the more promising younger men. He gave £20 toward the decoration of the galleries and bought four curtains for the doorways of the main room. All this in spite of its being a time when, as he said, he "often found a long face and a short account" at his bank.

The president's innovations were unpopular with the members. Although delighted to have their debts paid, they did not want their pictures rejected. Their dissatisfaction was expressed at a meeting, and it was voted "that the experiment of hanging pictures in an isolated manner be discontinued." The members, it is said, made an estimate of the space left bare and counted the loss in pounds, shillings, and pence. Before Whistler, it seems to have occurred to no one that beautiful works of art should be displayed beautifully. Modern museums owe an incalculable debt to Whistler.

In 1887, Queen Victoria celebrated her Jubilee, and addresses to Her Majesty were prepared by every society of artists. Without consulting his board, Whistler wrote a tribute on behalf of the Society of British Artists. He used a sheet of his precious old Dutch paper, reserved for his etchings, and had his note bound and transmitted to Windsor. To accompany his tribute, he sent a beautifully tooled box containing the etchings he had done of the Jubilee Naval Review. (These are no longer in the Royal Collection, having been sold by Edward VII to pay some of his gambling debts.) In his letter, Whistler told the queen of the age and dignity of the Society, adding that it was devoted to Her Glorious, Gracious Majesty and suggesting what an honor it would be if she were to recognize this devotion by conferring a title, which would indicate that the Society was especially under her patronage.

The Embroidered Curtain

1889. Etching (fourth state), 9⅜ × 6⅜″
Courtesy the Freer Gallery of Art,
Smithsonian Institution, Washington, D.C.

To render in an etching water, street, people, and varied panes of glass shows a linear wizardry only Whistler could display.

When the Society learned that the president had written to the queen without consultation, the members at the meeting were outraged, and one resigned on the spot. "And when the storm had quieted," Whistler said, "I got up with great solemnity and I announced the honor conferred on them by Her Gracious Majesty, and that by the Queen's command the Society hereafter should be called Royal. And they jumped up and rushed toward me with outstretched hands. But I waved them off, and continued the ceremonies to which they objected. For the ceremony was one of their grievances. They were accustomed to meet in shirt-sleeves—free-and-easy fashion, which I would not stand." When the meeting was over, Whistler sent for champagne.

The year before, an exhibition of paintings by the president had been proposed, but nothing came of it. After Whistler's role in having the organization made a Royal Society, there was heightened enthusiasm for him, and the scheme was revived. Guarantors were found, owners of pictures written to, but then, as previously, the matter was dropped. The president was not sufficiently popular. He proposed a resolution that no member of the Society might be a member of any other art society. This was overwhelmingly defeated. He then offered a second resolution: that no member of the Society who was a member of any other society should serve on the Selecting and Hanging Committee. This, too, went down to defeat. The votes of the members were an indication of their dissatisfaction. But, as someone said, "With a little more of Disraeli and a little less of Oliver Cromwell," Whistler would have triumphed. Instead, he granted an interview, in which he said, apropos of the Society:

When I took charge of the ship I found her more or less waterlogged. Well, I put the men to the pumps and thoroughly shook up the old vessel; had her re-rigged, re-cleaned, and painted—finally I was graciously permitted to run up the Royal Standard to the masthead, and brought her fully to the fore, ready for action—as became a Royal flagship. And as a result mutiny immediately set in. Don't you see what might have been considered by the thoughtless as benefits, were resented by the older and wiser of the crew, as innovations and intrusions of an impertinent and intrusive nature. But the immediate result was that interest in the Society was undeniably developed, not only at home, but certainly abroad.

Whistler continued, regardless of his crew, his dictatorial ways; and on May 7, 1888, a letter signed by eight members asked him to call a meeting to request Mr. James A. McNeill Whistler to resign his membership in the Society. The meeting was called and a motion made for his expulsion. Whistler at first refused to approve the motion, but he was finally forced to accept it, and a vote was taken. Whistler won by nineteen to eighteen, with nine abstaining. After the ballot, the president said his majority showed approval of his actions. On June 4, however, at the annual election, the opposition got all the absent members to attend and put pressure on those who had abstained to vote, with the result that a new president, Wykebayliss, was elected and Whistler resigned. All who had joined the Society of British Artists with him left it, and Whistler commented, "The artists came out and the British remained."

Blue and Violet

c. 1889. Pastel, 10¼ × 6″
Hunterian Art Gallery, University of Glasgow
Birnie Philip Gift

A masterpiece of color: shades of turquoise are enframed by delicate black outlines to render one of Whistler's most enticing nudes.

A KING WITH A COURT

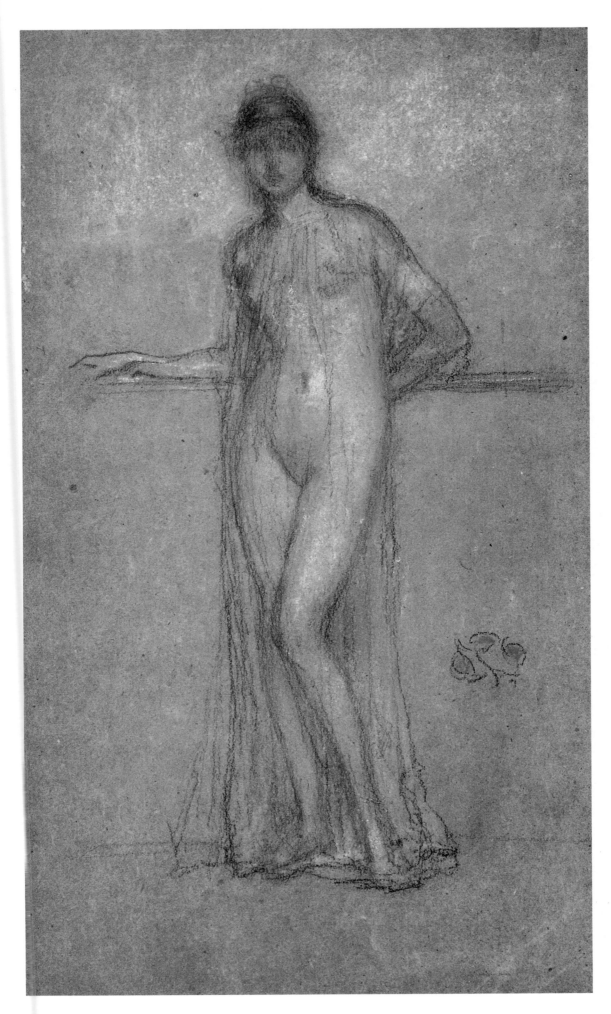

Blue and Violet

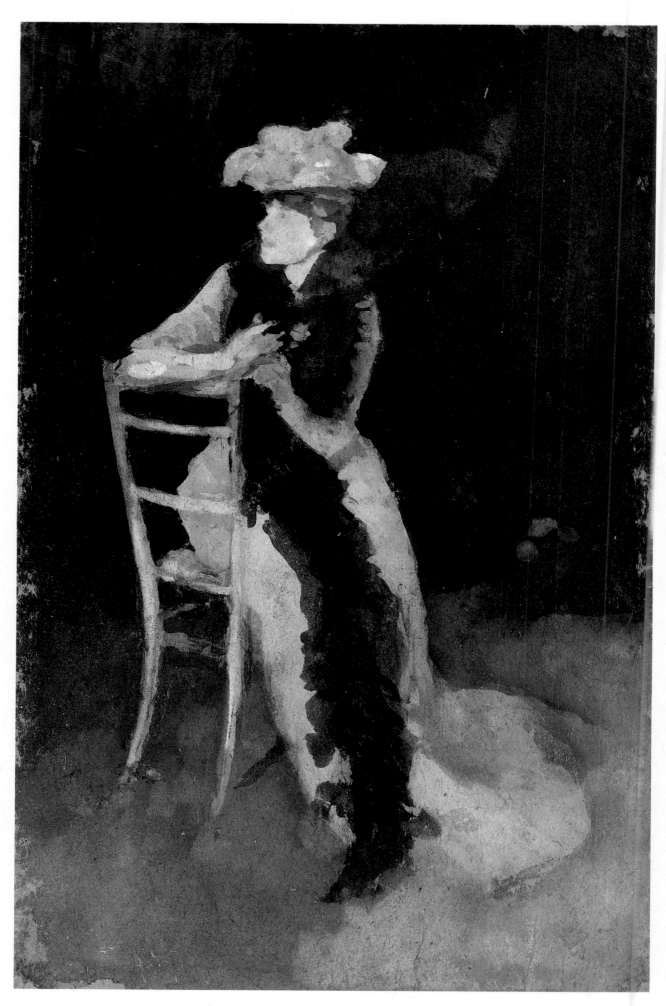

Rose and Silver: Portrait of Mrs. Whibley

V. Triumphs and Tragedy

IN 1888, Whistler married. He had said, "I don't marry, but I tolerate those who do." Thus, his abandonment of bachelorhood seems extraordinary. His wife was Beatrice Godwin, widow of the architect and close friend who designed the White House. She was a large, dark-complexioned woman who dwarfed Whistler. He believed she had Gypsy blood (which may be true), but she was the daughter of a sculptor, John Birnie Philip, who had worked on the lamentable Prince Albert Memorial. She had studied in Paris and, in England, considered herself a Whistler pupil.

Somewhat estranged from her husband, who had had numerous affairs, she had, for years, spent a great deal of time with Whistler. The two arranged a bizarre funeral for Godwin. Whistler, his wife-to-be, and Lady Archibald Campbell loaded his casket onto an open farm wagon and drove it into the country, where the dead man wished to be buried. In a jolly mood, they ate lunch off the coffin (which provided an ideal table).

Whistler's marriage presented a difficulty. Though he was seeing less and less of Maud, she still called herself (though without a marriage certificate) Mrs. Whistler; he, on the other hand, never acknowledged this designation. They had been together for fourteen years, she had borne him one daughter, possibly a second, and she was not going to be thrust aside unceremoniously. She made life as difficult as possible for Whistler. Hard up, she returned to her profession of modeling and in doing so made one mistake: she agreed to pose in the nude for William Stott, a minor artist and a friend of Whistler's. When Whistler saw Stott's *Venus* exhibited at the Society of British Artists, he was outraged and may have found this a good excuse to get rid of her. He gradually abandoned "Mrs. Whistler" and his home in the Vale and lived in his studio in Tite Street. Trixie (as he called Beatrice Godwin) was in and out of his house constantly, to Maud's annoyance. Once, a quarrel between the two women erupted with such violence that Whistler ordered them both out of the house and told them to settle their affair in the street. Maud was so angry that she burst a blood vessel, and Whistler, much to his annoyance, had to run for the doctor. She was never permitted to return, and their relationship ended.

Perhaps Whistler would never have married Trixie if it had not been for a decisive dinner. After a good deal of wine, Henry Labouchere, one of the small party dining together at the Welcome Club in Earl's Court, said to Whistler, "Jimmy, will you marry Mrs. Godwin?"

Rose and Silver: Portrait of Mrs. Whibley

Early 1890s. Watercolor on paper, 11⅛ × 7⅜"
Courtesy the Freer Gallery of Art,
Smithsonian Institution, Washington, D.C.

A delicate portrait of one of the sisters of Whistler's wife. Until she married Charles Whibley in 1894, she served Whistler as secretary and model. Turned in her chair, she shows her pert good looks. Beautifully rendered are her chic dress and stylish black boa.

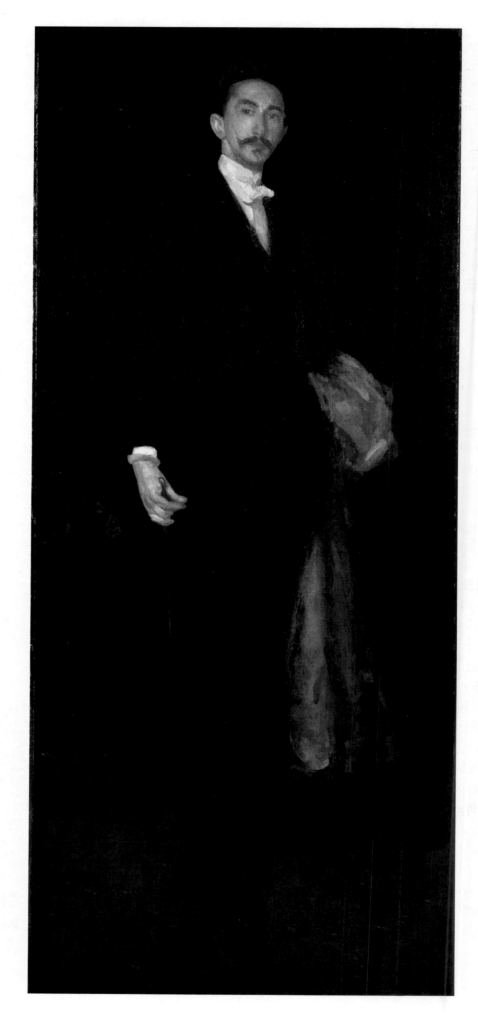

*Arrangement in Black and Gold:
Comte Robert de Montesquiou-
Fezensac*

1891–92. Oil on canvas, 82⅛ × 36⅛"
Frick Collection, New York City

*Logan Pearsall Smith, who volunteered to
pose in place of Montesquiou, has written,
"Whistler did not have the slightest pity for
his subjects; art was something sacred, and
the sufferings of those in its service were a
matter of complete indifference to him. If,
when he had finished his portraits of his
sitters, they should all perish what could
that have mattered to the world? . . . But to
die to make immortal the fur coat of a
stranger seemed to me a somewhat exces-
sive sacrifice." Pearsall Smith hoped his
writings would make him immortal. But
his immortality probably depends more on
the fur coat of a stranger in which he posed
for Whistler.*

"Certainly," said Whistler.

"Mrs. Godwin, will you marry Jimmy?"

"Certainly."

"When?"

"Oh, some day."

"That won't do," Labouchere insisted. "We must have a date."

"I wish," said Mrs. Louise Jopling, who was going to Rome (and who wrote about this most unusual proposal in her *Memoirs*), "that you would marry before I leave town."

"When is that?" Whistler asked.

"On Saturday."

"But this is already Tuesday!"

"That is easily managed," added a solicitor, who was another guest. "You have only to come to Lincoln's Inn Fields and get a special license, and there you are."

It was agreed that Labouchere should choose the date, the church, and the minister, and that he should give away the bride. The day before the wedding, Labouchere says he ran into Trixie at a chemist's shop. " 'Don't forget tomorrow,' I said.

" 'No,' she replied. 'I am just going to buy my trousseau.'

" 'A little late for that, is it not?' I asked.

" 'No,' she replied. 'For I am only going to buy a new toothbrush and a new sponge, as one ought to have new ones when one marries.' "

The wedding took place at Saint Mary Abbott's, Kensington. Whistler was deeply in love, probably for the first time. Trixie changed him. He went infrequently into society, traveled more, and painted less. He consulted her in his difficulties, and she shared in his triumphs. She also patched up his quarrels. "If I died before Jimmy," she said, "he would not have a friend left in the world." She did die first, having always been delicate, and Whistler continued to have friends.

A plethora of commissions came to him, but because of his wife's illness, which necessitated travel to consult various doctors, he had less opportunity to carry them out. He once said to the Pennells: "Now they want these things; why didn't they want them twenty years ago, when I wanted to do them and could have done them? And they were just as good twenty years ago as they are now!"

For years, Whistler's letters to the papers gave British journalism a tang, and readers eagerly awaited them. But newspapers are ephemeral, and Whistler wanted what he wrote to have a longer life. Sheridan Ford, an American journalist resident in London, told the master (or claimed to have told him) that he wanted to collect and edit the letters for a publication of his own. He proposed to call the resulting book *The Gentle Art of Making Enemies*. Whistler concurred and the work went on for some time. One day, to Ford's amazement, he received a note from Whistler telling him to desist (though the book was almost completed) and enclosing ten pounds to cover the work to date. Ford returned the money and continued his editing. Whistler, however, discovered the printer who was about to issue the book, threatened to proceed against him if he did not destroy the sheets, and himself seized the first sewn-up copy.

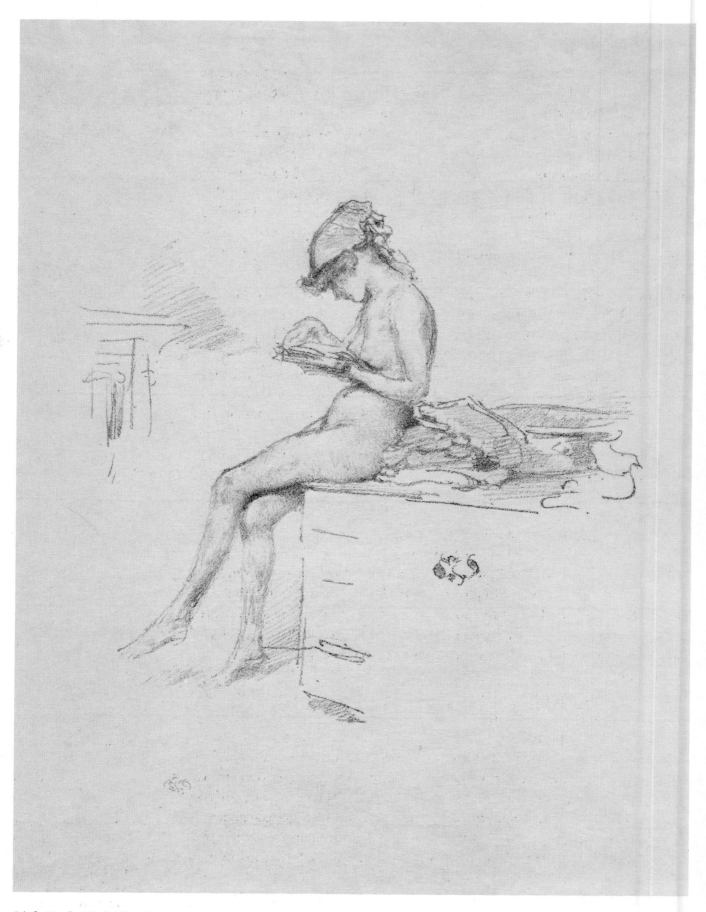

Little Nude Model Reading

This was a terrible blow to Ford, who had foreseen in the successful production of the book the beginning of a happy and profitable career in letters. Persisting in his belief that Whistler had given him permission to publish, Ford found another publisher in England, and, once more, the book was set up and ready to be distributed in the United Kingdom and America. Whistler's lawyers were preparing to get an injunction against its sale when the publisher told Ford that without Whistler's written permission it would be impossible to go ahead. Ford then went to Antwerp, and this time the book was actually printed and boxed, ready to be delivered to vans waiting at the door, when the procureur du roi seized the two thousand copies. The matter came before the Belgian courts, which gave judgment in favor of Whistler. Ford was fined, the two thousand copies confiscated, and costs leveled against the unfortunate editor. This is the last we hear of Ford.

The Gentle Art of Making Enemies was finally published by Heinemann. Whistler chose the type, arranged the paragraphs, designed the title page, and throughout the book strewed butterflies in various postures expressive of his emotions. Profitable as the book was—it had been reprinted twelve times up to 1953—few publishers ever had to spend so much time with an author. Heinemann had to drop everything else. The publication took place in England and America. Some readers found it a jest; others took it seriously. Whistler himself thought, with his book, he had joined the ranks of other great artist-writers: Cellini, Leonardo, and Reynolds. It is an artistic autobiography, a manifesto of his beliefs, a witty defense against the aspersions of criticism, which must have wounded him.

Prose is an art little valued at present, but in the 1890s there were a number of able prose writers, and among the best of these was Whistler. His choice of words, his sentences so carefully constructed, his paragraphs so discerningly arranged, prove him a master of English style. As Max Beerbohm said, "His meaning was ever ferocious but his method was delicate and tender. His style never falters. The silhouette of no sentence is ever blurred." *The Gentle Art of Making Enemies* is a minor masterpiece by one of the ablest prose writers of his day.

In 1891, success arrived. The *Carlyle* was purchased for Glasgow and the *Mother* for the Luxembourg Museum in Paris. In Glasgow, a petition was presented to the Glasgow Corporation, with a long list of distinguished names, asking that funds be appropriated to buy the portrait of their immortal historian. A deputation arrived in Chelsea to negotiate the deal. After some skillful fencing by Whistler, he got the reluctant committee to agree to his price, 1,000 guineas.

The *Mother* was sent to a dealer in Paris, and subscriptions for the purchase were opened. Before any significant amount was raised, Georges Clemenceau, on the advice of Roger-Marx, bought it, on behalf of the French government, for the Luxembourg Museum. The price offered was only 4,000 francs, less than Whistler had in mind, but he accepted it. He was proud of having his portrait chosen for the museum by the Minister of Beaux-Arts. As an added distinction, he was also made an Officer of the Legion of Honor, an award he valued more highly than any other he had received.

Little Nude Model Reading

Undated. Lithograph, 6⅝ × 7″
Courtesy the Museum of Fine Arts, Boston
Gift of Francis Bullard

About 1900 Whistler found a woman he considered the perfect model. Even when she was not posing, he kept sketching her from memory, and he was in despair when she married and left England. But before she went away he had immortalized her slender figure in many nudes in lithograph and pastel.

The Pantheon, from the Terrace of the Luxembourg Gardens

1893. Lithograph, 7⅛ × 6⅜″
Courtesy the Freer Gallery of Art,
Smithsonian Institution, Washington, D.C.

Whistler had a studio on the sixth floor of a building in the Rue Notre-Dame-des-Champs. To get up the stairs was a severe strain on his heart, but when he arrived he had a spectacular view over the Luxembourg Gardens to the Pantheon in the distance.

In the winter of 1892, the dealer David Croal Thomson arranged with Whistler for a retrospective exhibition to be held at the Goupil Gallery. The show was an unexpected success. One reason was Whistler's effort to vary the pictures shown. He wished to refute every criticism made in the past. His pictures had been dismissed as sketches—to which his response was *The Blue Wave, Old Battersea Bridge*, and *The Music Room*, which had not been seen in London since the early sixties. His pictures were said to lack finish and to be slovenly in detail—refutations were the Japanese pictures, as full of elaboration and detail as the works of the Pre-Raphaelites. Critics asserted he could not draw—but anyone could see how well drawn were his portraits. He was told he had no poetic feeling, no imagination—and there were his Nocturnes as evidence to the contrary, with factories and chimneys transformed by mist and darkness into the architecture of fairyland.

According to Croal Thomson: "Whistler labored night and day. He wrote letters to every one of the owners of his works in oil." Most of them lent, and forty-three pictures were gathered, the most complete collection of his best work shown till then.

Whistler did not attend the private view. Late in the afternoon, he and his wife entered a curtained-off portion of the gallery, where they received a few of their intimate friends. Everyone knew, however, that Whistler had been triumphant. The critics finally recognized that their ridicule had been silly, and most of them lavished praise without reserve.

Whistler declared that even Academicians had been seen prowling about the place lost in admiration. A season ticket was sent to Ruskin. Whistler said, "They were always pearls I cast before them, and the people were always—well, the same people." Whistler printed a catalogue with comments from the press when the pictures were first shown—a perfect revenge. The catalogue was reprinted five times.

As a result, Whistler was inundated with commissions. The duke of Marlborough wanted his portrait painted and asked the Whistlers to Blenheim for the autumn. Whistler wrote the duke one of his "charming" letters, then heard of his sudden death. "Now I shall never know whether my letter killed him, or whether he died before he got it," Whistler said. And, in his words, "Americans wished to pour California into [my] lap," to which he had no objection. He said his "pockets should always be full, or my golden eggs are addled." He thought it would be delightful to be rich.

And he became surprisingly well off. Of this we have proof. When he returned to England after his student days in Paris, he opened an account with Drummonds Bank. During his troubled financial times, his account was probably often overdrawn, but it remained, and letters in the files at Drummonds indicate that he was an able investor—when he had money to invest. In 1899, he was feeling prosperous and wrote his bank from Paris to buy him two hundred Northern Pacific Railway shares. Drummonds misinterpreted his somewhat ambiguous order and instead purchased two hundred pounds' worth of the shares. On learning this, he was furious and threatened to close his account, asking, "Why should I anyhow have nearly £4,000 idle with you?"

*Arrangement in Flesh Color and
Brown: Portrait of Arthur J. Eddy*

*The sitter was a Chicago lawyer whose col-
lection of Cubist and other abstract art
helped make Chicago a leader in the ap-
preciation of modern painting. Whistler,
with unusual rapidity, finished his por-
trait in six weeks—all the time his sitter
would allow him—but subsequently he al-
tered it slightly.*

According to a history of Drummonds published by Allen and Unwin, he added astute comments proving that he cared realistically for the money he earned. Drummonds, in spite of the ambiguity of his letter, credited his account with the profit he should have made from two hundred shares, for the stock had risen spectacularly. Whistler then wrote a note in his idiomatic prose to George Drummond, the chairman, on May 1, 1899—a letter such as few bankers have ever received:

Dear Mr. Drummond,—I am appalled at my extraordinary achievement, and can only feel envy and admiration for the graceful attitude of you gentlemen who so perfectly put me in the wrong by yourselves immediately insisting upon not being in the right! On n'est pas plus grands seigneurs.

I beg that you will convey my apologies to your Partners—I doubt they will have perceived the borrowed wisdom and bewildered calculations—and pray accept, with them, my high sense of all your courtesies, and my thanks for your kind expressions of sympathy during my recent illness.—Very faithfully yours, J. McNeill Whistler.

Soon after this, Whistler sent the partners an etching, with an amiable inscription, which now hangs on a wall in the bank.

He once said to a friend: "It is better to live on bread and cheese and paint beautiful things than to live like Dives and paint pot-boilers. But a painter should not have to worry.... Poverty may induce industry, but it does not produce the fine flower of painting. The test is not poverty; it's money. Give a painter money and see what he'll do; if he does not paint, his work is well lost to the world. If I had had, say, £3,000 a year, what beautiful things I should have done."

Croal Thomson, the impresario of the successful Whistler exhibition of 1892, pointed out that over half the paintings were sold within a year. Whistler concluded that there was hardly an owner of his pictures in England who would not sell if a large price was offered. These collectors thought that to receive four times what they had paid represented an impressive profit. They felt the enthusiasm for Whistler was ephemeral. They were wrong; today their pictures would be worth a hundred times the purchase price.

In the summer of 1892, Whistler was asked by the duke of Argyll to send the *Carlyle* to the British section of the World's Columbian Exhibition being held in Chicago. The portrait had been skied, hung close to the ceiling, some years before at the New Gallery in London, of which J. W. Beck was secretary. As he was now the executive officer of the British Fine Arts Committee for Chicago, Whistler wrote him, sending his distinguished consideration to the duke and the president; then he concluded: "No, no, Mr. Beck! Once hung, twice shy."

It is revealing that not only was Whistler never asked to become a Royal Academician but he was never asked to exhibit. A letter was sent to him addressed only: "The Academy, England." It finally reached him, with "Not known at the Academy" written on the envelope. Whistler was delighted. He said that "such incidents were among the droll things of this pleasant life." He had the envelope reproduced in the *Daily Mail* with the remark: "It is my good fortune to be able to send you an unsolicited and final certificate of character."

The Garden

1891. Lithograph, 6¾ × 7⅜"
Courtesy the Freer Gallery of Art,
Smithsonian Institution, Washington, D.C.

Whistler was gregarious, and he and his wife entertained charmingly in their garden in the Rue du Bac. The elegance that lends such distinction to his portraits emanates even from a print showing a simple afternoon tea.

At the Chicago fair, the director of the American section made up for the British ineptitude by showing three of Whistler's best pictures and etchings of every period. He was also awarded a medal—the first honor from his own country. Then the Boston Library asked him to do a mural at the head of the stairs, which were being decorated by Sargent. Whistler made notes for the design, which was

Unfinished Sketch of Lady Haden

Stéphane Mallarmé

Stéphane Mallarmé

1894. Lithograph, 3⅞ × 2¾″
Courtesy the Freer Gallery of Art,
Smithsonian Institution, Washington, D.C.

*The poet, who translated the "Ten
O'Clock" Lecture into French, was Whis-
tler's dearest friend, one of the few with
whom he never quarreled. The lithograph
was done for a new edition of Mallarmé's
poems.*

Unfinished Sketch of Lady Haden

1895. Lithograph, 15 × 10¼″
The Metropolitan Museum of Art, New York City
Harris Brisbane Dick Fund, 1917

*Whistler was devoted to his half sister,
Lady Haden. Her husband, a doctor and
competent etcher, got on his nerves. Final-
ly in Paris after a quarrel, Whistler
pushed his brother-in-law through a plate-
glass window, and they never spoke again.*

to be a large peacock, but the project was put off and his first opportunity for mu-
ral work since the Peacock Room was never realized.

In 1892, the Whistlers went to live in Paris. The atmosphere there was dif-
ferent from London. In the salon of his friend the poet Stéphane Mallarmé,
there was a firm belief in the value of art as an absolute necessity, which was lack-
ing in England. This enhanced Whistler's self-confidence. Moreover, his pic-
tures were a great success in the Salon that year. He was elected a Sociétaire and a
member of the jury.

After staying for a time in hotels, he took a charming apartment in the Rue
du Bac. It was a dwelling he particularly enjoyed, with a large garden that was a

bit of country in the middle of Paris. His studio was elsewhere—up six flights of steps at the top of one of the highest buildings in the Rue Notre-Dame-des-Champs. It was the largest place in which to paint that Whistler had ever had. He decorated it in tones of rose. There were a few chairs, a cabinet for prints and drawings, his blue screen with a gold moon reflected in the river and the Chelsea church in the distance, some easels, a printing press, and the precious old paper for his etchings. The great studio window overlooked all of Paris toward the Pantheon and the Luxembourg Gardens.

It was remarkable how little stir Whistler made in Paris. He remained an Officer of the Legion of Honor while a rich American, an amateur, was made a Commander. He was not offered membership in the Academy of Fine Arts, the highest honor for French artists. These slights caused his wife to develop violent Francophobia, but she was wrong if she thought her husband had no friends in Paris. A few artists were much more than acquaintances—Monet, Helleu, Puvis de Chavannes, Rodin, Alfred Stevens, Aman-Jean, and Boldini. Whistler, however, spent more time with writers than with artists, and the person who understood him and his work best was Mallarmé, the translator of "Ten O'Clock." Their affectionate and sympathetic friendship remained unbroken throughout their lives.

Mallarmé was one of the leaders of the Symbolist writers. This circle of young, avant-garde intellectuals admired Whistler's paintings, which they felt were the visual equivalents of their poetry. They preferred twilight to the crudity of midday. So did Whistler. They had fastidious taste but lacked robustness, as did the painter. They were drawn to mystery, to dreamlike figures, to the intangible. Whistler's Nocturnes expressed their vision of the world about them. If a school of literature can be said to have a color, theirs was a misty gray-blue—the tone of Whistler's night scenes. They compared his pictures to the music of Wagner, a composer who was a hero to the group. Whistler and Wagner, they felt, were in harmony with the spirit of the time.

Whistler's wife may have been Francophobic, but he adored Paris. He wrote to Sidney Starr, who published his recollections of the artist:

Our address, as you see, Paris—and I must say I am delighted with the place. The dreariness and dullness of London was at last too depressing for anything—and after the exhibition there was nothing to stay for. Indeed, the exhibition [in Bond Street] itself summed up the situation most beautifully, a complete triumph crowning all my past victories. No further fighting necessary. I could at last come out to this land of light and joy where honors are heaped upon me [insufficiently, his wife thought], and Peace threatens to take up her abode in the garden of our pretty pavilion. However, I do not promise that I shall not, from time to time, run over to London, in order that too great a sense of security may not come upon the people.

Whistler's conceit and arrogance were an important part of his personality. Together, they kept his head up during his bankruptcy, when he was being attacked on every side.

His new success was being recognized in Paris, if not officially, at least by po-

The Arabian

c. 1892. Pastel on brown paper laid down on card,
7⅛ × 11"
Hunterian Art Gallery, University of Glasgow
Birnie Philip Gift

Hettie Pettigrew, a favorite model, posed for this pastel. The seductiveness of her young body is irresistibly conveyed by Whistler, one of the most sensuous of artists.

The Arabian

The Fortune Teller

tential patrons. As he wrote Mallarmé (for whose new edition of poems he did a lithographic portrait), Count Robert de Montesquiou had come to see him. "I work every day until nighttime on his portrait. Count Robert has said that he wanted a portrait of himself to lend to the Exposition Universelle." As usual, Whistler needed many sittings. Eventually the portrait, at Montesquiou's suggestion, was brought to Paris. (It had been begun in London.) At last, it was finished, and Whistler wrote his wife that Montesquiou was "enchanted and childlike in his joy. . . . Certainly in the flattering light of the evening our Montesquiou *poète et grand seigneur* did look stupendous." Whistler, convinced he had painted a masterpiece, hoped Montesquiou would leave the portrait to the Louvre. Instead, he sold it, and it is now in the Frick Collection in New York. Whistler wrote him a bitter letter: "Bravo, Montesquiou! The portrait which you acquired as a poet for a song is resold for ten times that song. Congratulations!"

To finish the portrait had been an ordeal. Sittings had to be arranged between Montesquiou's social engagements, and the painting dragged on. Finally, a model posed in place of the count, and progress was more rapid. Much of the portrait was done late in the afternoon. Whistler liked to paint in the twilight. He said: "As light fades and the shadows deepen, all petty and exacting details vanish, everything trivial disappears, and I see things as they are in great strong masses: the buttons are lost, but the sitter remains; the sitter is lost, but the shadow remains; the shadow is lost, but the picture remains. And that, night cannot efface from the painter's imagination." Walter Gay, a fellow expatriate painter, has also written about Whistler at work: "No one can realize, who has not watched Whistler paint, the agony his work gave him . . . I have known him work two weeks on a hand, and then give it up discouraged."

Whistler was seemingly settled in life. He had an adoring wife, an enchanting apartment, and a splendid studio. It was time, he felt, to make up for the unsettled years after his marriage. He painted a number of full-length portraits. Arthur J. Eddy of Chicago insisted that his portrait be done in the few days he was to be in Paris—and it was, though worked on subsequently. Whistler said, "Well, you know, who ever got a picture out of me on time, while I worked and he waited?" Eddy must have been a determined man.

J. J. Cowan posed sixty times for a small full-length portrait, each sitting averaging three or four hours. Like many of Whistler's sitters, he finally got tired, and a model had to take his place. The last sittings were in London, three years after the portrait had been begun, and even then, according to the Pennells, "Whistler wrote Mr. Cowan the head needed just one touch, with the sitter there, so that perfection might be assured." Perfection was never attained!

Portraits of women painted at this time were more numerous. Many were rubbed out or can no longer be located. Some artists, such as Giorgione and Vermeer, seem to have painted relatively few pictures, but it is difficult to think of an artist who painted as many canvases as Whistler and destroyed so large a number. The catalogues raisonnés of his paintings and etchings reveal a lamentable number of items rubbed out, cut up, torn up, or lost. The percentage of his vanished work as compared to what has been preserved is appalling.

Studies of Loïe Fuller Dancing

c. 1893–94. Pencil and blue-black ink drawing on white paper, 8¼ × 12⅝"
Hunterian Art Gallery, University of Glasgow
Birnie Philip Bequest

Whistler learned the beauty of calligraphy from his study of Eastern art. In this drawing he has used his knowledge to convey pure movement, to depict the twisting form and flowing draperies of a superb dancer.

The Fortune Teller

c. 1892. Pastel, 10⅞ × 7¼"
Hunterian Art Gallery, University of Glasgow
Birnie Philip Gift

This is another of Whistler's nude drawings of Hettie Pettigrew. Whistler was probably referring to this pastel when he said, "I think it very pretty—and I wouldn't mind having it if I could afford it." It was in his estate, so presumably he found he could.

Whistler entrusted the results of his increased productivity to dealers to sell, as he had in the past, but he began to object to their profits. With his ever-increasing fame, he decided to be his own dealer. He used to say to his various agents, "I will lay the golden eggs; you will supply the incubator." But they remonstrated that when the incubator was waiting, he would not give up the golden eggs. To prevent dealers from making large profits selling his work, he decided to form his own corporation, which he called the Company of the Butterfly. Gallery space was rented, but customers did not come, and the scheme was abandoned.

Whistler hoped his shop would keep clients from disturbing him in his studio. One American collector, after wasting the artist's time looking around the room, asked, "How much for the whole lot?"

"Five million," Whistler replied.

"What!"

"My posthumous price!"

Today his estimate would be a bargain.

There can be no doubt that Whistler was industrious. He was therefore furious when his friend of earlier years, George Du Maurier, published a novel, *Trilby*, in which two of the characters, in appearance and personality, closely resembled Poynter, the Academician, and Whistler. The virtues of Lorimer (Poynter), the industrious apprentice, are contrasted with the vices of Sibley (Whistler), the idle apprentice. Sibley was said to be always in debt and eccentric in dress. There were illustrations drawn by the author that left no doubt as to the real identities of the two characters. In a vituperative letter to the Beefsteak Club, Whistler stated that he and Du Maurier could not both remain members. His threatened resignation was somewhat inappropriate as Du Maurier had resigned sometime before. The novelist, who had not meant to trouble his old schoolmates, withdrew the offending paragraphs and changed the name and appearance of Sibley to pacify Whistler.

At about this time came his altercation with Sir William Eden over the price of a portrait of his wife. After originally offering to do a watercolor or pastel sketch of Lady Eden for £100 or £150, he became fascinated by her beauty and, instead, painted a small full-length portrait—for which, of course, he would have charged much more. On Valentine's Day, 1894, Eden attempted to foist off an envelope containing a check for £100, saying it was a Valentine. Whistler, furious, cashed the check but refused to deliver the picture. Sir William sued, and the case was heard before the Civil Tribunal in Paris. The court ruled in Sir William's favor, but Whistler then appealed to the Cour de Cassation.

On November 17, 1897, this court handed down a decision in Whistler's favor. He thought he had not only been vindicated but had made history by establishing a precedent proving that an artist has the right to his own work. He felt that he had added to the Code Napoleon and would go down in history with the emperor. He prepared a book entitled *The Baronet and the Butterfly*. Published in Paris in 1899, it was a flop. Unlike the Ruskin trial (which appeared in *The Gentle Art of Making Enemies*), there was too little of Whistler and too much of the judges.

Meanwhile, tragedy struck him at home. His wife developed cancer, which

The Little Rose of Lyme Regis

1895. Oil on canvas, 20¼ × 12¼"
Courtesy the Museum of Fine Arts, Boston William Wilkins Warren Fund

According to Pennell, Whistler felt that this was one of the pictures in which "he had really solved the problem of carrying on his work as he wished to until it was finished." The scarcity of alterations in the portrait bears out the statement. The painting is a jewel of observation and faultless brushwork.

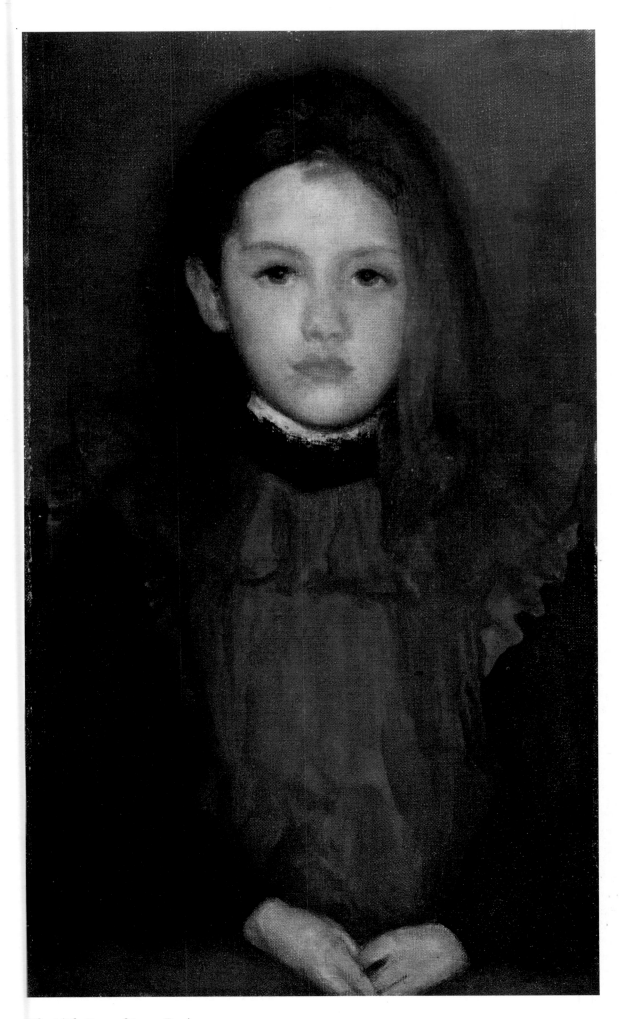

The Little Rose of Lyme Regis

The Siesta

1896. Lithograph, 5⅜ × 8¼"
The New York Public Library
Astor, Lenox and Tilden Foundations

Whistler's wife was desperately ill with cancer. Here her book is pushed aside; her arm is hanging limply; she has fallen back on her pillows. Her husband never left her bedside, holding her hand and often falling asleep on his lithographic stone.

The Master Smith of Lyme Regis

1895. Oil on canvas, 20¼ × 12¼"
Courtesy the Museum of Fine Arts, Boston William Wilkins Warren Fund

Whistler was reluctant to part with this painting. He wrote to E. G. Kennedy, his dealer: "Keeping Smith a bit to see if further precious touches—probably between 600 & 800 guineas." Kennedy had no difficulty in selling the painting at Whistler's price. Though on a minor scale, it is a work of sheer perfection.

was diagnosed by his brother, Dr. Willie. Whistler could not accept the idea of an incurable disease. There was talk of going to America to consult a specialist, but it seemed too far away, especially crossing the Atlantic in midwinter. Instead, they stayed in London in several hotels and then a flat in Half-Moon Street. Their time was largely spent consulting doctors. They finally ended up at the Savoy in an apartment overlooking the Thames.

For a time, thinking the sea air might be beneficial, they stayed in Lyme Regis. But Trixie was no better. She returned to London, where her sisters could look after her. Whistler, she insisted, should remain in Lyme Regis and work without having her on his hands. He wrote her, almost daily, letters filled with uncertainty about his work. It seemed a futile struggle, he said. Inspiration would not come. Trixie replied with letters of encouragement and optimism.

She wrote him about the Greaves brothers, whose work as artists instead of boatmen he had encouraged. They were painting murals in Streatham. Sick as she was, she dragged herself to Streatham Town Hall to see what the aging pupils of Whistler were doing to earn a living. She was shocked. She wrote her husband:

You have no idea how dreadful it all is! You enter at the side into a narrow stone passage, as dark and damp as possible. I think it was painted grey with a dado and pictures above in panels . . . there is no attempt at anything original. They have remembered anything and everything you ever did, even to the Japanese panels in your drawing room, your brown paper sketches, the balcony, Battersea Bridge . . . another room with an imitation of The Fire Wheel, Chelsea in Ice. *There! I can't go on—it was like a sort of hideous Whistlerian chaos, I felt quite mad and sick—I laughed out loud at last. I couldn't help it, and turned round and found the man who showed us around was laughing too. It's frantic. My God, I could kill them—conceited, ignorant, miserable gutter-born wretches. . . . Don't, don't, my own*

The Master Smith of Lyme Regis

dear, darling love, draw any attention to them—besides the place will be rotten in ten years, it is running with damp and beginning to peel off. They have been at it for four years!!!!... My darling, don't write to the papers. You must go and see yourself. I cannot give you any idea.

Whistler answered: "As to the work in the Hall itself—it may not be all that good. It may be absolutely wild and uncultivated as decoration—the work of peasants perhaps, but take my word for it, there must be some stuff in all that. *To have done it*... what others have done anything? Besides, they were very intelligent and nice boys... I feel kindly about them after all—Chinkie dear!" He wrote a tactful letter to the Greaves brothers and did nothing to cancel the project. That was done speedily by damp.

In Lyme Regis, Whistler pressed on with his work. He found a girl of ten with auburn hair and persuaded her family to let her pose for him. This resulted in *The Little Rose of Lyme Regis*, one of his best late works. He also painted a small portrait of about the same size, *The Master Smith of Lyme Regis*. The subject was Samuel Govier, a blacksmith, who came for his sittings directly from the forge. Both pictures were sold to the Museum of Fine Arts in Boston. He told Trixie that "all is simple and clear where once was vexation and doubt." He had found models who inspired him. All he need do was concentrate on painting them just as they appeared; and this he now found himself able to do without the complications caused by many others who had posed for him.

He returned to London, where seventy of his lithographs were shown at the Fine Arts Society. He was too busy looking after Trixie to decorate the gallery as he had in the past, but now he was acclaimed by the critics, even those who had earlier written of him disparagingly.

Of Whistler's prints exhibited at the Fine Arts Society, *The Balcony* and *The Siesta* showed the wan and wasted Trixie asleep on a daybed or sinking back against the pillows, a book abandoned beside her. Whistler made only thirty-one proofs, and none were for sale. He was always at her bedside, sometimes so exhausted he fell asleep on the lithographic stone.

There was never any hope, although Whistler and Trixie pretended to each other that there was. A friend remembered "the misery and pathos of his sitting beside his wife's sofa, holding her hand, while she bravely tried to cheer him with banter and gossip." He confessed to a former sitter, J. J. Cowan, that Trixie's illness had made his life "one long anxiety and terror." He was unable to speak in the first person singular about his endless pilgrimage to find some lingering health for Trixie. "And so have wandered from home and work—going from town to country, and from doctor to doctor. Living in hotels, and leaving behind the beautiful place you know so well in Paris—and the studio in which we both passed so many hours! All sense of time and ambition was lost—we were ill and the sun had gone out of the sky." Yet they still believed the impossible. "At last there is hope that all will be well."

Whistler rented a cottage on Hampstead Heath. He wrote Walter Sickert, "We are very, very bad." On May 10, 1896, a friend, Sydney Pawling, saw him running across the Heath, disheveled and mad-looking. Alarmed, Pawling tried

Lillie: An Oval

After 1896. Oil on canvas, oval, 23¾ × 19¼"
Hunterian Art Gallery, University of Glasgow
Birnie Philip Bequest

On the way to his studio, Whistler would ride through some of the poorer streets with his eye out for possible models. In this way he found Lillie Pamington, who had the red hair he loved. She posed for several of his late paintings.

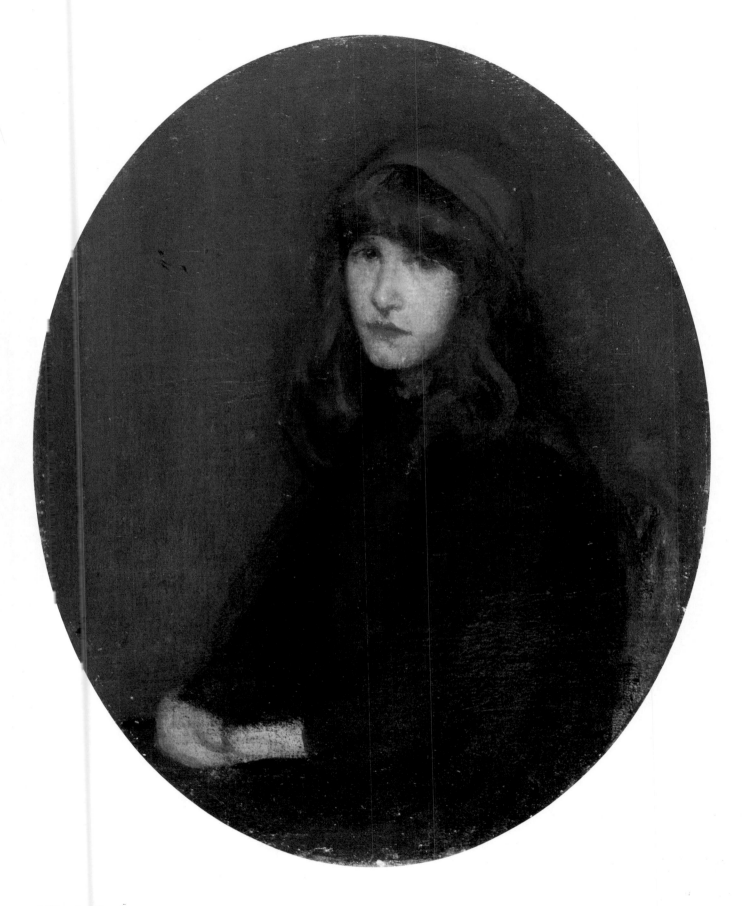

Lillie: An Oval

to help him, but he cried out: "Don't speak! Don't speak! It is terrible!" and he ran on. Trixie had died.

She was buried at Chiswick Cemetery. The day after her death, Whistler went, as usual, to his studio, then remembered that nothing would ever be the same and, in a daze, wandered around London with a friend until both were worn out. The Sunday afternoon after the funeral, he took Trixie's sister to the National Gallery to look at the pictures his wife had loved. They spent a long time gazing at Tintoretto's *Milky Way*, a painting that was her favorite. Neither spoke, and then, in silence, they left.

Whistler had no heirs except his illegitimate son and daughter, whom he did not want to receive his estate. He decided to make his wife's youngest sister, Rosalind Birnie Philip, his ward, and he drew up a new will making her his executrix. Eventually, he canceled all his bequests and made her his sole beneficiary. It seems curious that he never showed any attachment to his own flesh and blood, even though born out of wedlock.

Nearly a year after Trixie's death, he wrote to Charles Lang Freer, a close friend and founder of the Freer Gallery in Washington. He spoke of his "forlorn destitution" and beautifully described a scene he could not forget:

She loved the wonderful bird you sent her with such happy care from a distant land! And when she went—alone, because I was unfit to go too—the strange dainty creature stood uplifted on the topmost perch and sang and sang—as if it had never sung before! . . . Peal after peal until it became a marvel [that] the tiny breast, torn by such a glorious voice, should live!

And suddenly it was made known to me that in this mysterious magpie from beyond the temples of India the spirit of my beautiful lady had lingered on its way—and the song was her song of love, and courage, and command that the work, in which she had taken part, should be complete—and so was her farewell.

I have kept her house in Paris—in its fondness and rare beauty as she made it—and from time to time, I will go to miss her.

The Jade Necklace

1896–1900. Oil on canvas, 20⅛ × 12½"
Hunterian Art Gallery, University of Glasgow
Birnie Philip Gift

This is a portrait of Rosalind Birnie Philip, a sister of Beatrice, Whistler's wife. She was twenty-two when Beatrice died, and the painter made her his ward and executrix, bequeathing to her his estate and unsold paintings and prints, which she gave to the Hunterian Art Gallery, a part of the University of Glasgow. Until Whistler's death, she kept house for him. He nicknamed her "Major," an echo of his days at West Point.

The Jade Necklace

The Little Red Glove

VI. Old Friends, New Subjects

To alleviate his sorrow over Trixie's death, Whistler opened the apartment on the Rue du Bac and persuaded his two sisters-in-law, Rosalind Birnie Philip and Mrs. Charles Whibley, to look after it for him. In London, he went to live with William Heinemann. Although much younger, the publisher was good for him. His flat in Whitehall Court was filled with celebrities, gossip flowed, good food and drink abounded, and the walls were covered with Whistlers.

In Paris, he had chosen his apartment and studio badly. The Rue du Bac was low and damp, and to climb six flights of stairs to reach his studio was bad for a man with a weak heart. Nevertheless, he worked harder than ever. His portrait of George Vanderbilt—"the modern Philip," he called him—traveled back and forth between Paris and London as artist and sitter commuted between the two cities. He also painted Mrs. Vanderbilt, *Ivory and Gold*, which was shown in the Salon of 1902. It was one of his first oval portraits.

At this time, he also painted many children. It is said Whistler loved children and was thoughtful and considerate of them. According to his follower and pupil Mortimer Menpes, Whistler would take a "grubby child by the hand, and the three of us would trot along to ask the mother if her daughter might sit, the child with upturned face gazing with perfect confidence at Whistler. And the Master would talk to that little gutter-snipe in such a charming and intimate way about his work and inspiration! 'Now we are going to do great things together,' he would say, and the little dirty-faced child blinking up at him seemed almost to understand. For Whistler never failed with children; no one understood them quite like the Master, and no one depicted child life better than he."

If one accepts the truth of Menpes' statement, indicating Whistler's fondness for children, why was he so indifferent to his own son? His moment of "infidelity to Jo" had produced a child, which he certainly did not want. Was this enough to explain his neglect of his own flesh and blood? Or did he cajole urchins to render them better models? Was his apparent sympathy with the young only a contrivance to make them more cooperative? These are puzzling questions for which there will never be definite answers, but, judging by his treatment of his children and of Jo and Maud, one glimpses a streak of cold indifference to other human beings.

The children in his portraits have a disturbing, speculative air. Like Symbolist poetry, they seem sensuous but evasive. One cannot help feeling an overtone

The Little Red Glove

1896–1902. Oil on canvas, 20¼ × 12⅜"
Courtesy the Freer Gallery of Art,
Smithsonian Institution, Washington, D.C.

Enthralled by her adolescent loveliness and the color of her hair, Whistler painted at least ten portraits of this model, Lillie Pamington. At the end of his life he was obsessed by the beauty of young girls.

Portrait of George W. Vanderbilt

1897–1903. Oil on canvas, 82⅛ × 35⅞″
National Gallery of Art, Washington, D.C.
Gift of Edith Stuyvesant Gerry

This is the last full-length portrait Whistler painted. In 1897, he wrote Vanderbilt, "And for once I think I may say as Ingres did when he was confronted with his own portrait of Prince Napoléon, 'Quel beau portrait que vous avez là mon Prince!'" Pennell thought that, although it was once as fine as any portrait Whistler had ever painted, "it had been worked over too often" and was a wreck. Perhaps Pennell is right, but in its present condition it is like the ghost of a great gentleman.

of some erotic response on the part of the artist, especially in his painting of a young girl, *Dorothy Seton—A Daughter of Eve*, his last important work.

Nudes absorbed Whistler as much as children. He had found the perfect model in London, and he was in despair when she married and left England. When she could no longer pose for him, he continued to paint her from memory. These pastels are among his most sensuous works of art. Her flimsy draperies float about her or fall in long straight lines. There are innumerable poses drawn on brown paper, each one more appealing than the last, all drawn in black lines, with only blue, rose, or violet to lend color.

All this work was done with feverish concern about mediums, materials, and methods. Whistler usually sat now as he worked, and he wore spectacles—sometimes two pairs, one over the other. He was never more careful in the preparation of his colors and canvases. At last, knowledge was coming to him, he said again and again. And he was never more successful in achieving the unity and harmony he had always looked for, while concealing the labor by which it was obtained.

Whistler thought there should be international exhibitions of art. He did not care whether they were held in New York, London, Paris, or Berlin. It never occurred to him that the location might be Pittsburgh, Pennsylvania. Yet, beginning in 1896, such an exhibition was held there on a regular basis and still continues. It was due to Whistler's influence on Andrew Carnegie, the founder of the Museum of Art, Carnegie Institute, and on J. W. Beatty, its director, who, in 1896, bought the portrait of Sarasate, one of the first Whistlers acquired by an American institution.

In 1898, Whistler was elected chairman of the International Society of Sculptors, Painters, and Gravers, and that organization sponsored the first international show held in England, which took place at the Prince's Skating Club in Knightsbridge. Whistler did all the work, provided a scheme of decoration, and supervised the hanging. The show was artistically a success but financially a failure. Luckily, the society had no pecuniary responsibility.

To the second exhibition Whistler sent some recently painted sketches, and the critics discussed them as promising works of the past. The *Times* praised "the vanished hand which drew *The Symphony in White* and *Miss Alexander*." Whistler, in turn, quoted from the same paper what had been written when the pictures were first shown: "*Miss Alexander* suggests a sketch left before the colors were dry in a room where the chimney-sweeps were at work" and was "uncompromisingly vulgar." Whistler's only comment was: "Other *Times*, other lines."

In February, 1899, Heinemann was married in Rome, and Whistler went to Italy as his best man. This was his only visit there, apart from trips to Venice. "Rome was awful—a hard sky all the time, a glaring sun and a strong wind." He thought "St. Peter's was fine, with its great yellow walls, the interior too big, perhaps, but you had to go inside to know where Wren got his ideas—how he, well, you know, robbed Peter's to build Paul's."

And Michelangelo? A tremendous fellow, yes; the frescoes in the Sistine Chapel, interesting as pictures, but with all the legs and arms of the figures sprawling everywhere, I could not see the decoration. There can be no decoration without repose.... There is often elegance in the Loggie of Raphael, but the big frescoes of the Stanze did not interest me.

During the winter of 1899–1900, he was in Paris at the Hotel Chatham, where, in the last three years of his life, he stayed to avoid the damp of the Rue du Bac. With fewer friends in Paris than in London, he was often lonely. Duret tried to amuse him and would gather together some of their old student acquaintances for little dinners.

In February, 1900, came news of his brother's death. They had been close since childhood, but Trixie's illness had brought about a quarrel. A French surgeon had recommended that she have exploratory surgery, but Dr. Whistler said it would do no good and only increase Trixie's agony. Whistler was furious and refused to admit her illness was incurable. A violent quarrel erupted between the brothers, and they saw no more of each other. The doctor was desolate, took to drink, and was soon in financial trouble. When he died, however, Whistler was in tears. More than ever, he needed his friends in London.

Purple and Gold: Phryne the Superb!—Builder of Temples

1898–1901. Oil on wood panel, 9¼ × 5⅜"
Courtesy the Freer Gallery of Art,
Smithsonian Institution, Washington, D.C.

Phryne, the mistress of Praxiteles and herself a wealthy prostitute, offered to rebuild Thebes at her own expense after it had been destroyed by Alexander. In 1898, Whistler wrote, "I sit in the studio and almost laugh at the extraordinary progress I am making and the lovely things I am inventing." The painting was admired by the Symbolist poet Francis Vielé-Griffin, and it is possible that he or Mallarmé suggested the title.

Purple and Gold: Phryne the Superb!—Builder of Temples

Portrait of Richard A. Canfield

VII. The Final Years

IN 1898, THE RUMOR that Whistler planned to open a school in Paris caused a sensation among artists. An American sculptor, Frederick MacMonnies, was to assist him, and the Académie Whistler was to be operated by a former model, Carmen Rossi. All this was true. Whistler established the school to give Carmen a livelihood. He allowed her to use his name, but he was sure it would end in disaster, for he hated art schools. The only difference between art schools in France and those in England, he said, was that in France pupils were taught which end of the brush not to put in their mouth. In spite of his distrust of art education, he wished Carmen to keep the Academy going, and he hoped that she might get rich someday—might make it as successful as the Académie Julian and, he trusted, not as bad.

Skeptical as he was about the value of art schools, there were certain principles he taught. One of the first pupils to enroll was Inez Bates (Mrs. Clifford Adams), who wrote an account of Whistler's methods. As soon as he arrived at the studio, he examined the palettes of the students. He pointed out that it was the instrument on which the painter plays his harmonies. He said it must always be as beautiful as the tenderly-cared-for violin of the great musician. On the palette everything must be planned before transferring one brushstroke to the canvas.

He recommended the small oval palette as being easy to hold. In the center of the top edge he placed white. On the left came, successively, yellow ochre, raw sienna, burnt sienna, raw umber, cobalt, and mineral blue; on the right, vermilion, Venetian red, Indian red, and black. One of his palettes may still be seen in the Hunterian Art Gallery in Glasgow.

Many brushes were used. Some were quite long, but Whistler rarely seemed to need a maulstick. He did, however, use his cane when required. Each brush contained a full quantity of every dominant note. Whistler used to say, "I do not teach art. I teach the scientific application of paint and brushes."

He would often refrain from looking at the pupil's canvas and examine only his palette, saying that there he could see the progress being made, and that it was really much more important for it to present a beautiful appearance than for the canvas to be fine and the palette inharmonious. He repeatedly said, "If you cannot manage your palette, how are you going to manage your canvas?"

He taught his pupils to look at the model as a sculptor would—to create on the canvas a statue, using the brush as a sculptor his chisel, to make the figure ex-

Portrait of Richard A. Canfield

1901–3. Oil on canvas, 21 × 13"
Collection Manuel K. Berman

Canfield was a notorious gambler, but his patronage and companionship were welcomed by Whistler. The title he gave the portrait, His Reverence, *was an ironical reference to Canfield's sacerdotal appearance and to the derogatory comments in the American press about their friendship. This is one of Whistler's finest portraits, expressing more individuality and character than he generally allowed himself. It is also a measure of the stupidity of many curators. It was bought by the Cincinnati Art Museum in 1922 and sold by them in 1945! It would be amusing to know what was purchased with the money.*

ist in the proper atmosphere. Once he modeled a figure standing in the light of the studio against a rose-colored wall. After spending almost an hour on his palette, he began to paint and, with swift touches of his brush, made the figure exist—modeled, as he said, in painter's clay.

Another pupil, Cyrus Cuneo, told of working very hard with charcoal, drawing from the model. Whistler looked at what he was doing and commented:

You know that such sort of work would get you prizes and your drawings would be framed and hung on the walls of those other schools. Yes, yes. You know you'll go on working like that for four or five years, and you'll never know anything. There you sit drawing a figure on a white sheet of paper, which to begin with is absolutely false. As you will observe, the model is a delicate silhouette against a green background. The composition before me is emphasized by the entire absence of white. It is a tone harmony enclosed in atmosphere. My advice to you, Mr. Cuneo, is to paint—draw—draw with your brush and endeavor to produce what you see before you.

And then he added, as he walked off: "You may be shocked with the result."

The Académie Whistler lasted until 1901. The students were discontented at the master's absence, caused by his ill health, and gradually ceased to come. He eventually wrote them a formal letter of dismissal, wishing those who remained Godspeed.

In the spring of 1900, Whistler decided that Joseph Pennell should write his biography. He had intended to do an autobiography and even wrote a few chapters, starting with: "Determined that no mendacious scamp shall tell foolish truths about me when centuries have gone by, and anxiety no longer pulls at the pen of the 'pupil' who would sell the soul of his Master, I now proceed to take the wind out of such speculators by immediately furnishing myself the fiction of my own biography, which shall remain and is the story of my life."

Whistler, however, found the job of writing an autobiography more boring than writing venomous notes to the papers. When he had decided on his biographer, he practically moved into the Pennells' house, where Elizabeth Pennell had been asked to join her husband in the task. He was there so much that he said to them, "Well, you know, you will feel about me as I did in the old days about the man I could never ask to dinner because he was always there! I couldn't ask him to sit down, because there he always was, already in his chair!"

The Pennells began when Whistler was sixty-six, but only the grayness of his abundant hair, the lines in his face, the loose flesh of his throat suggested his age. He was as erect as he had been at West Point, and his gaiety and enjoyment of life were undiminished.

At the Universal Exposition in Paris, he was awarded the Grand Prix for painting and another for etching. He was overjoyed to receive this long-awaited recognition and still more pleased to learn that the awards were made unanimously and greeted with applause.

Whistler never forgot his years of battle in England. He disliked the British as a whole—he much preferred the French—but loved London for its beauty. Moreover, he admitted, nowhere were there to be found so many congenial com-

Portrait of Charles L. Freer

1902–3. Oil on wood panel, 20⅜ × 12½″
Courtesy the Freer Gallery of Art,
Smithsonian Institution, Washington, D.C.

Freer, who retired a wealthy man at forty-four, devoted himself to collecting Oriental art, as well as paintings and prints by his close friend Whistler. He established the Freer Gallery of Art in Washington. This institution and the Hunterian Art Gallery in Glasgow—the beneficiary of Rosalind Birnie Philip's bequest—have the two greatest collections of Whistler's work. Freer's portrait has an informality that implies the intimate relationship between painter and sitter. For once Whistler did not rework his canvas. He might have considered the picture unfinished, but it has a vitality and spontaneity he had lost in many of his late portraits.

Portrait of Charles L. Freer

Dorothy Seton—A Daughter of Eve

panions. Nevertheless, he expressed the wish that none of his pictures should form part of an English national collection, and he emphasized that his sitters at the end of his life were Americans or Scots. The beauty of the English countryside left him cold. It was not paintable, he thought, because there were too many trees. However, he said, "You know, I can't say that, toward twilight, it is not pretty in a curious way, but not really pretty after all—it's all country, and the country is detestable." The one landscape that interested him above all was the landscape of London.

His conversation was as brilliant as ever, but he was also more irascible than ever. He was furious that critics said the medal he received in France was given him because of *The Little White Girl* and not his newer pictures. "The critics are always passing over recent work for early masterpieces, though all are masterpieces; the work has always gone on; it has grown, not changed, and the pictures I am painting now are full of qualities they cannot understand today any better than they understood *The Little White Girl* at the time it was painted."

It soon became apparent that Whistler was not well. He developed a cough he could not shake off. "Lowered in tone, the doctor says, I am—well you know—the result, no doubt, of living long in the midst of English pictures." Finally, he realized he could not face an English winter. In December, 1900, with his brother-in-law, he set sail for Gibraltar. At Tangier, the wind was cold. When they moved to Algiers, it rained. He was unhappy away from London. Then he went to Marseilles, where it was snowing, and he stayed in his room and sent for a doctor. Corsica was recommended, so he sailed alone for Ajaccio. The weather was bad, and he was confined to his hotel. Fortunately, the director of the local museum was charming, and Heinemann came to see him for a time. When the weather was better, he did a number of pen and pencil drawings, a few watercolors, and an occasional etching. While convalescing, he was pleased to learn that he had been honored with a gold medal at Dresden and elected unanimously to the Académie Royale des Beaux-Arts. But his health did not seem to improve.

His friend the director told him: "Mr. Whistler, you are all nerves; you do nothing. You try to, but you can't settle down to it. What you need is rest—to do nothing—not to try to do anything." And then, as Whistler wrote: "All of a sudden, you know, it struck me that I had never rested, that I had never done nothing, that it was the one thing I needed. And I put myself down to doing nothing—amazing, you know. No more sketch books, no more plates. I just sat in the sun and slept. I was cured. You know, Joseph [Pennell] must sit in the sun and sleep. Write and tell him so." Whistler returned from Corsica early in May, much better than he had been.

During the summer, the warmth of England revived him further, but with the damp and fog of autumn he relapsed. Realizing that his studio in Paris was too difficult to reach and that he could not live in the Rue du Bac, he went to Paris to close them and when he returned to London was ill in bed at Garlant's Hotel. He was restless. For a time, he stayed with the Birnie Philips in Tite Street. Then he moved to Bath and took rooms in one of the crescents, where he thought he could work. He came often to London, and on some days he was surprisingly

Dorothy Seton—A Daughter of Eve

1903. Oil on canvas, 20⅜ × 12½"
Hunterian Art Gallery, University of Glasgow
Birnie Philip Gift

This, the last important painting by Whistler, was done in a couple of hours. The sitter's seductive expression is perhaps the key to the plethora of portraits of young girls just reaching maturity that Whistler painted toward the end of his life.

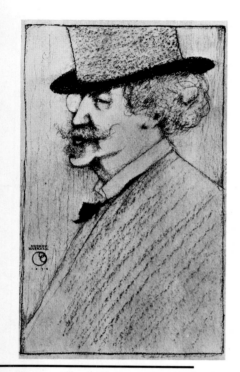

Ernest Haskell. *Portrait of Whistler*

1898. Lithographic reproduction
of a charcoal drawing, 9¾ × 6"
The New York Public Library
Gallatin Collection of Whistler Portraits

well. He went to the show of old masters at Burlington House. Impressed by Jacob Ochtervelt's *Lady at a Spinet*, he said: "The Dutchmen—they had respect for the surface of a picture; the modern painter has no respect for anything but his own cleverness, and he is sometimes so clever that his work is like that of a bad boy, and I am not sure that he ought to be taken out and whipped for it. . . . Except in England, would anything short of perfection in art be praised? Why approve the tolerable picture any more than the tolerable egg?"

To put an end to his wanderings, he took a house in Chelsea, 74 Cheyne Walk. It had a spacious studio in the back, but the windows, with small panes, were placed too high for him to see much of the Thames, which he loved so dearly. The street door was of beaten copper, and the house was full of decorative tricks. Whistler wondered, "What am I doing here? The whole [house], you know, is a successful example of the disastrous effect of art on the British middle classes."

The Ashbees, who owned the house, were no more pleased with Whistler. Janet Ashbee wrote in her journal: "I saw the copper door open, and Minnie parleying with a stranger. I arrived in time to usher into the hall an old gentleman dressed in a cocoa-colored ulster and a crepe silk hat of exactly that cylindrical form affected by Parisians. I knew from my recollection of a Nicholson drawing that it must be Whistler. . . . I hope I did not show the antipathy he raised in me. . . . He gave the impression of an old man trying to be young and sprightly, and aping the oddities of youth, or rather of an old monkey copying the affectations of man."

Ashbee was having a building erected next to the house. "It is knock, knock, knock all day," Whistler complained. Excitement was bad for his heart, the doctor said, and must be avoided. He hoped for legal redress and referred the matter to his solicitor, Mr. Webb, but the knocking continued. To get some rest, he decided to go to Holland with his friend Charles Freer. They stayed in the Hotel des Indes in The Hague, and Whistler became dangerously ill. The *Morning Post* published what he considered an obituary. He wrote to beg that "the ready wreath and the quick biography be put back in the pigeon hole for later use." In its biographical sketch, the *Morning Post* said that Swinburne's verses had inspired *The Little White Girl*. Whistler explained that "this could not be so, since Swinburne's lines had been written in my studio after the picture was painted. And the writing of them was a rare and graceful tribute from the poet to the painter—a noble recognition of work by the production of a nobler one." The bitterness of "*Et tu, Brute*" had vanished.

Whistler was joined in The Hague by Heinemann. Rooms were found for them both in an apartment a short distance from the Hotel des Indes. The artists in The Hague, learning that the painter was ill and staying nearby, were most attentive. Whistler also enjoyed the company of his doctor, the physician of the court and the most distinguished medical man in Holland—as he was delighted to point out. He recovered speedily and was full of gaiety again. He loved The Hague.

Professor George Sauter, a Bavarian artist whose pro-Boer sympathies ap-

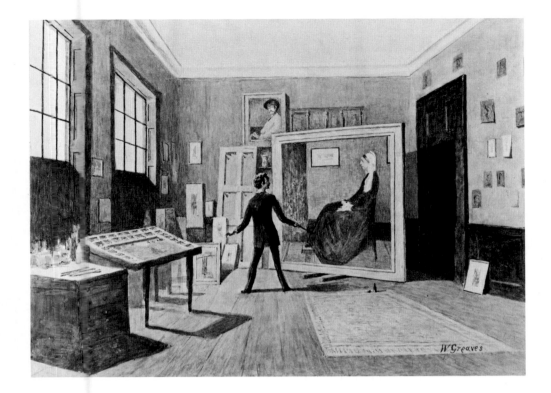

Walter Greaves. *Whistler in His Studio*

Watercolor, 13 × 18″
Courtesy Archives Iconographiques Centrales,
Brussels

pealed to Whistler, came to call. He proposed a trip with him and his wife to Haarlem to look at the Frans Hals portraits. The moment Whistler entered the gallery, all his love of Hals returned. Finding that the barrier between him and the pictures spoiled his enjoyment, he crept under it and was about to be rebuked when the guard learned who he was. He turned to his companion and said, "Now *do* get me a chair," and when it was pushed under the railing he added, "Now *do* help me on top of it." He went into raptures over Hals's painting of the regentesses of the almshouses. He said he had to touch the painting and moved his fingers tenderly over the face of one of the old women. He exclaimed, "Oh, what a swell he was!" And he asked Sauter, "Can you see it all?—and the character—how he realized it! Look at the beautiful color—in the flesh—look at the white—that black—look how the ribbons are put in!" In his weakened state the excitement finally proved too much for Whistler, and his friends feared he would collapse, but they got him home, and the next day he revived.

Whistler came back to 74 Cheyne Walk—to the noise of building, to the bedroom at the top of the house, to everything the doctor had warned against. He eventually moved downstairs, to a tiny room next to the studio intended as a dressing room for the model. Small and uncomfortable as it was, he at least avoided the stairs.

His energy returned from time to time, and he worked intermittently. But it was tragic to see someone who had once been a dandy shuffling around his large studio in a worn-out fur coat and a nightshirt hanging out. Once, upon hearing that he had been referred to as untidy and slovenly, he exclaimed: "I—I, when if I had only a rag to cover me, I would wear it with such neatness and propriety and the utmost distinction." Now he was a forlorn old man, hardly able to walk, wearing a shabby torn coat. Much of the day he slept, but his nights were sleepless. He had a cat, and she was his closest companion. When she had kittens, he roused

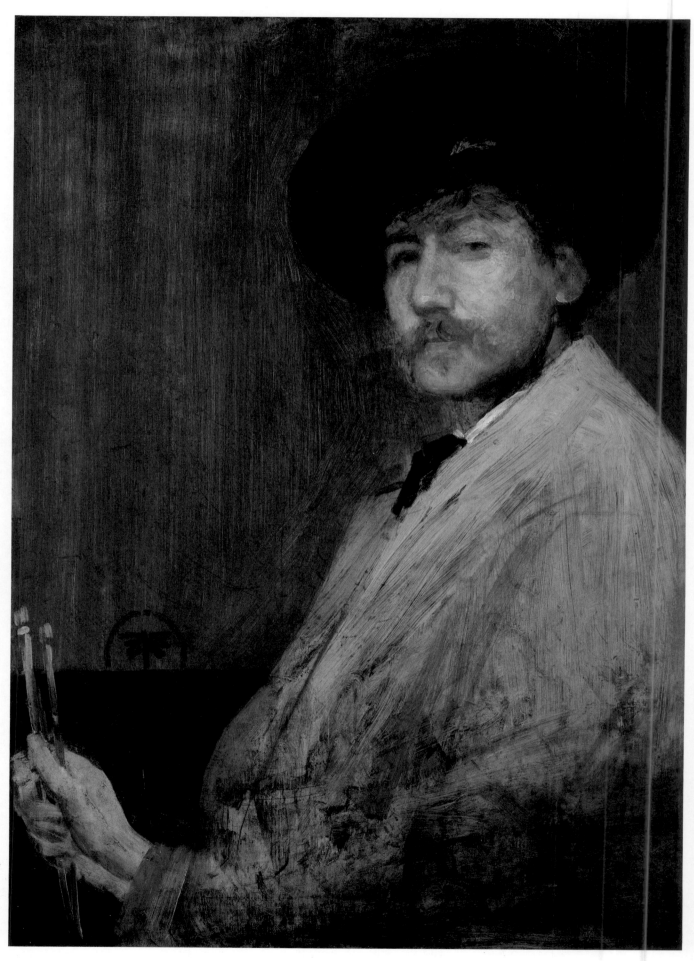

Arrangement in Gray: Portrait of the Painter

himself and was delighted.

On his good days, he liked to play dominoes, and he cheated with his usual skill. At times, he would say he would never paint again; and then, suddenly, his vitality would flare up and he would paint as well as ever. He had a model with red hair, the shade he liked. In a couple of hours, he painted her with an apple in her hand and entitled the picture *Dorothy Seton: A Daughter of Eve.*

The gambler Richard A. Canfield again sat for his portrait. He was welcomed both as a client and as a friend. That so notorious a person should have been received by Whistler shocked the newspapers in America. It resulted, however, in one of his masterpieces of portraiture, which he called *His Reverence.*

Whistler took great pleasure in the degree of doctor of laws conferred by Glasgow University. He was also pleased to be asked to sit as chairman of the committee to select American artists in England for the Universal Exposition of 1904 in Saint Louis.

Though Whistler's health varied during the winter, by spring it was evident there was no hope. The afternoons of sleep increased, and he could not shake off a cold that was dragging him down. At times, his cough was so bad that he dreaded to speak and wrote out what he wanted to say. His eyes were the first to go; they lost their glitter and faded away. His body, however, succumbed slowly. He seemed better and was planning to go for a ride with Freer when, on July 17, 1903, death overcame him.

Whistler's funeral service was held in the Chelsea church to which he had often walked with his mother from his house in Lindsey Row. There were few people at his funeral; and Whistler, who longed for recognition, would have been disappointed that no one came from the American Embassy, nor from the German, French, or Italian Embassies, although all these countries had honored him during his life. The only body officially represented was the Royal Scottish Academy. Only a few friends went to the graveyard at Chiswick, where he was buried beside his wife. Among the mourners was an elderly lady, Jo, the former mistress, leaning on the arm of a young man, Charles Hanson, the disinherited son. It was a stormy day, and, fittingly, Whistler's coffin was illumined by the misty English light that he had so loved.

At the annual meeting of the International Society of Sculptors, Painters, and Gravers, Joseph Pennell, then secretary, had the sad duty of informing the members of their chairman's death. It was decided to mount a memorial exhibition of Whistler's work. It was the most successful show the Society ever assembled. Although retrospective shows of Whistler's paintings and prints had previously been held at the Scottish Academy, as well as in Boston and Paris, the Memorial Exhibition in London was the finest of all. It contained nearly all his principal oil paintings, the largest group of etchings ever shown together, all but one or two of his lithographs, and many watercolors, pastels, and drawings.

The long battle Whistler had fought was over. His reputation appeared secure. The neglect that followed his death was only temporary. Today, he is accepted as a painter of stature, worthy of a place in the pantheon of great artists, where there is reason to believe he will always remain.

Arrangement in Gray: Portrait of the Painter

1872. Oil on canvas, 29½ × 21″
The Detroit Institute of Arts
Bequest of Henry Glover Stevens in memory of
Ellen P. Stevens and Mary M. Stevens

An example of Whistler's many types of brushwork. The background has vertical strokes except where they follow the outline of the figure. The face is modeled fluently, using small brushes. By contrast, the jacket is roughly painted and rigorously scraped down. Yet the unity of the whole is preserved. Whistler, like Rembrandt, painted numerous self-portraits. Would it be possible, he wondered, to fix on canvas his mercurial personality? The answer is no. Unlike Rembrandt, he was basically too great a poseur.

Epilogue

AFTER THE FIRST WORLD WAR, Whistler's reputation declined from its peak. The work of the significant painters of the School of Paris—Picasso, Matisse, Braque, Modigliani, and Soutine—pointed in a different direction. As they became increasingly fashionable, all that Whistler stood for seemed a deviation from "Significant Form," as the English art critic Clive Bell defined the essence of Post-Impressionism.

In some houses a few years ago, one could still see Whistler's etchings and lithographs, but that was before the Impressionist inundation washed everything from the walls except brightly colored scenes by such artists as Monet, Sisley, and Pissarro. A search has now begun for something different, another way of looking at human beings and landscapes. For such connoisseurs, Whistler's individuality and originality have a strong appeal. His fame has begun to revive.

He will never have the influence and popularity of the Impressionists, with whom he exhibited in 1863 at the Salon des Refusés. Yet a highlight of that famous exhibition was his *White Girl*, or *Symphony in White, No. 1*. It had its critical eulogists and attracted the greatest crowds as well as the greatest derision. It struck a new note, and artistic innovations take time to be understood. His reputation was not enhanced, however, by paintings that made people laugh. If he had been more conventional, if paintings like *The Music Room* had been less spectral, if his introduction of Japanese design and accessories had been less novel, he would quickly have received the acclaim he deserved.

But worse was to come. His Nocturnes startled the public. They were unprepared for paintings in which familiar scenery was transformed by darkness, the well-known banks of the Thames only dimly discerned, the buildings on either side metamorphosed into palaces and campanili. Ruskin's famous jibe describing one of the Nocturnes as "a pot of paint flung in the public's face" is apt—that is, when Whistler's picture is compared with other paintings Ruskin knew. But today it seems a silly comment, for our eyes have been trained to see abstractions; Ruskin's were not. We are so used to pictures without subjects of any kind that we do not realize the singularity of Whistler's scenes of night. They were a breakthrough toward abstract art and thus an important milestone in art history. Moreover, this milestone appeared almost half a century before the abstractions of the Cubists and nearly a century before the abstractions of the New York School.

Whistler, however, even in his most abstract pictures, retained some indication of subject matter. This may seem puzzling, since he regarded the formal aspects of painting as the only elements of significance. His explanation might have been that color and composition had to be derived from a subject seen by the painter; and this motive, he felt, should be part of the picture. Whistler looked for scenery that was partially abstract, scenery that was wrapped in mist, in fog, or in the darkness of night. Much as he might emphasize form over content, or insist that form and content were one, his pictures, in spite of their musical titles, are always painted around a subject. Almost a century had to pass before artists consistently renounced all representation and painted pure abstractions—tonal arrangements considered beautiful in themselves. Such abstractionists can look to Whistler and Turner as their ancestors. The emphasis of many contemporary artists on chromatic arrangements to the exclusion of everything else would have aroused the sympathies of both painters.

The popularity in recent years of abstract painting provided a milieu, an atmosphere conducive to the revival of Whistler's reputation. Appreciation of his work was unlikely in America during the 1920s when the Ashcan School predominated, or in the 1930s when Social Realism took over. To the earthy painters of American urban life or their successors, the Social Realists, Whistler's elitism was repellent. His work seemed no more than the dainty fluttering of a butterfly and, as such, unworthy of attention.

But their attitude is part of the past. Taste has changed. This is apparent in literature as well as in art. The novels of Henry James and the autobiography of Marcel Proust have become more popular than the realism of Theodore Dreiser or the tales of Sherwood Anderson.

And with this transformation in art and literature, Whistler is again being recognized as one of the great masters of the nineteenth century. The high regard he enjoys today comes from those who refuse to look on art as the product of fashion, or as morally uplifting, or as propaganda for some cause: those who share Whistler's belief in art for art's sake and are convinced that its only purpose is to create beauty. They are the audience he always sought: connoisseurs prepared to accept his fastidiousness, his extreme elitism, his dandiacal withdrawal from the vulgarity of everyday life and to appreciate his craftsmanship, his dedication, and his genius.

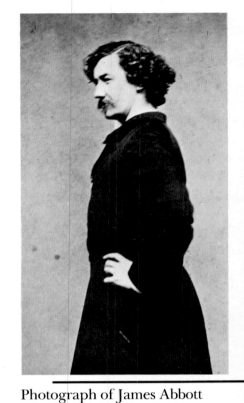

Photograph of James Abbott
McNeill Whistler by Carjat

Biographical Outline

1834 Born July 10 in Lowell, Massachusetts, third son of Major George Washington Whistler, civil engineer, and eldest son of his second wife, Anna Matilda McNeill.

1837 Family moved to Stonington, Connecticut, where Major Whistler was in charge of construction of a railroad.

1842 Major Whistler traveled to Russia, where he was employed by the czar to build a railroad from Saint Petersburg to Moscow.

1843 Mrs. Whistler, with James, William, and her stepdaughter, Deborah, joined Major Whistler in Russia.

1845 Attended drawing lessons at Imperial Academy of Fine Arts.

1846 Gained first prize at the Academy for drawing heads from life.

1847 Visited England and served as best man at wedding of his half sister to Francis Seymour Haden, a well-to-do surgeon, who became a notable etcher.

1848 Returned to England after attack of rheumatic fever.

1849 Stayed with Hadens in London. Returned to America after father's death, living first at Stonington, then in Pomfret, Connecticut.

1851 Entered West Point.

1854 Discharged from West Point for deficiency in chemistry. Joined Drawing Division of United States Coast and Geodetic Survey.

1855 Resigned from Coast and Geodetic Survey. Moved to Paris and attended Ecole Impériale et Spéciale de Dessin.

1856 Entered the studio of Gleyre.

1857 Copied paintings in the Louvre. Saw paintings by Velázquez at Manchester.

1858 Produced series of etchings known as *The French Set*. Went to London and began his first important painting, *At the Piano*.

1859 Returned to Paris. *At the Piano* rejected at the Salon but praised by Courbet.

1860 *At the Piano* accepted by the Royal Academy, the first painting exhibited by Whistler in Britain. Bought by John Phillip, R.A.

1861 Visited Britanny after another attack of rheumatic fever. Worked on *The White Girl*, with Jo (Joanna) Hiffernan as model.

1862 Thames etchings shown in Paris and praised by Baudelaire. *The White Girl* rejected at the Royal Academy. Met Dante Gabriel Rossetti and Algernon Swinburne.

1863 *The White Girl* rejected at the Salon but shown at the Salon des Refusés. Whistler's mother came to London to live with him on Lindsey Row.

1864 *Wapping* and *The Lange Leizen of the Six Marks* shown at the Royal Academy. Jo sat for *The Little White Girl* and *The Golden Screen*.

1865 Posed in Paris in a Chinese robe for Fantin-Latour's *Hommage à la vérité*, which was exhibited at the Salon with Whistler's *La Princesse du pays de la porcelaine*, *Symphony in White, No. 2: The Little White Girl* and *Old Battersea Bridge* shown at the Royal Academy.

1866 Journeyed to Chile; painted several seascapes at Valparaiso, including his first night scenes.

1867 Exhibited three paintings at the Royal Academy, including *Symphony in White, No. 3*.

1868 Attempted a large painting, *The Three Girls*.

1870 Birth of his son, Charles James Whistler Hanson, by Louisa Hanson, a parlormaid.

1871 Painted portrait of his mother. Began portraits of Frederick Leyland and his wife. Small London dealers, including Durand-Ruel and the Society of French Artists, began to exhibit his work.

1872 Briefly engaged to Leyland's sister-in-law, Elizabeth Dawson. Commissioned to do two mosaics for Victoria and Albert Museum. Portrait of his mother shown at Royal Academy, the last picture he ever exhibited there.

1873 Completed portraits of Thomas Carlyle and Leyland. Maud Franklin replaced Jo as his mistress and principal model.

1874 First one-man show held at the Flemish Gallery in London.

1875 Painted Nocturnes of Cremorne Gardens. Of these, the most important is *The Falling Rocket*.

1876 Began work on hall and dining room of Leyland's house. Maud Franklin posed for several portraits.

1877 Peacock Room praised by critics. *Black and Gold* and *The Falling Rocket* exhibited at opening of the Grosvenor Gallery. Construction of the White House begun. Sued Ruskin for libel.

1878 Society of American Artists exhibited *The Coast of Brittany*, his first painting shown in New York. Moved to White House. Learned from the London printer Thomas Way how to do lithographs. Painted portrait of Rosa Corder. Ruskin trial ended; awarded one farthing damages but had to pay his costs. Deeply in debt. Published a pamphlet, *Whistler v. Ruskin: Art and Art Critics*.

1879 Declared bankruptcy; his effects auctioned at White House. Left for Venice with Maud Franklin; commissioned by the Fine Arts Society to do twelve etchings.

1880 In Venice made fifty etchings and over ninety pastels but few paintings. Returned to London in November. Twelve etchings of Venice shown at Fine Arts Society.

1881 Exhibited, with great success, fifty-three pastels of Venice. Mother died at Hastings. Worked on portrait of Lady Meux. Became friendly with Oscar Wilde.

1882 Painted portrait of Lady Archibald Campbell. Met Walter Sickert, who left Slade School to become his pupil and assistant.

1883 Painted portrait of Théodore Duret. Nocturnes exhibited at Galerie Georges Petit in Paris and at Grosvenor Gallery in London.

1884 Spent long periods at Saint Ives, Cornwall, with his pupils Mortimer Menpes and Walter Sickert. Elected member of the Society of British Artists. Showed a portrait of Mrs. Louis Huth.

1885 Delivered "Ten O'Clock" Lecture in Prince's Hall, London. Portraits of Lady Archibald Campbell and Duret shown at the Salon. Visited Belgium and Holland.

1886 Elected president of the Society of British Artists.

1887 Exhibited fifty small oils and watercolors at Galerie Georges Petit in Paris. Obtained royal charter for Society of British Artists from Queen Victoria.

1888 Forced to resign as president of Society of British Artists. Stéphane Mallarmé agreed to translate the "Ten O'Clock" Lecture. Married Beatrice Godwin. Elected honorary member of the Royal Academy of Fine Arts, Munich.

1889 Exhibited oils, watercolors, and pastels at Wunderlich's in New York. Awarded first-class medal at Munich. *The Balcony* shown at the Universal Exposition in Paris and awarded gold medal; made Chevalier of the Legion of Honor.

1890 Controversy over publication of *The Gentle Art of Making Enemies*.

1891 Asked by Count Robert de Montesquiou to paint his portrait. Corporation of Glasgow bought portrait of Carlyle. French government bought *Mother* for Luxembourg Museum.

1892 Made Officer of the Legion of Honor. Retrospective exhibition held at Goupil Gallery in London. Sent six paintings to Columbian Exhibition in Chicago; awarded a gold medal. At the Internationale Kunstausstellung in Munich awarded first-class gold medal for *Fur Jacket*.

1893 Painted portraits in Paris of Edward G. Kennedy and J. J. Cowan (the latter never completed). Sold *La Dame au brodequin jaune* to the Philadelphia Museum of Art, the first painting he sold to an American museum.

1894 Painted portrait of Lady Eden in Paris, which was exhibited, along with portraits of Mrs. Walter Sickert and Count Robert de Montesquiou, at the Société Nationale des Beaux-Arts. Mrs. Whistler developed cancer.

1895	Took his ailing wife to Lyme Regis, where he painted *Little Rose of Lyme Regis*.
1896	Mrs. Whistler died. Adopted his sister-in-law, Rosalind Birnie Philip; made her his executrix and eventually his heiress. Sent his portrait of Pablo de Sarasate to the Pittsburgh International Exhibition, and it was bought by the Carnegie Institute.
1897	Established Company of the Butterfly, which lasted until 1901. Commissioned by George W. Vanderbilt to paint his portrait and that of his wife.
1898	Elected chairman of the International Society of Sculptors, Painters, and Gravers, which held its first exhibition at the Prince's Skating Club in Knightsbridge. The Académie Whistler opened in Paris.
1899	Exhibited work in Russia. Visited Italy. Published his account of the Eden case, *The Baronet and the Butterfly*.
1900	Dr. William Whistler died. Joseph Pennell asked to write the authorized biography of Whistler. Ill health; went to Corsica seeking warmer climate.
1901	Returned to England; closed studio and apartment in Paris. Health poor.
1902	Painted portrait of Richard A. Canfield titled *His Reverence*. Moved to 74 Cheyne Walk. While on holiday with Charles Freer became seriously ill; convalesced in The Hague.
1903	Given honorary degree by Glasgow University. Health deteriorated rapidly. Died in London on July 17. Buried in Chiswick Cemetery.

Selected Bibliography

ANDREWS, ANNULET. "Cousin Butterfly, Being Some Memoirs of Whistler." *Lippincott's Magazine* 73:318–27. March 1904.

ANGELI, HELEN ROSSETTI. *Pre-Raphaelite Twilight*. London, 1954.

BACHER, OTTO. *With Whistler in Venice*. New York, 1908.

BALDRY, ALFRED L. "James McNeill Whistler: His Art and Influence." *Studio*, October 1903.

BARBIER, CARL P. "Whistler and Mallarmé." *The College Courant. Journal of the Glasgow University Graduates Association* 25:14–19. Martinmas, 1960.

BARRETO, RICARDO DAVID. "Whistler and Photography." Master's thesis, Oberlin College, 1976.

BECKER, E. M. *Whistler and the Aesthetic Movement*. Ann Arbor, 1981.

BEERBOHM, MAX. "Whistler's Writing." *The Metropolitan Magazine*, September 1904.

CAFFIN, CHARLES H. *The Story of American Painting*. New York, 1907.

CUNEO, CYRUS. "Whistler's Academy of Painting." *The Century Magazine* 73:19–28. November 1906.

CURRY, D. P. *James McNeill Whistler at the Freer Gallery of Art*. Washington, 1984.

DONNELLY, KATE, and THORP, NIGEL. *Whistlers and Further Family*. Glasgow, 1980.

DURET, THÉODORE. *Whistler*. Translated by Frank Rutter. London and Philadelphia, 1917.

EDDY, ARTHUR JEROME. *Recollections and Impressions of James A. McNeill Whistler*. London, 1903.

FENELLOSA, ERNEST F. "The Place in History of Mr. Whistler's Art." *Lotus*, December 1903.

FINE, RUTH E. *Drawing Near*. Los Angeles, 1984.

FLEMING, GORDON. *The Young Whistler*. London, 1978.

GALLATIN, A. E. *Whistler's Art Dicta and Other Essays*. Boston, 1904.

GREGORY, HORACE. *The World of James McNeill Whistler*. London, 1961.

HOPKINSON, MARTIN. *Whistler Inheritance*. Glasgow, 1985.

HUBBARD, ELBERT. *Little Journeys to the Homes of Eminent Artists*. New York and London, 1897.

KENNEDY, EDWARD G. *The Etched Work of Whistler*. New York, 1910.

KEPPEL, FREDERICK. *The Gentle Art of Resenting Injuries, Being Some Unpublished Correspondence Addressed to the Author of "The Gentle Art of Making Enemies."* New York: Privately printed, 1904.

LANDOR, A. HENRY SAVAGE. *Everywhere*. London, 1924.

LAVEF, JAMES. *Whistler*. London, 1951.

LEE, VERNON. "Imagination in Modern Art: Notes on Whistler, Sargent, and Besnard." *The Fortnightly Review* 68:513–21, October 1897.

LEHMAN, KATHERINE A. *Whistler's Etchings*. New Haven, 1984.

MACCOLL, DUGALD S. "Mr. Whistler's Paintings in Oil." *The Art Journal*, 1893.

MACDONALD, MARGARET F. *Whistler Pastels*. Glasgow, 1984.

MCMULLEN, ROY. *Victorian Outsider*. New York, 1973.

MANSFIELD, HOWARD. *Whistler as a Critic of His Own Prints*. New York, 1935.

MAUCLAIR, C. M. *De Watteau à Whistler*. Paris, 1905.

MEIER-GRAEFE, JULIUS. *Modern Art*. London and New York, 1908.

MENPES, MORTIMER. *Whistler as I Knew Him*. London, 1904.

PEARSON, HESKELL. *The Man Whistler*. London, 1952.

PENNELL, ELIZABETH ROBINS, and PENNELL, JOSEPH. *The Life of James McNeill Whistler*. Philadelphia, 1911.

————. *The Whistler Journal*. Philadelphia, 1921.

POCOCK, TOM. *Chelsea Reach. The Brutal Friendship of Whistler and Walter Greaves*. London, 1970.

ROSSETTI, WILLIAM M. *Rossetti Papers, 1862–1870*. London, 1903.

SCOTT, WILLIAM. "Reminiscences of Whistler: Some Venice Recollections." *Studio*, November 1903.

SEITZ, DON CARLOS. *Whistler Stories*. New York and London: Harper & Brothers, 1913.

SPENCER, ROBIN. *The Aesthetic Movement*. New York, 1972.

STARR, SIDNEY. "Personal Recollections of Whistler." *Atlantic Monthly* 101:528–37. April 1908.

SUTTON, DENYS. *Nocturne: The Art of James McNeill Whistler*. Philadelphia and New York, 1964.

THOMPSON, SIR HENRY. *A Catalogue of Blue and White Nankin Porcelain....* London, 1878.

THOMSON, DAVID CROAL. "James Abbott McNeill Whistler: Some Personal Recollections." *The Art Journal*, September 1903.

WAY, THOMAS R. *The Lithographs by Whistler*. Arranged according to the catalogue by T. R. Way. New York, 1914.

———— *Memories of James McNeill Whistler, the Artist*. London and New York, 1912.

WEINTRAUB, STANLEY. *Whistler, A Biography*. London, 1974.

WHISTLER, JAMES ABBOTT MCNEILL. *Eden v. Whistler. The Baronet and the Butterfly*. Paris, 1899.

————. *Etching. Drypoints. Venice*. 2nd series. Chelsea (London?), n.d.

————. *The Gentle Art of Making Enemies*. London, 1890.

————. *Mr. Whistler's "Ten O'Clock."* London, 1888.

————. *Nocturnes, marines, etc.* London, n.d.

————. *Whistler v. Ruskin: Art and Art Critics*. 7th ed. London, n.d.

Wilde v. Whistler, Being an Acrimonious Correspondence on Art Between Oscar Wilde and James A. McNeill Whistler. London: Privately printed, 1906.

YOUNG, ANDREW MCLAREN; MACDONALD, MARGARET; SPENCER, ROBIN; and MILES, HAMISH. *The Paintings of James McNeill Whistler*. New Haven and London, 1980.

Photograph Credits

The author and publisher wish to thank the museums, libraries, and private collectors who permitted the reproduction of works of art in their possession and supplied the necessary photographs. Photographers (listed by page number) are gratefully acknowledged below.

Geoffrey Clements, New York: 76; John C. Lutsch, Boston: 140; Eric Mitchell, Philadelphia: 94; John Webb: 47, 53.

Index

Page numbers in *italic* refer
to illustrations.